THE PAINTER'S WORKSHOP
creative composition & design

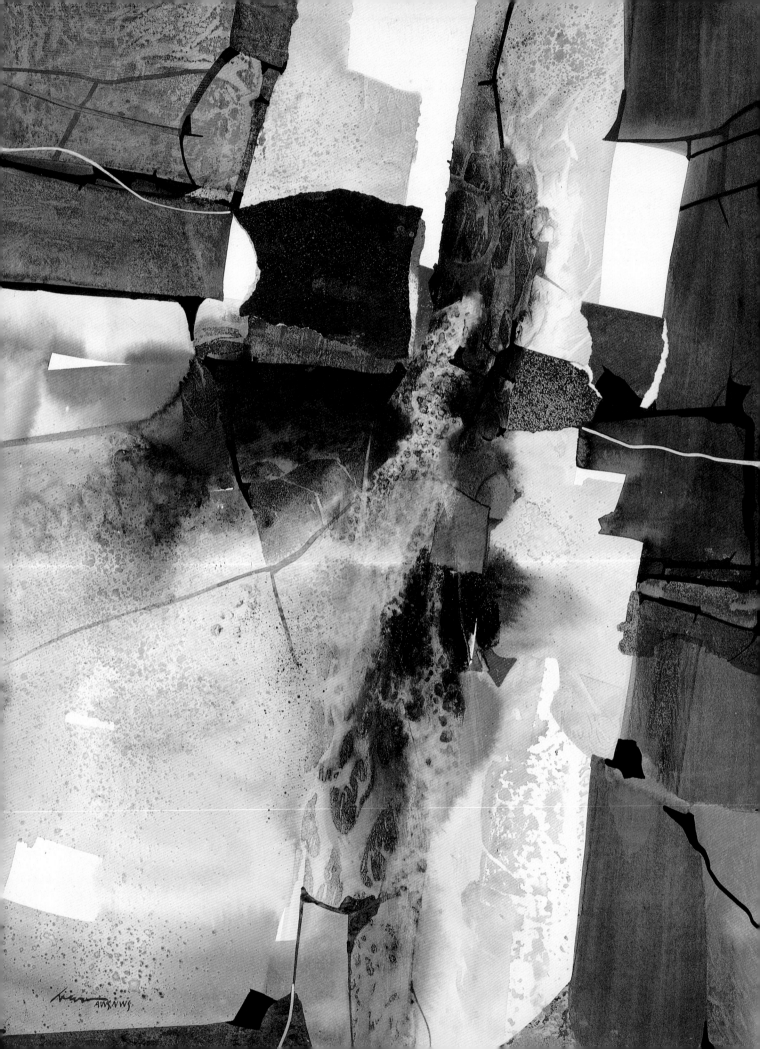

[the painter's workshop]

creative
composition
& design

PAT DEWS

NORTH LIGHT BOOKS
CINCINNATI, OHIO
www.artistsnetwork.com

Art from page 2:

CLIFF STUDY
Pat Dews • Watercolor, ink and acrylic on heavyweight Rives BFK print-making paper • 30" × 22" (76cm × 56cm) • Collection of Anna and Bill Dunlop

Metric Conversion Chart

To convert	to	multiply by
Inches	Centimeters	2.54
Centimeters	Inches	0.4
Feet	Centimeters	30.5
Centimeters	Feet	0.03
Yards	Meters	0.9
Meters	Yards	1.1
Sq. Inches	Sq. Centimeters	6.45
Sq. Centimeters	Sq. Inches	0.16
Sq. Feet	Sq. Meters	0.09
Sq. Meters	Sq. Feet	10.8
Sq. Yards	Sq. Meters	0.8
Sq. Meters	Sq. Yards	1.2
Pounds	Kilograms	0.45
Kilograms	Pounds	2.2
Ounces	Grams	28.6
Grams	Ounces	0.035

The Painter's Workshop: Creative Composition & Design. Copyright © 2003 by Pat Dews. Manufactured in China. All rights reserved. No part of this book may be reproduced in any form or by any electronic or mechanical means including information storage and retrieval systems without permission in writing from the publisher, except by a reviewer who may quote brief passages in a review. Published by North Light Books, an imprint of F&W Publications, Inc., 4700 East Galbraith Road, Cincinnati, Ohio 45236. (800) 289-0963. First edition.

Other fine North Light Books are available from your local bookstore, art supply store or direct from the publisher.

07 06 05 04 03 5 4 3 2 1

Library of Congress Cataloging-in-Publication Data

Dews, Pat.
The painter's workshop : creative composition & design / Pat Dews.—1st ed.
 p. cm.
Includes bibliographical references and index.
ISBN 1-58180-303-6 (hc : alk. paper)
1. Composition (Art) 2. Design. 3. Painting—Technique. I. Title.

ND1475.D48 2003 2002045469
751—dc21 CIP

Editor: Stefanie Laufersweiler
Cover designer: Brian Roeth
Interior designer: Wendy Dunning
Layout artist: Christine Long
Production coordinator: Mark Griffin

Cover art by Pat Dews, Mark E. Mehaffey, Betty Carr and Jacqueline Chesley. The permissions on page 139 constitute an extension of this copyright page.

ABOUT THE AUTHOR

Pat Dews, an award-winning artist, works experimentally using watermedia on paper and canvas. She is an elected member of both the American Watercolor Society (AWS) and the National Watercolor Society (NWS) and a signature member of the National Collage Society. She is also a full member of the New Jersey Water Color Society, the National Association of Women Artists, and The Artist Guild of the Boca Raton Museum of Art in Florida. Some of her successes include the 2002 AWS Ida Wells Stroud Memorial Award, the NWS Liquitex Merchandise Award and the New Jersey Water Color Society's Nicholas Realle Memorial Award.

Pat conducts national and international workshops and has judged numerous watercolor exhibitions. She is represented by Jane Law's Long Beach Island Art Studios and Gallery in New Jersey. Pat is the author of *Creative Discoveries in Watermedia* (North Light Books, 1998).

With her husband, Joe, Pat lives and works in Florida during the winter and on the East End of Long Island in the summer. Visit Pat's website at www.watercolorplace.com/dews.

We are all worms,
* but I do believe I am a glowworm.*
* —*WINSTON CHURCHILL

DEDICATION

Dedicated to

Lillian and Joe

Kaili, Caitlin, K.C. and Courtney

They make my heart glad.

ACKNOWLEDGMENTS

First and foremost, I thank God for blessing me with a talent.

I'd also like to thank:

My husband, Joe, who in every way enables me to use this talent to its fullest. I could not have written this book without his complete support. While I was working, he helped not only me, but my elderly parents as well. He will be glad to end his stint as a "wife"!

My parents, Ed and Ethel Kane, for teaching me to be tenacious. My sister, Diane, and brother-in-law John Howland for their extra support in the care of my parents.

Rachel Wolf, for believing in this book. My editor, Stefanie Laufersweiler, a smart lady, for always being there for me with her experience and guidance in the writing of this book. Designers Brian Roeth and Wendy Dunning and everyone else at North Light who helped bring this book so beautifully to the printed page.

The contributing artists—Betty Carr, Mark Mehaffey, Jacqueline Chesley, Eydi Lampasona, Dorothy Masom and Lynn Weisbach—for so kindly sharing their wonderful work and their design input.

My students, for taking a risk and sharing their great experimental starts and finishes and for making me a better painter. Thanks especially to those students from the following groups who so kindly contributed their work to this book: Art in the Mountains, Bend, Oregon; Art Center Sarasota, Sarasota, Florida; Artists' Workshop, Inc., New Smyrna Beach, Florida; Beaufort Art Association, Beaufort, South Carolina; The Bloomington Art Center, Bloomington, Minnesota; and the Hudson River Valley Art Workshops, Greenville, New York.

Mike Darcy at The Camera Shop, for convincing me to buy a Pentax and for prompt developing. Mike Richter at Mike Richter Photography, for showing me how to bracket and for shooting transparencies on the weekend. Positive Images Photo Labs Inc., for shooting and developing needed transparencies on short notice. Carolyn Fogle at Cheap Joe's Art Stuff, for providing paper for testing in the eleventh hour. Barbara Golden at Golden Paints, for so generously supplying materials for my students to play and learn.

TABLE OF CONTENTS

PART ONE
What Is
Good Design? 10

Start by taking a look at the design elements and principles that are essential for well-composed paintings. Then, begin honing your skills with three projects designed to get you moving: making a painting from a texture sheet, creating an abstract design understructure, and allowing a piece of a larger image to inspire an entire painting.

PART TWO
Different Artists,
Different Approaches 52

See how six accomplished professional artists put together successful compositions in their own unique styles. Each painter shows his or her approach to design through demonstrations in a variety of mediums and examples that offer specific pointers.

PART THREE
How to Bring a Good Start to a Great Finish 108

Many artists have no trouble getting started with a painting but don't know how to finish it. This section provides a list of questions to consider as you finish your paintings. You will see how two particular abstract starts are brought to successful completion, and you'll learn from design suggestions offered in critiques of student work.

Conclusion 136

RED 2
Pat Dews • Watercolor, ink and acrylic on Rives BFK heavyweight printmaking paper • 11⅝" × 11⅝" (30cm × 30cm) • Private collection

INTRODUCTION

I wrote this book because my students always ask me to help them learn more about design. I have a passion for helping artists become better at their craft. I am thrilled when students have success with their work. I delight in their discoveries. This book is for my students and students everywhere. I hope it will answer many of your questions about design and make your journey easier.

In teaching workshops around the country, I find that students know how to start a painting, but they don't always know how to finish. They are unsure of what they want to convey—the content of their painting. They reach a certain stage in their work and are unsure of what to do next.

Having a basic knowledge of the elements and principles of design gives you tools to work with. They are the language of design, the foundation on which you compose or design your painting. They are learned and then exist in the background to be called forth as needed, enabling you to create with freedom and imagination.

A student recently said to me after a group critique, "I'm never entering a show you judge. You know everything that's wrong with a painting!" If I am in position to judge, I'd better know what is wrong. Of course, it isn't true that I know everything. I continue to learn. If you can begin to articulate what design is—what makes a design good or bad—and if you can learn to see what is wrong with your painting, then you can begin to learn how to fix it. You have to determine your strengths and focus on improving your weaknesses. You have to nurture creativity and have a good attitude. If you think you can, you can; if you think you can't, you can't.

The six main contributors to this book are all pros in their fields—working in watercolor, pastel, mixed media and encaustics in realistic, experimental and impressionistic styles—and offer their secrets for making great designs. Their demonstrations and examples will help you see in a new way. They will start you thinking about emphasis, content and the principles of design.

Specific projects in this book are designed to help make the business of composing good art exciting and easy to understand. I use these projects in my workshops, and you can use them without leaving home.

Collage is a great aid in learning design. You can move and change shapes and see the results immediately. Texture sheets will allow you to learn new techniques for creating texture, an element of design, while creating a painting. Working with abstract design understructures will help you learn about shape and color, two more elements of design. Take bits of small images extracted from magazines and, with the aid of a viewfinder, discover the basis for a larger design. These newly discovered images will get you working with new shapes and help you avoid the trap of repeating your safe designs. Your work will remain fresh and exciting.

You will learn to paint unique pieces. These projects are designed to make you think, use your imagination and find your own personal vision. Don't try to be someone else; you could be better. Start looking, gathering and collecting. In addition, there is a section on how I finish paintings from the middle stage, where everyone seems to get stuck. And, best of all, there is a critique section where I give suggestions to students on how to finish their paintings. Students always think I can finish mine because it is mine and that somehow finishing their paintings is different. I'll share with you techniques I use to finish my own paintings and give you questions to ask yourself when finishing yours. I'll clearly show you how to plan your finish with the help of colored construction paper.

This book has projects to get you started and answer many of your design questions. The rest is up to you. You learn by doing. You become a good artist by painting and learning from your mistakes. Learn the rules, then paint enough so you can forget the rules, follow your gut feeling and win the prize.

Buy a quire of paper and begin! There are so many design ideas that you will finish those first twenty-five sheets very quickly. And if you get hooked, the way I and the contributing artists you will meet in this book are, you will begin an exciting journey. You'll buy the next twenty-five sheets and begin painting the hundreds of paintings it takes to learn how to become a good painter. Paint what you know and what you love. I can't think of a better way to spend a day.

What Is Good Design?

Good design works! Paintings with good design have harmony—there is a feeling of completeness. They also have unity with variety—adding one more line, color or shape would not make it better. In any well-designed painting, the elements and principles of design are evident. The elements and principles dictate good design and how to organize the parts to make a pleasing whole.

Painting is a journey. It starts by taking small steps that lead to bigger steps. Once you have the basic information, then you have a guide for the path you are to take. First, you have to set your mark on the paper. The projects in this section—creating a texture sheet, painting from an abstract design understructure and composing from a larger image—show the elements and principles of design at work and demonstrate how you can apply them in different ways to put together unique, structurally solid paintings. With basic guidelines, strong desire, hard work and many sheets of paper, you will be on your way to an exciting journey of designing art.

MORNING, NOON AND NIGHT
Mickey Schemer • Oil on paper collage, mounted on board • 7½" × 18¼" (19cm × 46cm) • Collection of Pat Dews

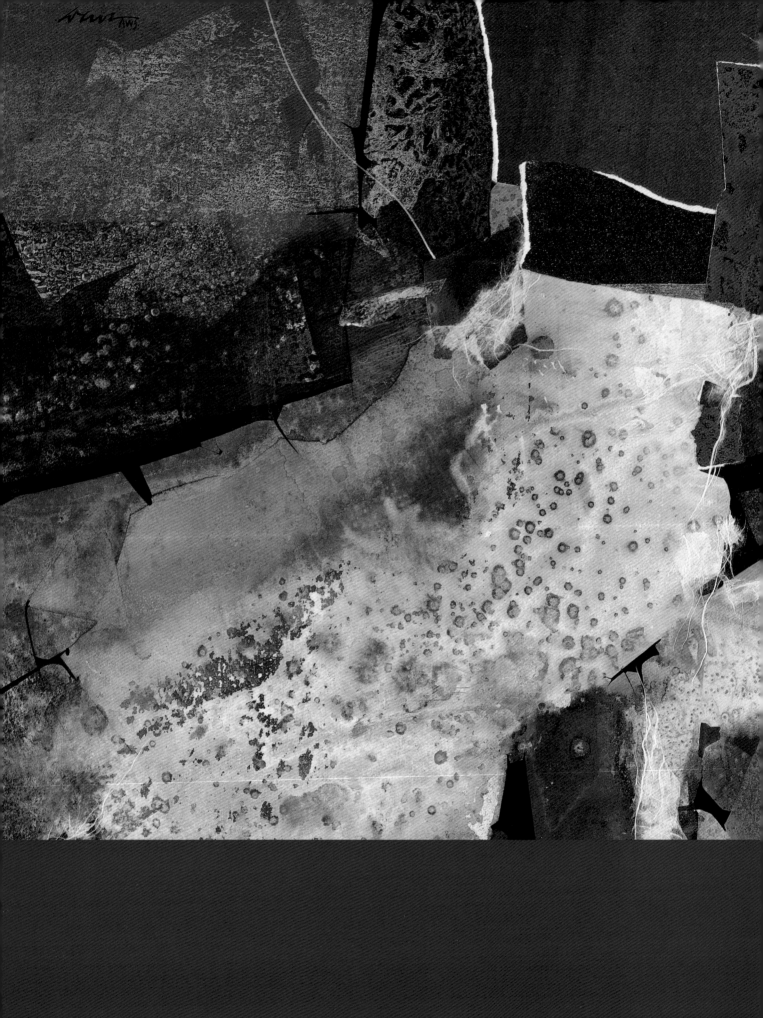

THE *Elements* AND *Principles*

You cannot go about the business of making good paintings without studying what goes into making a good design or composition. The elements of design are the visual elements or tools you use to compose and design. The principles tell you how to use and combine these elements. They help you organize your composition.

Most of the decisions you make as an artist will be based on the elements and principles of design. You have to teach yourself the basic rules, and then you have direction and guides for your design plan or composition. When starting your journey, they show you the way. After you have been painting awhile, the process becomes intuitive. To become a better painter, learn as much as you can about design.

DEEP GORGE
*Pat Dews • Ink, acrylic and collage on heavy-
weight Rives BFK printmaking paper • 18½" ×
22" (47cm × 56cm) • Collection of the artist*

how to approach the elements and principles

Knowing how to talk about your art—being able to discuss it out loud with someone—is very valuable. You need to know the language of art to identify and discuss your strengths, weaknesses and what you are trying to say with your art. A knowledge of the elements and principles of design will help you accomplish this.

Teaching experimental art workshops around the country, I find that students know how to make great abstract starts but are not sure how to bring them to completion. They want to paint abstract paintings but are not sure how to give these starts shape and form and make them into good compositions. They don't know enough about design.

Artists working in a realistic manner say they want to get looser, but what they are really looking for is a different way of seeing. All good work, whether abstract or realistic, has a good abstract understructure, or underlying design.

Many beginners do not always think about what they are trying to communicate in their work (in other words, the content). Imagination and vision have to be nurtured and developed. And most importantly, a basic understanding of the elements and principles of design has to be learned and applied. Eventually these guides become intuitive. When you are stuck in a painting, it is good to be able to use them to solve a design problem.

Some artists have a plan before they actually touch paint to paper. Many artists, like myself, prefer to let the paint, textures and color shapes lead them to the design. The artist who best uses the elements and principles in his painting often "wins the prize." Products that have the best package design become the best-sellers; the product is not necessarily better, but the designer

Thirteen tips to become a better artist

All the design advice in the world will not help you create better art if you are missing the fundamentals it takes to become a better artist. Before you read any further, take this list and vow to live by it.

1 **Look at good art.**

2 **Read.** A wealth of information is waiting for you in art books. Discover bookstores that sell out-of-print books.

3 **Study.** When I studied with Ferdinand Petrie, he said that if you know how to draw the figure, you can draw anything. He was right. I always try to listen to good advice from a pro.

4 **Find a place to paint.** You cannot paint if you are worried about staining your carpet or ruining your furniture.

5 **Paint.** After you have looked and studied, paint and then paint some more. There is no substitute for actually putting paint to paper.

6 **Make small studies.** I have learned about design from making small studies that often have collage pieces added to help me work out ideas. I always have twenty-five in the works at one time so I don't get stuck on one piece. These small pieces have taught me much that I need to know for my larger works.

7 **View your in-progress paintings on an upright easel, from a distance and in every orientation.** I start my paintings flat and finish upright, and study them while standing five feet away. This is the best way to view my work and change it immediately if it doesn't look right.

8 **Learn to take good photos for reference.** In order to create abstraction from reality, you must know that reality. You need reference material that you have made, not someone else's. And while you are at it, learn how to take slides of your work. You need slides for a serious art career. Be ready for success to happen. When *American Artist* magazine wanted my slides for an article, I had them.

9 **Work in more than one genre.** One enhances another.

10 **Enter shows.** When you have been painting for awhile, start entering local shows. You must view yourself as a professional if you want to be treated as one. It is good to see how your work holds up against other artists' work. It is great to win an award. If you never do, find out why. If you start to win prizes at every local show you enter, it is time to enter national shows.

11 **Sell your work.** Do this to earn the funds needed to support your artwork. (Supplies are very expensive!) Your self-esteem gets a boost when someone wants to own something you created.

12 **Make the time.** If you really want to paint, do it now. Tomorrow may never come. Find the time, even if you have to get up very early or go to bed very late. If you want to paint, you have to make it happen.

13 **Reward yourself.** Rewards work for me. Whenever I get into a show or win a prize, I treat myself to Chinese food. It's fun to be good to yourself. If you've made an important step or reached a personal goal, then pat yourself on the back!

makes you want what is inside the box. Looking at good ads in magazines can teach you a lot about good design.

Layout artists design ads to make you buy. See how they use design to their advantage. In painting you want the same thing—for the viewer to look at your painting and stay awhile. You don't want the viewer to walk right by or go directly to the painting next to yours. You can achieve your goal with color, content and value—in other words, good design.

The elements of design we will deal with are line, shape, space, form, color, value and texture. The principles of design we will deal with are proportion/scale, unity/variety, contrast, rhythm/repetition, balance and emphasis. These are on most lists and are fairly universal. Other lists vary by one, two or even three elements or principles. The important thing to remember is that not all elements or principles are used at all times and to the same degree. Sometimes texture, not color, is most important in a painting; other times color is the main emphasis.

Sometimes artists have other considerations that are not considered universal principles but are nevertheless incorporated into artwork. These considerations include:

1. Conflict. Sometimes artists create conflict with their color choices, subject matter, strong diagonals, etc., to create added tension.

2. Gradation. This can include gradually changing values from light to dark, sizes from small to large or colors from warm to cool.

3. Alternation. This involves using one or more elements in a repetitive sequence (for instance, alternating small and large shapes or thick and thin lines).

There is a lot to learn about design. Whole books have been written on just one element of design (color, for instance). I have found the best way to learn is by doing. In this section I have tried to give you the basics of design in a way that is easy to understand. I have included studies to get you in the right frame of mind and give you ways to learn. For further study, consult the books listed in the bibliography at the end of the book.

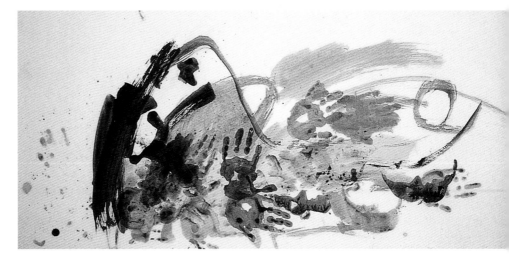

Lessons from a child artist
Before we look at the elements and principles of design, let's look at my youngest student's work. Kaili painted this piece at age three. With no direction from me, she freely and with great glee painted her hands and made prints on the board. She intuitively knew to paint an odd number of hands and to make a color change. She has variety and repetition in her piece. Varied linework leads you through the painting. The moon, a stamp I bought for her, is pressed into the lower right. She loves what she calls the "moonie," so her piece has content for her. Kaili has no idea what the elements and principles of design are, but intuitively, she does know.

See if you can go back to when you were young and have fun when you paint. You don't have to stay within the lines. And when it doesn't seem like fun, do what Kaili does: Jump on your bubble wrap and break out in a big grin. If you nurture your imagination, look around at your world, paint often, believe you can, and have enthusiasm for what you do, success is sure to follow.

MOONIE WITH HANDS
Kaili Sherman • 14" × 29" (36cm × 74cm) • Watercolor on acid-free mat board • Collection of the artist

the elements of design

The elements of design are the visual tools that you use to make a work of art. The elements I rely on are line, shape, space, form, color, value and texture. These elements are important whether you work in a realistic or an abstract manner. In nonobjective work—with no recognizable subject—the elements are even more crucial because you have to rely on them to create the essence of a subject.

The general public often thinks a realistic painting is good if the artist makes a reasonable facsimile of a barn, tree or mountain scene. In discussing the painting's merits, you can say it would be stronger if the horizon line were higher or lower, if the sky were more intense, if the tree were made larger or smaller, etc.

In experimental art, pure design is what you have to work with. It is good or bad depending how you use the elements of design and how you organize them using the principles of design. The elements and the organization of these elements *are* the painting. When discussing the painting's merits, you would have to say the shape is too big or too small, the painting is off balance, there isn't enough edge variety, there is too much texture and no quiet area, etc.

Regardless of the style of painting you choose, a strong background in design will enable you to create better paintings.

■ line

Lines can be straight or curved, thick or thin, clustered or individual. Lines move you into, around and out of your painting. They lead the viewer's eye and can direct it to the center of interest.

Straight lines are more static than lines that curve. Diagonal lines can add excitement to your painting. Making some lines vertical and others horizontal gives more tension and variety.

Riggers are great for painting lines. Practice forming lines with your hand held at the end of the brush. To draw straight lines I stand and slide the ferrule of my brush along a ruler that is supported by my left hand. The ruler is not flush with the paper. It is raised and supported, on one end, by my fingers. It is good to practice freehand linework by holding the brush at the end, standing, and using the wrist for free movement. Try using your less dominant hand to make lines that look more organic.

Water-soluble crayons and colored pencils are also useful for enhancing your painting. The bonus of working with water-soluble crayons is that the color lifts with water if you don't like what you did. Lines also can be scratched onto your paper with the handle of a brush, a single-edge razor blade or other tools. Lines can be made by leaving plastic wrap and waxed paper in wet ink, watercolor or acrylic and left to dry. You can even use a stick.

In experimental work, the direction the painting will take is not often known at first. It is therefore best to save some linework for last, once the direction of the painting has been established. If you don't know the orientation of the painting, you can't know where the focal point will be. You might want to stamp a spiral shape, for instance, to establish a center of interest. You also won't know

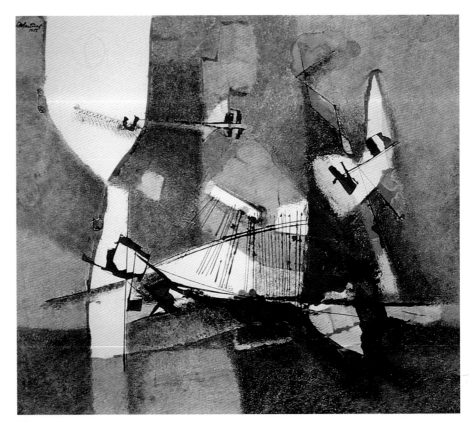

Linework
This painting has great linework. Look at the variety. Lines can be stamped with mat board or drawn freely by hand. Cross-hatching creates great texture.

TINTA Y TONO AGOSTO
D. Martine • India ink and watercolor on bristol (plate finish) • 20" × 24" (51cm × 61cm) • Collection of Pat Dews

where you might need an anchor to ground the painting. (See *Richmond Letters* on page 136 to see how a single line can anchor a painting.) These are the lines that come last, when they serve a specific purpose.

shape

Think small, medium and large, for variety. Shapes of the same size would result in a static, boring painting.

Shapes are either geometric or organic. Geometric shapes include a triangle, square, rectangle and circle. Organic shapes are more curved, irregular and have a more natural feel to them. Usually both types of shapes coexist in a painting, but one should be more dominant.

Shapes can be created in many ways. Shapes are formed by connecting lines. You can paint shapes positively, by painting the actual shapes, or negatively, by painting the space around them. You might choose to reserve areas of your painting with masking, creating white shapes. Some shapes are formed by printing materials that leave an impression when left to dry in wet water-color, ink or acrylic. Even blocks of color can be considered shapes.

space

Shapes fill space. A full sheet of watercolor paper is a shape in itself: a rectangle. It is a two-dimensional shape, having height and width. You fill this space with shapes to create your painting. The shapes or objects are positive space, and the space between and around these shapes or objects is negative space. Both are important.

Just as you must know how to create shapes, you need to know how to connect them in space and create a feeling of depth. For example, overlapping shapes creates depth. Designing a painting is like putting together the shapes of a puzzle or a quilt. You interlock and weave your shapes and colors one by one within the space of your paper until you make a unified whole.

form

When you add a third dimension to your flat, two-dimensional watercolor paper, you have form. You model a shape to give it form—for example, a circle with form becomes a sphere. A square becomes a cube.

In realistic paintings, a direct source of light provides shadows and gives form to a subject. In my abstract, experimental work, light is implied. I often use washes of Raw Sienna to signify light. This light is internal and comes from within the painting. Form can be suggested by painting around shapes rather than by modeling the shapes themselves. Glued collage pieces are often used to build up the surface and give real dimension to a flat surface.

color

Color can express a mood or suggest a specific emotion. Different colors make you think of different subject matter. Reds and warm colors make you think of something hot such as the sun, southwestern landscapes or sunflowers. But if you use a warm palette for a seascape, the pairing of a traditional subject with nontraditional colors stands out from the crowd. You want to entice the viewer to take a second look. Color can make the painting.

Good shapes

This painting has predominately warm shapes with cool accents and neutrals for color intensity change. The shapes are varied in size, with angular rocks slanting inward to give tension. I created tension at the center of interest by slanting the green collage piece to meet the pink-violet triangular rock in the top right. This small shape meets the green rock and visually supports the larger rock at the top center. The green and red shape in the bottom right points you to this center of interest.

ROCK STUDY WITH GREEN
Pat Dews • Ink, acrylic and collage on heavy-weight Rives BFK printmaking paper • 3" × 5" (8cm × 13cm) • Collection of Jan Ledbetter

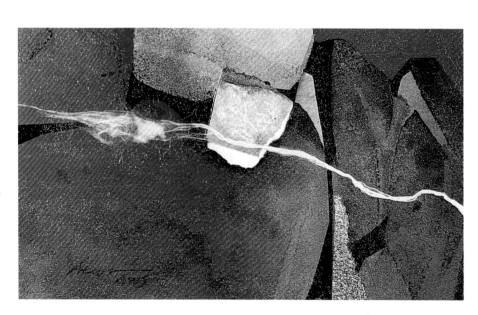

You need to study the color wheel so you can use color to your advantage. The name of a color is its *hue*. *Value* is the relative lightness or darkness of a color. *Intensity* deals with the brightness or dullness (or grayness) of a color.

Colors opposite each other on the color wheel are *complementary colors*. When used next to each other in a painting, they create excitement. When mixed together, they create good grays. *Analogous colors* sit beside each other on the color wheel and always work when used together. Warm colors advance and cool colors recede, although in abstract art this visual fact isn't always considered.

My students love using a neutral palette, even though some are reluctant to try it. Start looking at good French and Italian fabric for inspiration. They use neutrals with flowers of intense color, and they are great. The contrast of intense color and neutral color is wonderful. Turquoise is fabulous with blacks, grays, whites and neutrals. If you don't believe neutrals can work, think of designer Calvin Klein, who has made millions on neutrals.

There should be dominance in all aspects of a painting, including color. When everything is equal and nothing is important, a painting is boring. A hint of cool color against a warm one gives contrast, variety and excitement. If you paint a realistic barn side, going from warm to cool in your wash makes for a much more interesting barn—it can vibrate, glow and have more punch. When I paint flowers I put some pink, orange and a little blue in a yellow flower for the same contrast, variety and excitement.

value

Think light, medium and dark. Your paintings should contain all of these values in unequal amounts. Often when a painting isn't working, values are the problem. Remember that placing the lightest light next to the darkest dark at the center of interest will lead the viewer's eye right there.

Paintings that are close in value—high key with many light values or low key with mostly dark values—are more difficult to see in slides. That is why you see so many paint-

Color and value

The warm-colored flowers in this painting are given contrast by the addition of various warm and cool greens. Opaque darks give value contrast and paint contrast (the opaque areas make the transparent areas more important). The negative white spaces were carefully planned and lead you through the painting.

Spraying paint through a grid in my floral pieces makes them relate to my more abstract work. A painting friend, Dorothy Skeados Ganek, gave me the idea to use the grid shapes I use in my more abstract work. The grid serves to add texture as well as linework. Good values help make this a strong painting.

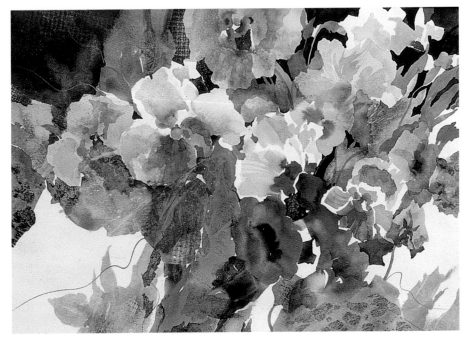

PANSIES SOUTHAMPTON
Pat Dews • Watercolor and acrylic on 140-lb. (300gsm) cold-press watercolor paper • 22" × 30" (56cm × 76cm) • Collection of Steve and Rhonda Ellisor

ings with strong value contrast in national shows. Dominant areas of light and dark can create emphasis and mood in both high- and low-key paintings.

■ texture

Texture can be actual or perceived. In realistic work you can render texture with modeling and lights and darks. Trees, wood, hair and rocks all have texture. When placed in wet watercolor, ink or acrylic and left to dry, materials will leave their prints behind when lifted. These printed shapes give interest and form to your piece. It is often hard to tell that the simulated texture is not real.

In abstract work, you can create simulated textures to give variety to your piece, or you can simply glue on actual pieces of paper, fabric, wood or metal to give dimension and "real" texture to your work. In abstract work, texture often makes the painting.

Just like color and size, textures should be formed using different materials, for variety as well as repetition. Too much texture can lead to variety but not necessarily unity, an important principle of design. The texture sheet project in chapter two will teach you how to create a variety of textures and how to subdue them for a better design.

Artists working in an experimental manner are lucky to be working today. Some acrylic products on the market have texture components such as sand added right into the medium. All types of effects can be achieved with this instant texture. Molding paste makes fabulous dimensional texture. Search for different texture products to try.

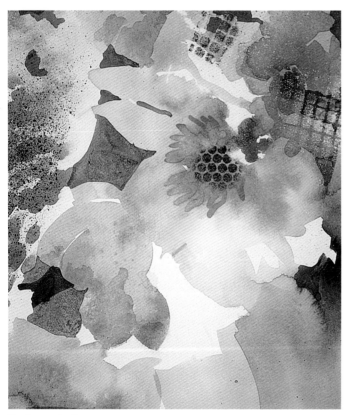

Texture study
In this small study, I am exploring my abstract texture materials with realism. I pressed plastic wrap and wax paper into wet paint for texture in the leaf areas and to make this more realistic work relate to my abstract pieces. I used a hole-punched polyester film (Mylar) to spray dots in the center of the flower. I sprayed paint through grids and the circle and did some plain spraying. Watermarks were encouraged to prompt the viewer to think flower shapes. I think it works. What do you think?

[TIP] You can learn a lot about design by making small studies using collage. You can lift the pieces up, move them around and try all types of combinations. You can make a design that works before you glue it. From just looking at the quick assembly of collage above, you can see how value and color contrast work, how lines can move your eye, and how your eye goes to the light area in the bottom right. This is a good thing to know. If you know your eye goes to the lightest area, you can put it at the center of interest. Collage studies are good for testing the possibilities and sharpening your designer's eye.

the principles of design

The principles of design that we deal with here are proportion/scale, unity/variety, rhythm/repetition, balance, emphasis and contrast. It is difficult to look at some of the principles separately from others because they are best understood when defined within the same context. Usually they work together in a painting.

■ proportion/scale

Proportion and scale deal with size relationships. Proportion deals with sizes of the parts that make up a whole. For instance, if you put a child's head on an adult or draw someone's arms longer than his legs, the proportions would be wrong.

Scale deals with sizes that are in relation to something viewed as normal. For instance, if you have a man standing in front of a skyscraper and they are the same height, the scale would be wrong. Realistic paintings often have people in them so the viewer can truly judge the size of the other parts of a landscape. A drawing of what could be a mountain might in fact be a small mound, if a man has his hand resting on it or is sitting on it.

Artists sometimes change and distort the scale and proportions of a subject to make a statement and give content to their work. When you do this, though, it still has to look right in relation to the entire composition. For example, in a perfectly rendered, realistic painting, one distorted building might seem like a mistake, whereas several buildings or parts of buildings distorted to emphasize a point, and integrated into the whole, could look just right.

In abstract, experimental work, the sizes of the shapes have to look balanced and work with one another. It is easy to see how a tree, barn and dog relate. You are familiar with the sizes they should be relative to each other. When you have only shapes, you have to combine shapes to form a pleasing, good design. All similar shapes would be boring; placing all the shapes on one side would look off balance. You must have varied sizes—small, medium and large—and place them in the space properly so that there is unity and harmony. One shape should lead to another, moving you through the picture plane.

■ unity/variety

When a painting has unity, there is a feeling that it works as a whole and is complete. Repetition of color and shape can unify a painting, weaving it together like a puzzle. Each piece belongs.

Variety is often linked with unity. While you want to have unity in a painting, you don't want it to be boring; you want variety as well. Having all shapes the same size would provide unity, but it would not have much variety. In all things, it is the proportion of the elements that makes something work. Variety can be achieved with differences in color, size, paint quality, texture and edges.

When there is unity with variety, then the painting is said to have harmony, the end result of all good painting.

■ contrast

Webster's New World Dictionary defines contrast as: "to compare so as to point out the differences; set against one another." I always strive for contrast in my art. Contrast makes your work exciting. You can use light against dark to create a center of interest. A spark of intense color can make a neutral painting sing. Strong value contrast can allow a paint-

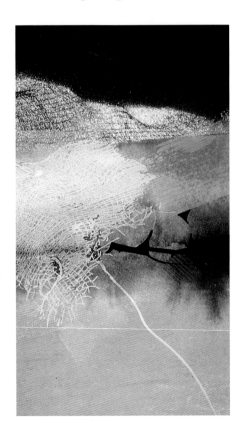

A unified study
Black, whites, grays, browns and other neutrals are graphic and strong. This type color scheme has great appeal. Using all neutrals in a painting gives you unity. (Collection of Gary and Anne Baker)

Add a touch of variety
A small piece of turquoise construction paper is taped to this study to show you how this color works great with this type of palette. A spark of color can change a painting. A touch of turquoise adds variety.

ing to be seen from across a room. That is certainly a good a way to get attention.

If you walk into a room of paintings, the smallest or largest will grab your attention. The size doesn't make it better, just different, and different is always noticed. Some artists create conflict to really make a difference. They play diagonals against verticals and horizontals; they use colors that jar; they leave an edge unresolved; they combine unpleasant imagery in peaceful planes.

There are so many ways to create contrast. I love the contrasts of light vs. dark, hard edges vs. soft edges, warm color vs. cool color, intense color vs. neutral color, small shapes vs. large shapes, horizontal lines vs. vertical lines, and texture vs. quiet areas. Too much contrast can be confusing, though. Too much contrast prevents unity. Once again, it is a matter of balance.

■ rhythm/repetition

Rhythm is created by having an element repeat at intervals. Rhythm always has repetition. Repetitions visually move you through a painting. Rhythm can have regular repetitions—a similar shape, color or texture repeated within the painting—or repetitions that alternate (from warm to cool and cool to warm, for instance) or progress (from large to small, for example). The painting on pages 108–109 is a good example of alternation—a pattern of color going from light to dark and dark to light; from larger window to smaller window and smaller window to larger window; from warm to cool and cool to warm.

The grid pattern I tend to use gives rhythm to other linework in my painting. Repeating shapes can lead your eye through the painting and give it rhythm. A continuous line can give rhythm to a painting; gradation can, too. Sometimes the rhythm is almost lyrical, because the line and colors are light and airy and playfully move across the paper or canvas. Sometimes the rhythm seems to jump up and down and move you quickly through a piece. Just like in music, you can have a slow beat or a fast beat.

A well-designed study
There is variety and repetition in the linework and grids in this study. The lines and grids also give rhythm to this study. The grid in the center is collage. The rice paper used to make a print has been glued on for contrast in texture and variety.

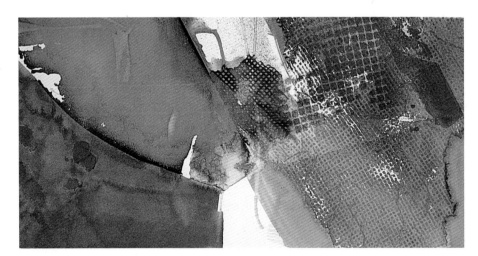

An addition
A wine-colored collage piece could be added for contrast in color and intensity and for variety. The wine color is a good choice as it is a complement of the green. Since it is a warm color, it would be a good contrast with the cool blues and greens. These cool colors are grayed, so there would be additional contrast in intensity of color.

This piece could remain monochromatic. You are the designer; you get to decide. Many choices can be good. If you have many of these studies in the works at any given time, you eventually get to try every combination. This will make a good painting.

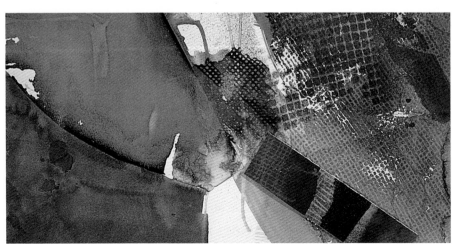

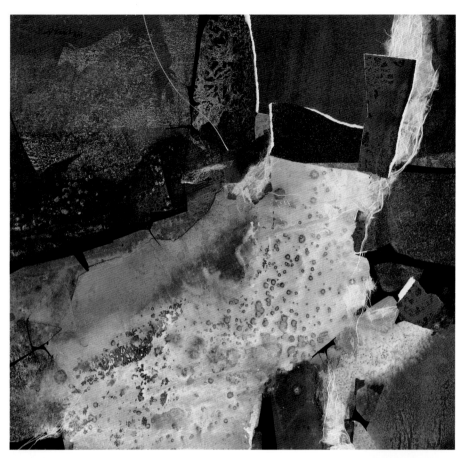

A good design

This painting is about color and contrast. Memories of gorges in upstate New York are rendered in nontraditional colors, giving an abstract feel to realistic subject matter. A variety of warm colors—reds, oranges, purples and rusts—are made more important and are tempered as well by neutral quiet areas. There are contrasts of warm colors against cool colors, intense color vs. grayed color, hard edges and soft edges.

The shapes are varied: small, medium and large. This painting has both real and implied texture. The white torn edges of the collage papers serve as linework. Painted lines repeat the filament lines in the Natsume 4002 rice paper collage piece that is used for texture.

An S curve in the form of water makes a good design format and is one I often use. The colors and shapes give unity to this painting.

DEEP GORGE
Pat Dews • Ink, acrylic and collage on heavy-weight Rives BFK printmaking paper • 18½" × 22" (47cm × 56cm) • Collection of the artist

Where *Deep Gorge* began

This is the painting start for *Deep Gorge*. Compare it to the finished painting. I cropped, changed orientation, gave form and designed this start to make it into the final painting. If you turn the finished painting counter-clockwise to a vertical orientation, the design still works, but it is not as strong or interesting.

In a vertical format the painting reads as more traditional. The water seems pushed to the right and the focus seems to be on the large rock in the bottom left. The size of the rock shape in the lower left is different from the water shape in the lower right, but it appears to be closer in size in this orientation. In the horizontal format the water is rushing forward and is the dominant feature. The cluster of rock shapes in the lower right of the painting is varied and interesting and much more noticeable and important in this orientation. The rushing water that I remember from the gorges in New York had this type of feel. This orientation is more abstract in nature to my eye, and it reads more "design" to me as an experimental painter.

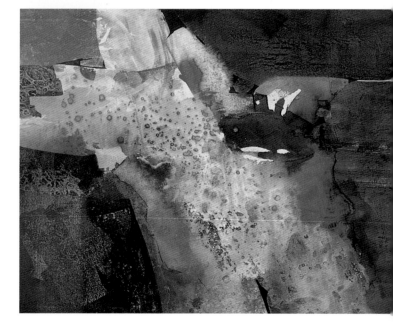

[TIP] Small painting studies give you big confidence and the satisfaction of a job well done.

■ balance

Balance is key to a successful painting. An unbalanced painting needs more visual weight on one side or another to make it look right.

Symmetrical balance has identical or very similar parts on either side of a central line. Portrait paintings and needlework sometimes have this type of balance. Asymmetrical balance has different shapes and colors on either side of a central line, but the weights of the objects make it visually balanced. The lightness or darkness of a color, the proportions of color or the size or number of shapes all can affect how visual weight is perceived.

Radial balance, such as that in a flower, for instance, has a central core that shapes or elements radiate from and around. This type of balance can be either symmetrical or asymmetrical in nature as well, depending on the distribution or placement and size of the radiating shapes around the central core.

Repetition of color and color choices—warm colors come forward, cool colors recede, dark colors are heavier, etc.—all are factors in balance. You can balance a large shape with a few smaller shapes, depending on where you place them. When something is balanced it looks "right." This is where collage can come into play. You can actually move different shapes around to see how they connect and continue the process until it looks and feels right.

In realistic work, the heavy weight is usually on the bottom to make the image appear grounded. Weight can be actual or implied; it can be a shape or a dark color. In experimental work, I find that the heavy weight often works better at the top. The heavy weight appears to become more dominant and important, and it becomes the painting. Tension causes excitement—there is the implied feeling that the weight may fall.

■ emphasis

You want to establish a place for the eye to go to after traveling through your painting. This is the focal point, center of interest or point of emphasis.

There are many ways to achieve emphasis. Intense color can make you gravitate to a certain area. Lines can point you there. Value contrast is another way to create a focal point; the eye will go to either a very dark area or a very light area. The same is true of size: the eye goes to the smallest shape or the largest shape.

Content is another aspect of emphasis. What are you trying to convey? Having a theme or story to tell gives your painting emphasis. Letters or words can give emphasis. Look at good advertising to see how graphic artists get a point across. Overall patterning does not always have a center of interest; the patterning itself is the emphasis.

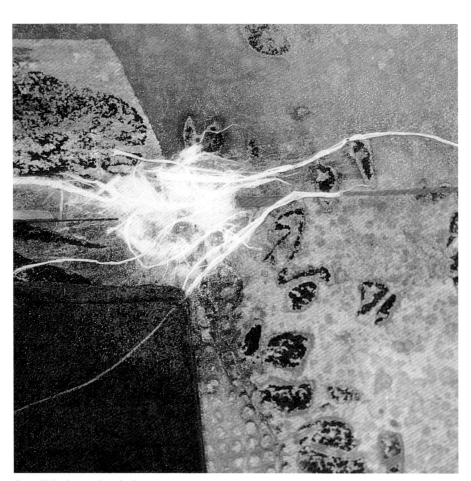

A well-balanced painting
This is a good example of asymmetrical balance. Even though the dark shape on the left is visually heavy, the sizes of the two shapes on the right are larger. The blue on the top right recedes and gives a feeling of depth and space. The smaller shapes to the right of the dark shape and grid give enough interest and weight to balance the two strong shapes on the left. And just to make sure, the intense red lines make you go across from the right into the left quadrant to meet up with the red tip on the black shape.

ELEMENTAL FORCE
Pat Dews • Ink, acrylic and collage on heavyweight Rives BFK printmaking paper • 4⅜" × 4⅜" (11cm × 11cm) • Collection of Frederick and Karen Rosasco

design formats that work

After you learn the elements and principles, you can use them in an overall plan or design format. Often the subject makes the decision—how the subject will fit into the area. Popular formats are:

- **Strata.** Think linear sections. This format is good for landscapes, and I especially like this format when I'm working with collage.
- **Shapes.** Circles, squares, triangles and many other shapes can all be used as a basis for a design. Portraits work well in a triangular shape. In her flower paintings, Georgia O'Keeffe often extended her flowers to the edges, emphasizing them as shapes, not just flowers.
- **Diagonals.** A slant in your painting gives it motion and excitement. You can create great tension by having diagonals intersect. Be sure the triangles or arrow shapes you get when you intersect the diagonal lines don't point to the painting next to yours—it will get the prize!
- **Cruciform.** This format is based on a cross theme. The center of interest is where the parts of the cross intersect. The intersection can take place high or low on the picture plane. It can be close to or far from the edges in all directions. Vertical and horizontal crossings provide tension, thus excitement. It is hard to make a bad painting using this format.
- **Low Horizon/High Horizon.** In these formats, the horizon line is placed in the lower or upper part of the painting. If you are a realistic painter, it is great to do both high and low horizons for contrast and variety. A low-horizon landscape could emphasize a dramatic sky; a high-horizon landscape could bring the focus to dynamic rock shapes below.
- **Overall Patterning.** This format is a little harder to do, as you must have shapes

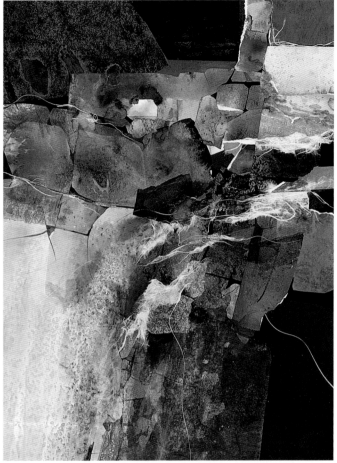

GEMSTONE FALLS
Pat Dews • Watercolor, ink and acrylic on heavyweight Rives BFK printmaking paper • 29" × 21" (74cm × 53cm) • Private collection

Cruciform format
This a good example of a cruciform design format, my favorite. Verticals and horizontals cross in this format, creating a strong center of interest at the juncture. See how warm vs. cool and neutral vs. intense contrasts work. Linework moves you down, across and through this painting.

and colors that weave together and have unity, and often there is no center of interest to draw you someplace in particular. The whole painting has to be special.

- **Central Orientation.** This is a format in which the interest is placed in the center of the paper, whether the orientation is horizontal or vertical. The motif could be a rectangle, circle or square. The emphasis is right in the middle and you can't miss it.
- **S Curve.** An S curve is very helpful to lead the eye through a painting. Landscape artists can create a river or a path very effectively using this shape.

As an artist who does primarily abstract work, the actual direction my painting takes can and often does change after I eye my painting start on an easel, from a distance, and with a mat. Usually one orientation will look better. A horizontal orientation often says "landscape." A vertical orientation can seem more dramatic, and often the shapes appear more abstract in nature in that format.

If I have been painting verticals for awhile, I might paint a horizontal just to keep myself interested. I just bite the bullet and start somewhere!

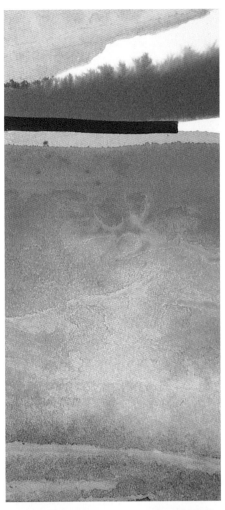

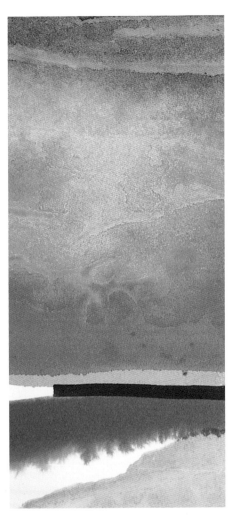

Low-horizon/high-horizon formats

This study can be used in either orientation. In the image on the left, in which the horizon line is high, you may see snow-covered mountains, sky and the beginning of strata. When the same study is viewed upside down, it becomes a low-horizon image. In this orientation, you may see clouds, distant land, water's edge and a beach.

Look at your paintings from every orientation. I have had students working and struggling with a realistic floral and have told them to turn it upside down. Usually there is a wonderful, more abstract feel to the flowers, and the students are ready to get right back to work. (Collection of Nancy and Don Marple)

Diagonal format and shape format

Here's a little gem I found from a larger painting. The size of this section is only 2½" x 2½" (6cm x 6cm). In this orientation this is a great diagonal design format. Turned clockwise, it is a great design based on a triangular shape.

Strata format

The basis for this small study is a great piece of collage. I didn't have a piece handy that could serve as the sky or water area, so I tested a piece of purple construction paper for general color. (I would actually use blue in the final painting instead of purple.) The edge of the torn white collage has a bit of orange peeking out—a nice complement to the eventual blue area. (Collection of Kate Chodor and Vince Rieger)

Design Projects TO GET YOU *Moving*

I started out as a real-istic painter and worked from setups and out in the field. I now design my paintings in the studio, using the techniques you will learn in this chapter. I continue to take reference photos from life, but I try to capture and paint the essence of the subject rather than the subject itself.

As I tell my students, "I have to get you started and excited about the possibilities." Many of my students tell me they never work the same again after trying these design projects. I have my students use full sheets of watercolor paper to try them. Trust me when I say that you need to buy twenty-five sheets of paper and paint that many paintings before you can see where you are going with these methods. At the end of twenty-five finished paintings, you will have learned many things about your art. If you have only one sheet of paper, your painting had better be good!

Compare your paintings that result from the following projects to paintings you did prior to these. Do not compare yourself to me or to a friend. See how you have grown. You are the only one who matters. Paint what you want, not what someone else wants. Your husband, your sister, your mother or a friend does not have to like your paintings. You do!

LANDSCAPE WITH GRID, 5
Pat Dews • Acrylic, ink, watercolor crayon and collage on canvas • 36" × 48" (91cm × 122cm) •
Collection of the artist

design from texture practice sheets

A texture practice sheet is just that—a sheet of paper used to practice various textures, new techniques, new colors or new ideas. You get to practice and create a painting at the same time.

When left to dry in wet ink or paint, some materials will leave a texture. Some of my favorites are plastic wrap, wax paper, bubble wrap, lace, embossed vinyl wallpaper, rice paper, rubber grids used to prevent rugs from slipping and fabric grids used for hooking rugs.

After the initial textures dry, you can practice other techniques on the same sheet—glazing, negative painting, juxtaposing opaque paints with transparent washes, making value changes, creating quiet areas, giving form to the textures, recovering areas of the underpainting, etc. Latter-stage techniques may include gesso washes, gesso spritzed with alcohol, wax paper and plastic wrap transfers, linework or designs scraped into dry or somewhat damp opaque paint, linework made with watercolor crayons and pencil, sanding, collage additions and, of course, cropping.

If you use good values (lights, mediums and darks) when you do your texture sheet, it's easier to bring to completion. Sometimes the imagery is completely painted over and only small areas of the underpainting remain.

Because you are practicing disparate textures and techniques, not every complete practice sheet will culminate in a finished painting. But a sheet nevers goes to waste. It can be cropped into several smaller paintings, cut up and recycled as pieces of collage for other works, or used as masking for saving white spaces in another painting.

Sometimes textures just don't take. This can result from using too little pigment. If you are painting in a very dry room or climate, the paint can dry too quickly and not leave a visible texture. Other times you may

Where a texture practice sheet may lead
This a great figure, painted right over a texture sheet by one of my students. The artist is a dancer, and even the small shapes to the right of the figure near the top appear to be dancers. Plastic wrap texture can do wonders. Painters working in a realistic or an abstract manner can benefit from using these textures.

TAI CHI
Ruth Wood Davis
Mixed media
19½" × 13¼" (50cm × 34cm)
Collection of the artist

be dissatisfied with a color choice. I have found that yellows and oranges often don't make good texture. Add some rose or red and perhaps a bit of blue to the yellow or orange for better results. Bubble wrap that has been used can have flat bubbles and often will not texture the same as new bubble wrap. As you experiment, you also may find that certain materials work best with certain mediums. I found out the hard way not to use acrylic paint with delicate paper materials—such as rice paper and paper doilies—since the paper will stick when dry.

The following examples of texture sheets have good values as well as texture. I like to show my workshop students how to crop, so you will see sizes smaller than a full sheet for some of the following examples. However, they all started out as a full sheet.

Look at these examples in every orientation and see if you get any ideas for one specific direction to take. Start cultivating your imagination. You are about to start creating paintings from just texture and what the image before you conjures up. You are starting a journey!

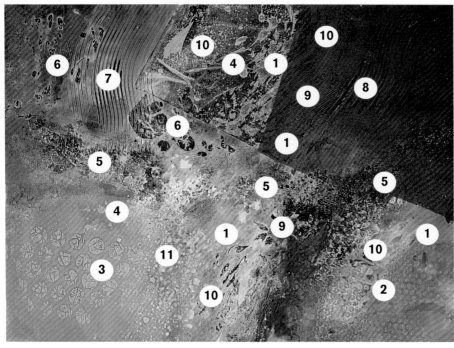

[TIP] If you are not getting good textures, you might not be using enough pigment or enough water, or the texture material might not be making contact with the surface. When I tell my students that the wash they place texture material in must be wet, they usually just add more water, which will not always solve the problem. Be sure to add more pigment as well.

Texture sheet example #1

This truly is a texture sheet. I have tried not only products that create the illusion of texture, but those that create actual texture on the surface.

1 Coarse pumice gel applied with a natural sponge
2 Bubble wrap placed in gesso and ink
3 Gesso and acrylic paint applied to bubble wrap and printed (Note: It works best to press bubble wrap into a paint mixture and print rather than applying paint to the bubble wrap directly with a brush.)
4 Gesso flung from a brush
5 Clear granular gel
6 Wax paper
7 A trowel pulled through wet molding paste
8 A trowel pulled through wet acrylic paint
9 Plastic wrap pressed into wet gesso
10 Plastic wrap pressed into coarse pumice gel
11 Alcohol spritzed over acrylic/gesso mixture

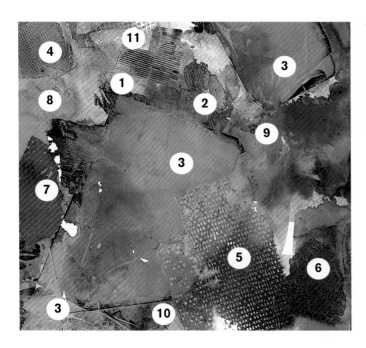

Texture sheet example #2

Usually the entire sheet is textured so you can practice creating quiet areas. In this case, plastic wrap was used to texture the large blue/lavender shape in the center of the painting, but it only added texture around the edges. Sometimes, textures just don't take, often because the paint dries too quickly. Because the plastic wrap did not texture this area, I now have a quiet space without having to create one.

1 Thin cardboard packaging material (used for lightbulbs) placed in wet watercolor or ink and weighted down (a tip from a student!)
2 Wax paper
3 Plastic wrap
4 Rice paper (used with watercolor, not acrylic)
5 Open-weave fabric
6 Lace
7 Dotted Swiss fabric (the dots stick and print circles)
8 Alcohol spots
9 Bubble wrap
10 Lines scraped into wet paint
11 Ink sprayed over fabric grid used for hooking rugs

These construction paper squares test the placement of red in this painting.

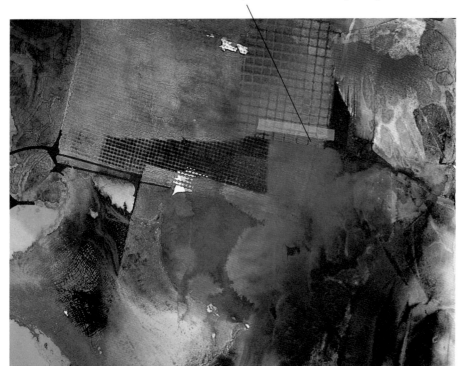

Use construction paper to give you direction

This section, cropped from a much larger texture practice sheet, will become a good painting. Construction paper can help you decide where to go with a painting start without committing immediately. Place or tape colored shapes on areas of the painting to see if you will want to add paint or collage papers there.

Red shows up in this painting, but none of the reds are connected. Red has to move throughout the painting to create rhythm and harmony. A good place to do this is to change some of the squares in the blue grid at the top to red. You get color movement and variety at the same time. This happens to be a good place for a center of interest because the red is intense to begin with and is made more so in relationship to the grayed colors in the painting. This area draws the eye.

Find little gems

This is the type of small painting I often crop from a full sheet of textures. I painted white gesso over cheesecloth and sprayed a gesso wash with alcohol to get the spotting effect in the central gray area. I think this needs only a single line and perhaps a touch of intense color to finish.

I buy dropouts (pieces that are left over from mat openings—the part that drops out) from a local framer. She is happy to get money for pieces that aren't of much use to her, and I get a great bargain. I usually buy twenty at a time. The dropouts are then cut like mats and placed over artwork so I can experiment with different crops.

The original dropout for this piece was 11" x 14" (28cm x 36cm), but I had the framer cut off of one end to make it 11" x 13" (28cm x 33cm). The framer then measured in four inches (10cm) from each edge to cut a 3" x 5" (8cm x 13cm) opening. The crop I chose for this final painting measures 3½" x 5½" (9cm x 14cm), allowing an overlap to make sure the mat opening covers the painting.

These small paintings are often little gems, and you learn a lot about design by doing twenty of them. A mat border that is four inches (10cm) wide gives importance to even very small paintings and makes them look major.

Developing a subject from a texture sheet start

This is a student texture start on a full sheet of watercolor paper. This was the first time she ever used this type of technique. It looks great. You can just as easily make your own start and be on your way! The largely pastel-colored palette and multiple laces give off a floral, lyrical, sentimental feel.

How would you finish this start? If you make your background light enough, you can simply paint a floral or figure right over the background. Usually I paint any realistic subject matter negatively—I paint transparent and opaque shapes, with the emphasis on the opaque around the image so it pops out. The texture becomes the positive and the transparent and opaque shapes around it become the negative shapes. Within these negative shapes, positive shapes are popped out with successive negative painting.

create a texture sheet painting

We start with texture because in abstract, experimental work, texture is a very important element of design. We will be using texture in all the design projects. This warm-up texture sheet will get you ready for the next projects. Always start with a full sheet of watercolor paper, giving yourself plenty of room to experiment.

I always tell my students they should not try to copy what I do. Their efforts could be better than mine, and they often are. It is my job to direct and show you the way. It is your job to use your own background and imagination to paint what is within you.

1 Start With Plastic Wrap, Stencil Patterns and Bubble Wrap

First I manipulated plastic wrap in a wet wash of Turquoise Tech ink. You can create deliberate directional lines or place the wrap randomly and leave it to form its own texture as it dries. You could crumple wax paper, open it flat and then lay it in the wash, too. Try both ways. Note: Often students think the more crumpled the wax paper, the better the texture. But if you have a ball of crumpled wax paper, remember that only the parts touching the paper's surface will create texture.

Next, I sprayed Brown India ink through a rubber grid. I brushed Indigo Tech ink with my Skyflow brush over the rubber grid, drywall spackling tape and hole-punched ribbon. I pressed bubble wrap into the wet wash next. I placed cheesecloth into the wet wash and painted over it for more texture, connecting the bubble wrap to the grid texture.

[TIP] Be prepared to start accumulating lots of "stuff" if you decide to work this way. Don't put it in garbage bags, because people who don't know how great our "stuff" is might think it's garbage! Aren't we lucky to know better? Use plastic containers to store your collection.

materials

surface
140-lb. (300gsm) Canson Montval rough water-color paper, 22" × 30" (56cm × 76cm)

acrylics
Golden Airbrush Colors: *Raw Umber Hue*
Golden Fluid: *Carbon Black, Quinacridone Crimson, Quinacridone Gold, Raw Umber*
Liquitex: *Burnt Sienna, Raspberry, Raw Sienna, Unbleached Titanium, Yellow Orange Azo*
M.Graham & Co.: *Phthalo Blue*

inks
Dr. Ph. Martin's Bombay India Ink: *Black, Brown*
Dr. Ph. Martin's Tech Ink: *Antelope, Indigo, Rose, Turquoise*
FW Acrylic Artists Ink: *Turquoise, White*

other
Winsor & Newton watercolor: *Raw Sienna*
Brushes: *2-inch (51mm) Robert Simmons Skyflow, 2-inch (51mm) foam brush, rigger*
Papers: *Rice, construction and wax*
Easel
Liquitex Gloss Medium & Varnish
Liquitex white gesso
Rubbing alcohol
Spray bottle with a nozzle for strong spray

Mouth atomizer
Large water bucket
Paper towels
Brayer
Lace
Bubble wrap
Drywall spackling tape
Plastic wrap (preferably Saran wrap for better textures)
Rubber grid
Cheesecloth
Hole-punched polyester film (Mylar)
Natural sponge
Collage pieces
Homosote board or Gator board
Staple gun

2 Add a Lace Texture

I wanted to try a lace texture with a new color, Raspberry. The lace was dipped in water and wrung out first so that the lace wouldn't soak up a lot of pigment. I placed the lace in the wet pigment and painted more pigment over and through it with my Skyflow brush. Since I was painting upright to shoot slides, the color started to drip down through the other texture materials. I painted Raspberry over the cheesecloth that had been placed in an Indigo wash in the first step. Painting Raspberry over the cheesecloth allows the Indigo from the first wash to show through the openings, adding variation.

3 Add Color Variation With Ink

I immediately took my Indigo and squeezed out pigment with the dropper to add color variation in the lace area. As more pigment got added, more drips appeared. As the colors floated down, some circles became blue, some pink.

The accidental drips added linework to the texture sheet. In the turquoise area, the drips seem to replicate the lace pattern. Since my paper was upright, I covered the lace with plastic wrap to hold it in place. This added more texture in that area.

4 Add More India Ink

I dried my Skyflow brush on a paper towel, picked up some Black India ink, and added dry-brush texture to the left of the lace. Some Raspberry was still on the brush, and I got pink lines as well as black lines. Black India ink was dropped into a clear water wash, allowing soft edges as well as hard edges to form. Then I dipped my Skyflow in water to spread the ink.

5 Create Cheesecloth Texture

I spread cheesecloth with my fingers so that the weave would be more irregular and interesting. To get the best texture print, it is necessary to place cheesecloth in the paint and then paint over the cheesecloth as well. This guarantees that there will be enough pigment and that the cheesecloth will make contact with the paper and paint. More dry-brush texture was added.

6 Create Wax Paper Texture

I wanted a dark area to show you a great texture using white gesso with gloss medium, but the black looked too black with the other colors. I dropped some of the Indigo ink right over the black and down the left side of the painting and used my Skyflow brush to spread it. I pressed crumpled wax paper into this wet wash. It is easier to put in texture early and then take it out later than to try to texture later. Remember to try other types of techniques in the latter stages of your painting. It is the covering up, yet leaving some of the underpainting, that makes the painting have variety and interest. Multiple layers also give a feeling of depth to the painting.

7 Finish Covering the Entire Paper

Since the white paper is usually completely covered in a texture practice sheet, I wanted to paint a light color so that I would have light, medium and dark values. I painted Raw Sienna watercolor right over rice paper that has a grid pattern. (Note: It isn't necessary to paint under and then over thin rice papers.) A wash of Quinacridone Gold was painted down the middle of the painting with my Skyflow brush to modify the underlying washes. Antelope Tech ink was dropped over this, and a very delicate rubber grid was pressed into the wash. More Antelope ink was applied, and plastic wrap was pressed into the top area to secure the grid in place as the paint dried. Crumpled wax paper was pressed into the wet ink from right below the plastic wrap to the bottom of the paper.

Quinacridone Crimson and Raw Umber acrylics were mixed and the remaining white space was covered. Some of the wax paper and plastic wrap extended into this white area. I painted over them, using them as masking to reserve the white paper. I usually cover all the whites, but I wanted you to see this good technique.

8 Add More Bubble Wrap Texture

Bubble wrap with large bubbles was placed into the wet Quinacridone Crimson/Raw Umber wash. I used small bubbles on the right side. This gives a different type of texture as well as repeating the circular pattern, creating unity with variety.

[T I P S] Using paper products for prints on texture sheets can be tricky depending on the medium you choose. Instead of being able to pull up the paper products to reveal a print, you may end up with collage. Some advice:

- You must use watercolors with rice paper and other paper products such as paper doilies.

- Corrugated cardboard or cardboard packaging for lightbulbs may stick if you use ink–check it as the ink dries.

- If you use acrylics with these materials, the papers will stick to the support.

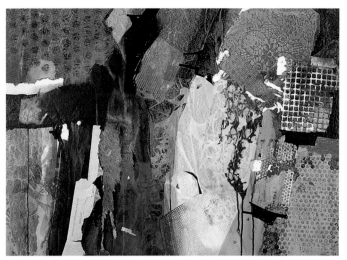

9 Let Everything Dry and Remove Materials

The entire paper has been textured. This is a great way to get started if you are afraid to cover your white paper. Remember, in order to get texture, the texture materials must stay in place until dry. If you want just a partial texture, you can remove the texture material before the paint is completely dry. The reserved white space and lower middle are covered with turquoise construction paper to plan for color movement throughout the painting.

How to stretch a painting in progress

Paper stretching signals me that it is time to finish. Here's how:

1. **Wet the entire back** with clean water using a natural sponge. Do this on a flat surface with the painted side down.

2. **Staple the painting face up** on a piece of Homosote board (coated with two layers of gesso to keep any impurities from harming the paper) or Gator board (does not have to be coated). Place the staples an inch (3cm) apart. Start by applying six staples to the top middle, six staples to the bottom middle and repeating on each side. Then continue out from the middle staples, stapling to the corners.

3. **Let the paper dry.** As the painting dries, it buckles; the painting is dry when the surface is completely flat. The drying time will vary; it usually takes a day or overnight in normal circumstances.

10 Evaluate

Turquoise Tech ink was used in the reserved white space and Turquoise acrylic ink was used in the lower part of the painting. I switched to acrylic once I had used other acrylics in that area. Carbon Black was added in the upper right and the far left center of the sheet to give form and move the color across the painting, integrating both sides. I negatively painted rocklike shapes in both areas.

I am always amazed at how these texture materials print the paper. Some texture sheets look better than others. This is just a start, and many changes can be made. You can correct areas that do not work or are not pleasing to you. I stretched my paper to finish (see "How to Stretch a Painting in Progress"). Otherwise, it would be hard to paint paper that is no longer smooth and flat.

I used an easel to view my painting in every orientation before starting to finish and throughout the finishing process. I decided to carry out a sea theme. In step six, I painted a dark area so that I could show you a technique that I normally associate with water. After adding black to negatively paint rocklike forms, it looked visually right to me to develop this painting with a sea theme in mind. In my mind's eye I could see rock shapes of varying sizes, and I could visualize water falling down the left side of the painting.

At first I considered using a vertical format with the large turquoise area in the bottom quadrant and envisioned the drip from the first step as water ripples in a pool of crystal turquoise water. Images of rock formations in Bermuda came to mind. Note that in one case the turquoise area is a rock and in the other instance a pool of water. Start imagining your world. I settled on a horizontal format because I have a large area on the left to better explore the falling water technique using gloss medium, gesso and alcohol.

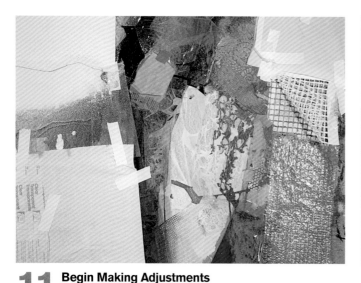

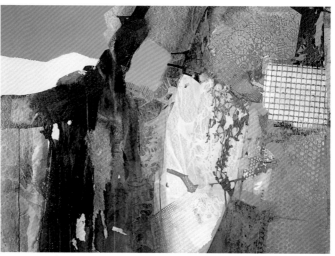

11 Begin Making Adjustments

I didn't want the bubble wrap texture in the upper-left corner once I planned to carry out a sea theme. I made this decision based not on the color but because I thought there would be too much texture once I tried to replicate water. As a result of the upcoming water technique, circles would form in the gesso by alcohol spritzing. The circles from the bubble wrap would compete with the circles forming in the water, and I wanted one area to be the focus and have the emphasis—the water itself.

I painted out the bubble wrap area using a favorite combination: Phthalo Blue and Burnt Sienna with white gesso. I sprayed a wave shape using White acrylic ink and used paper towels to mask areas I wanted to save. I used the same White ink to add white to the grid area on the right of the painting. Again, paper towels worked great as they absorbed the overspray and prevented drips. In order to have unity, I repainted the existing bubble wrap area in the lower right with the acrylic mixture and pressed bubble wrap into the wet paint.

12 Overview

The texture sheet was starting to look integrated. I wish I could have felt that the painting was finished, but I still was not happy with the drips on the right. I liked the lace texture but felt it was discordant with the overall imagery.

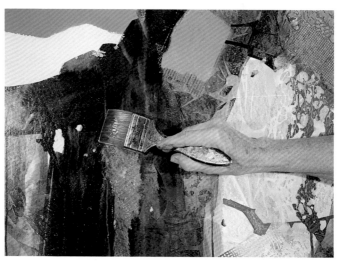

13 Prep Painting for a Water Effect

In keeping with the sea theme, I prepared the left portion of the painting with a technique for replicating water. Gloss medium was applied with my Skyflow brush. I have found this works better than using a gel medium. I diluted the medium only as much as there was water on my brush from dipping it in my water bucket. Brush the medium on smoothly; you don't want lumps and bumps. You have to be more careful brushing matte medium back and forth; read the label on the bottle. The gloss medium had to be absolutely dry before proceeding to the next step.

[TIP] Students often worry about using their watercolor brushes with acrylics. The Robert Simmons 2-inch (51mm) Skyflow is my favorite brush, and I use it with all media. I get good mileage out of this brush, being able to use it almost every day for at least three years before the bristles begin to fall out of the ferrule. If I can get three years from a brush, I am very happy indeed!

To help my brush last longer, I keep it upright in water and massage it against the bottom of the water container to loosen any dried paint after every paint application. I wash my brushes after each use, making sure to not let paint get caked in the ferrule. I dry my brush flat. When this type of brush is on sale, I buy two at a time. Always have an extra brush ready and waiting.

14 Begin Water Effect

Before continuing the water process, I sprayed Rose Tech ink into the white-spray water area on the top left of the painting, using a collage piece torn in a water's edge shape. This brings the warm rose color from the right of the painting to the left, giving contrast to the cools and bringing the painting unity and harmony.

White gesso was applied with the same Skyflow brush. The gesso cannot be too thick or too thin; it must be just right. Using a spray bottle with power, I sprayed the white gesso, making the water run. I tried to replicate the feel and look of water, so I used real water to get a natural flow. A bottle with a weak mist will not work.

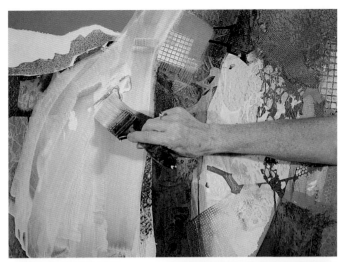

15 Finish Water Effect

I sprayed regular rubbing alcohol into the wet gesso using an old medicinal spray bottle. I have tried many squirt bottles and have found that this type of spray bottle works the best, so either get a sore throat or empty the liquid into another container! The alcohol produces white bubble spots by dissipating the paint. This process takes time. As the alcohol hits the gesso, it forms the spots and then they disappear because the gesso is wet. Continue spraying repeatedly, waiting for the mixture to dry a bit and then spraying again until it holds. Use a hair dryer if you want, but only for a few seconds. If the gesso dries, you can't get the water effect.

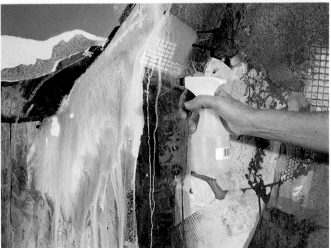

Throughout the process, I sprayed water and alcohol and manipulated the gesso with a natural sponge to try and replicate how water looks in real life. I had good photos for reference, and I went back and forth from one to the other until the effect looked right. The beauty of this technique is that if you don't like the results, you can wipe off the gesso very easily as long as it is still wet. This happens because the gloss medium puts a slick acrylic surface on the paper. You can still remove dry acrylic by rubbing very hard with alcohol.

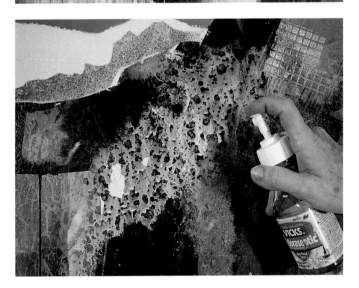

[TIPS]

After some trial and error with this texture sheet, done on Canson Montval watercolor paper, and on Nujabi, a handmade paper from India, I further tested papers such as these that have less rag content (in other words, not 100 percent rag). Both papers are inexpensive and make great texture, but keep these tips in mind when working with papers of less rag content:

- Acrylics and inks will often tear the ground paper when lightweight plastic wrap, such as Saran wrap, are lifted after the paint has dried. Heavyweight plastic wrap works fine with acrylics and inks on the several papers I tested. You may have to look for this plastic wrap in local hardware stores or test different brands to see which is heaviest.

- Cheesecloth, other fabrics and rubber and fabric grids are often a problem on these papers when using acrylics and inks.

- Bubble wrap and wax paper lift easily when using acrylics and inks.

- Watercolors will work fine with *any* texture materials on these papers.

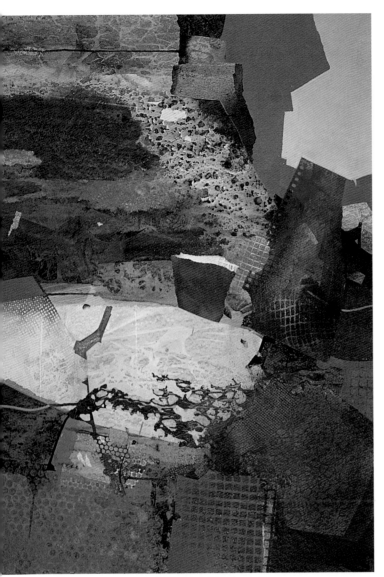

16 Finish

I still didn't like the Raspberry and Indigo drip from the second and third steps and found the painting a little boring, so I turned it into a vertical format. I no longer needed the wave shape with the rose ink spray that felt more correct in the horizontal format. I began to think just shapes—stronger shapes and color for a more abstract feel. Water could trickle down through the painting, but a sea theme was no longer my focus.

I still didn't think both sides were connected enough, so I used gloss medium to glue on a piece of red collage paper torn from a spiral pad to stir it up. I almost always use torn collage papers for a more natural look, but I was really intrigued by the small squares that related to my gridwork on this piece. A few other pieces of collage were also added for repetition and unity.

The Raw Sienna watercolor area in the lower left of the painting wanted company, so I added yellow to the upper right (using a mixture of Yellow Orange Azo, Unbleached Titanium and Raw Sienna acrylics with gesso). Next to the yellow went its complement, purple, which was created by mixing Quinacridone Crimson, Raw Umber, Phthalo Blue and white gesso. Red went great with the purple as well. Turquoise was sprayed through a grid, placed next to the red collage piece, for color temperature contrast and to add rhythm—it repeated the grid in the red collage piece while adding a color change for variety. This grid also connects you to the grid in the bottom, creating unity. A Raw Sienna line (made with acrylic and gesso) moves your eye through the painting by connecting you to the drip lines, the grid in the red collage piece and out the other side of the painting. The painting now looks much more exciting to me.

A surprise ending

While you were sleeping, the painting completely changed! I thought it was looking contrived and that I was trying too hard, so I simply painted right over it and had fun.

What I loved the most about the painting were the holes provided by the spiral pad paper, and they became the emphasis of the finished version. The holes repeat in the small grid pattern that was created by pressing a rubber grid into the wet acrylic paint and rolling over it with a brayer until the image was imprinted. The small circle in the top center with a soft line above it leads you to the bottom of the painting where the major interest takes place. Sgraffito—scraping through the top layer to reveal the underpainting—creates a visually exciting surface. To do this, a single-edge razor blade was placed flush to the surface and scratched back and forth. Linework was incised with the tip of the blade to form a grid pattern.

This painting evokes the old, crumbled walls and rocks that I seek out and record wherever I travel. It was worth it to me to have painted all the previous steps to get this painting. I would not have arrived here if I hadn't painted this particular texture sheet. Don't be afraid to redirect a painting if you want. A painting start is just a beginning.

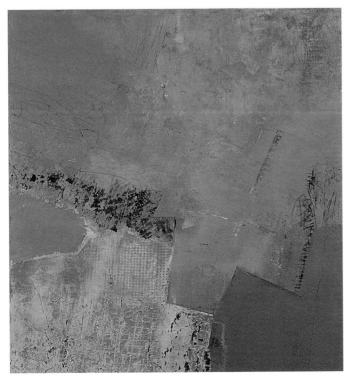

WALL, CITY SERIES 2
Pat Dews • Mixed media • 22" × 21" (56cm × 53cm) •
Collection of the artist

make an abstract design understructure

For this design project, torn collage pieces are arranged on a full sheet of watercolor paper in a pleasing design then painted over. When pulled off the dried paper, the collage pieces reveal white shapes that should be integrated into the overall design.

One understructure—made from a set of collage pieces in a certain arrangement—should be used to make three different paintings. Each understructure will be completed using a different color palette (neutral, warm or cool), with contrasting colors used to integrate the white areas into the painting. Each painting should also be completed with a different orientation and different content. One painting should be nonobjective (no recognizable subject), one should be abstract (abstracted shapes from realistic imagery), and one should have some realistic elements.

This design exercise will help you:

1. Create a good base design on which to build a painting. The understructure allows you to think in terms of design without being overly preoccupied with your subject matter. Beneath every good painting is a good abstract understructure. Best of all, this takes away the fear of covering the white paper!

2. Learn the importance of color dominance and contrast. Limiting yourself to using only warm colors to start, for instance, makes you realize the importance of a cool contrast.

3. Practice glazing. Since the contrasts need to be integrated throughout the painting, not only in the white spaces, you will hone your glazing skills. The white spaces must have some of the dominant color as well—not just the contrast colors.

4. See the beauty of working with neutrals. Your neutral palette may include black, white, browns and grayed colors. Water added to black India ink gives you gray, and so does adding white to black. Mixing complementary colors will give you a wider variety of grays. You can also use colors such as Burnt Sienna, Olive Green, Raw Umber and Raw Sienna for a neutral-palette painting.

5. Create depth. You will learn how to connect shapes, overlapping them to create depth in the picture plane.

6. Get creative! Most importantly, you will learn to think and use your imagination. Your paintings will be unique.

You will start with an odd number (five) of collage pieces. We always use an odd number in all aspects of art to avoid a perfect (thus boring) balance of any kind. I suggest five because you do not want to have so many collage pieces that the paper will be almost completely white when the pieces are removed. After you have done a few paintings using this method, you can try using only three collage pieces.

Your collage pieces must extend to the edge of your paper in at least three places. This allows three entrances or exits for the initial design. (Therefore, you cannot use a vignette or central design format for this project.)

When you make collage shapes to do your own project, tear randomly. The pieces should be small, medium and large for variety. The idea is to have shapes other than those you always use. Challenge yourself to use different shapes in various sizes. Get out of a rut and paint something new and exciting! If you have a collection of torn collage pieces, use them as you find them. This forces you to try new shapes.

When placing the collage pieces, which are positive shapes, be conscious of the negative shapes that will form around these pieces on the page. The positive and negative shapes are equally important.

The same texture techniques you learned for the texture sheet project will be used to provide the background and to get you started. However, the texture materials can and should be different for each painting. Some textures, such as those from plastic wrap and wax paper, can be repeated, but you want each painting to have a unique look.

Getting started is the key. Use a design project to start, but then let the painting itself give you direction. You must follow the three different orientations and palettes, but once you get your understructure painted, change the textures as you want and need to. And if you have to crop, then crop!

After you arrange your collage pieces for your first painting, trace the pieces and their placement on two pieces of wax paper before you begin to paint. Be sure to mark the corners of the paper so you can easily re-create the understructure for the other two paintings. When the paint has dried after texturing, lift the collage pieces and set them aside for the second and third paintings.

On the opposite page are two paintings based on the same design understructure, and a demonstration of the third painting follows. See how the same design understructure can result in three very unique paintings.

[TIP] Purple can be used for both the warm and cool versions of your abstract design understructure. Black may be used for all three versions.

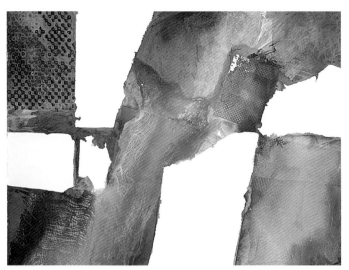

Cool-color palette understructure for a semi-realistic painting

Notice the blues, greens and violets used for this understructure. Warm colors will be introduced only to integrate the white spaces with the rest of the painting. Put some cool color into the white spaces, too—if the white spaces are all painted one color, they won't be integrated with the whole painting.

Finish

The realistic imagery in this painting involves flowing water and water lilies. I love this painting start and will think awhile before finishing it. This is one painting I do not want to overwork, or else it will lose its freshness and excitement.

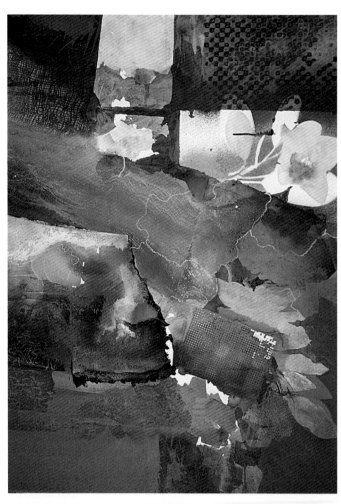

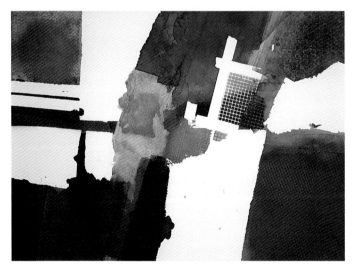

Neutral-palette understructure for a nonobjective painting

For this understructure, some taped areas (for linework) and a grid resist were added to the five collage pieces.

Finish

Can you see which portion of the start made it into the final painting? A cruciform design format helps make this a strong piece.

TEXTURED SHAPES WITH GRID
Pat Dews • Mixed media on heavyweight Rives BFK printmaking paper •
25" × 22" (64cm × 56cm) • Collection of the artist

begin an abstract painting with a warm-palette understructure

This demonstration begins with the same collage pieces used for the examples on the previous page, but here we will create an understructure with a warm palette instead of a neutral or cool one. Every color has warms and cools, but for our purposes in this demonstration, we consider warms the colors that remind you of the sun and heat—yellows, reds, oranges and pinks. Purple and black are used in this demonstration as well. Cool colors are used, but only as you begin to integrate the white spaces into the painting. Cools should fill in the white spaces and must be integrated throughout the painting. Remember to put some warms in the white shapes too for unity, repetition and harmony.

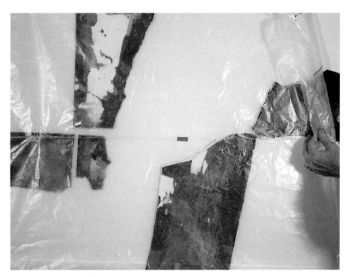

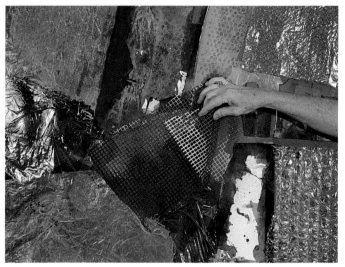

1 Position the Collage Pieces

Using the wax paper pattern as a guide, place your collage pieces on a fresh sheet of watercolor paper. Instead of three pieces exiting the painting, four pieces exit. The three pieces on the upper left are visually connected, as are the two pieces on the lower right. The spaces are all different, and there is a nice diagonal flow between them.

2 Start Texturing With a Warm Palette

Use bubble wrap, plastic wrap, wax paper and fabric grid all at once for texturing with the following acrylics and inks: Yellow Orange Azo, Raw Sienna, Cadmium Red Deep Hue, Purple Lake, Flame Orange, Brown India ink, Raw Umber and Quinacridone Violet. Also use white gesso. Let the paints and inks dry before removing the texture materials.

materials

surface
140-lb. (300gsm) Arches cold-press watercolor paper, 24" × 32" (61cm × 81cm)

acrylics
Golden Airbrush Colors: *Raw Sienna Hue*
Golden Fluid: *Quinacridone Violet, Raw Umber*
Liquitex: *Burnt Sienna, Cadmium Red Deep Hue, French Gray Blue (medium viscosity), Iridescent Antique Copper, Raw Sienna, Yellow Orange Azo*
M. Graham & Co.: *Phthalo Blue*

inks
Dr. Ph. Martin's Bombay India Ink: *Brown*
Dr. Ph. Martin's Tech Ink: *Antelope, Indigo, Turquoise*
FW Acrylic Artists Ink: *Flame Orange, Indigo, Purple Lake, White*

watercolors
American Journey: *Sky Blue*
Winsor & Newton: *Burnt Sienna, Cerulean Blue*

other
Caran d'Ache Neo-Color II water-soluble crayon: *Yellow-Green*
Easel

Mouth atomizer
Spray bottle
Reserved collage pieces
Reserved wax paper tracing pattern
White gesso
Bubble wrap
Plastic wrap (preferably Saran wrap for better textures)
Wax paper
Brayer
Fabric grid
Rubber grid
Craft knife or scissors

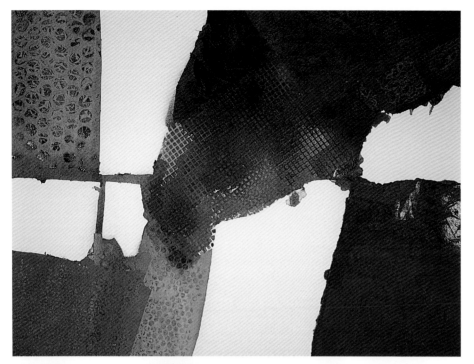

3 Remove Texture Materials

When everything has dried, carefully remove the texture materials. Turn the paper so that the placement of the reserved white areas matches the neutral and cool starts shown on page 39. See how different this arrangement looks with a warm palette?

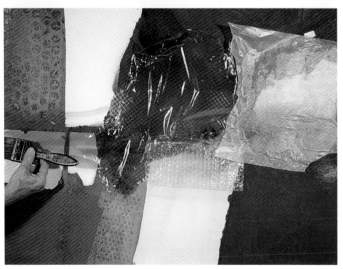

4 Add Cool Color

Brush clean water over the white shapes and middle area of the painting. Then hold the painting vertically and drop Turquoise Tech ink into the wet wash to create contrast in color temperature. Drop in more cool color (Indigo Tech ink) for variation. Squirt more water into the ink, letting it freely integrate the white spaces with the painted shapes. Immediately add Quinacridone Violet acrylic to some of the wet wash to integrate some warm color into the white shapes. Then place plastic wrap, bubble wrap and wax paper (crumpled, then opened flat) in the wet wash for texture. White spaces can be intimidating, so this is a good way to begin.

[TIP] Have reference material handy when trying to combine realistic imagery with the abstract shapes created from texture materials or reserved white spaces. I believe that having something look and feel "right" adds a sense of trueness to my work. Abstractions themselves are created from realistic imagery.

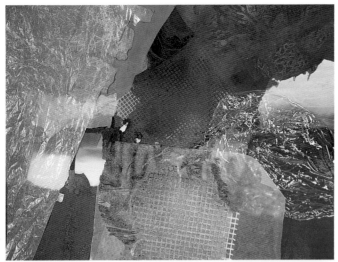
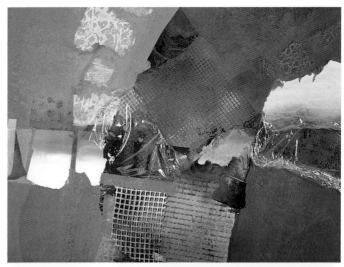
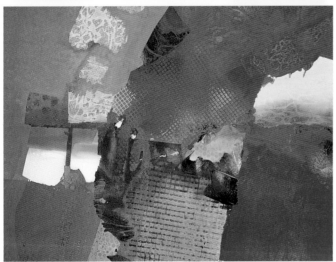

5 Continue Integrating White Areas and Adding Texture

Use Yellow Orange Azo and Raw Sienna acrylics, Antelope Tech ink, Brown India ink and Indigo Acrylic Artists ink to paint the large white shape at the bottom, and place a rubber grid in the wet wash. I placed wax paper over this area and weighted it with books. The size of these grid squares is different from the size of the squares in the fabric grid used in the top of the painting. This is done to achieve repetition with variation.

Use watercolors Cerulean Blue, Burnt Sienna and Sky Blue to paint the white shape in the upper left. Crumple wax paper, open it flat and place it in this wet wash. Paint French Gray Blue right over the top of the wax paper and down the entire left side of the painting, and place crumpled wax paper over the entire area. Roll a brayer over this area, pressing back and forth very hard several times before lifting. This gives immediate gratification, and you get to see part of the underpainting. Glaze Indigo ink over the Cadmium Red Deep Hue, going into the Turquoise, for color variation. Place plastic wrap over this for texturing.

Incidentally, the green in the grid area appeared when the Indigo and Antelope inks mixed over the yellow ground. I love to work this way—I always get some surprises!

6 Make Adjustments

Use a transfer to make a color and value change in the left middle of the painting. Use Burnt Sienna and Phthalo Blue acrylics and white gesso to make the wax paper transfer (see page 117 for instructions on making a transfer). This mixture can go from light to dark and from more brown to more blue, depending on the amounts.

At this point in my painting, I saw an "elephant trunk" shape that I tried to break up by spraying Raw Sienna Hue airbrush color and Flame Orange acrylic ink through a fabric grid. I glazed Brown India ink over the top of the trunk shape to gray the green and modify the brown and orange hues. Plastic wrap was placed over the wet paint and removed when dry. This gave better contrast to the intense colors in the adjacent area and a richer color surface in this area. Glaze Brown India Ink (mahogany in color) over the red area on the right (just below the middle) to add variety and move that color to this area, creating unity and rhythm.

7 Add a Few Whites

We need a few whites for repetition and unity. Spray a white grid on the left of the painting, and paint a white water's edge in the middle right of the painting. Use White acrylic ink for the spray and gesso for the white shape on the right. Place plastic wrap in the gesso for texture. Add a white gesso line to the left to provide an entrance/exit to the painting. Use Iridescent Antique Copper acrylic to tone down some of the stark whiteness of the grid.

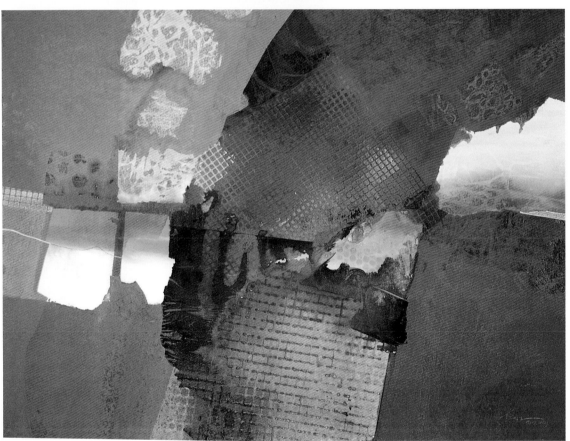

8 Finish—For Now

The line gets a color change—orange—in the white space. The orange is the complement of the blue, and the color change is for variety and contrast. Use a Yellow-Green watercolor crayon to firm up the edge of the rainbow in the lower-right quadrant.

I signed the painting, but I still think I need to work on the "elephant trunk" shape. I just hate when I see an image I don't want in my painting (or if someone else does!). I do have a tendency to overwork my paintings, however, and my ongoing goal is to leave them alone sooner. I am absolutely thrilled with the appearance of the clouds, beach and rainbow, and I would never have gotten this exciting imagery if I had not used this design project. I admit that the trunk shape does lead you back into the painting. My husband sees a hand—perhaps reaching for the gold. Like Matisse, I probably will make changes to this painting once it sits for awhile.

BEACH, CLOUDS, RAINBOW

Pat Dews • Mixed media • 24" × 32" (61cm × 81cm) • Collection of the artist

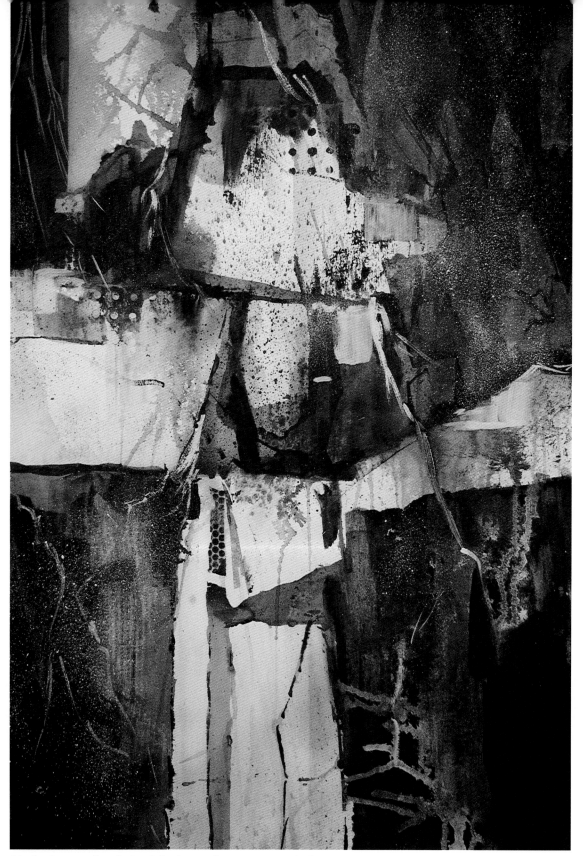

Student example: abstract design understructure painting
One of my students won an award with this painting at the 2002 American Watercolor Society annual show. This piece has great texture, value, contrast, rhythm/repetition and unity. Look at the varied linework. This is a good example of a cruciform design format.

THE ANCIENT MARINER
Selma Stern • Mixed media • 30" × 22" (76cm × 56cm) • Collection of the artist

[T I P] If you are in a painting slump, try different paper or a different palette. It works every time!

find composition possibilities from within a larger image

Magazines can provide great inspirational material for compositions. You can find the beginnings of great design ideas from magazines if you use a viewfinder. The size opening I recommend is 2¼" × 3¼" (6cm × 8cm). This is a good proportion to use with a full sheet of watercolor paper, the paper size I always use for this exercise.

You are not ethically or legally permitted to copy someone else's photograph. If it is a good design, it is the originator's design, and that should be recognized. For instance, you should never take a photograph of from a magazine, copy it and then enter the painting in a competition or sell it. Artists have done this, won prizes and sold their paintings, only to have the copies spotted and the prizes withdrawn.

The sections that are extracted from a larger image should be very small (part of a chair, a section of a building, part of a machine, etc.). Then you should let the interesting shapes within the small image inspire you to formulate a new, unique direction for a painting. Do not use the image as a reference photo, but instead use it as a springboard for your own creative ideas.

I have found that architectural magazines are the best sources for this type of painting exercise. These magazines can be expensive, so I buy them at used bookstores or when libraries sell old books and magazines. Architects are often willing to give away their old magazines, so ask. You could also use this method to look at your own collection of reference photos in a new way.

I get my best inspiration from these small extractions. Make sure the viewfinder opening has wide enough margins to cover the entire magazine page. You want to focus on only the small design you find, not the rest of the page.

Design inspiration from part of a photo
This design section is taken from a picture of a falling-down lumber shack. The wispy, white flowing material is a torn curtain. It says "great painting" to me, and I grab my cheesecloth to try and capture that floating effect.

This is a good design because it has contrast in values, edges (soft and hard), lines (vertical and horizontal) and shape sizes. I want to run right out and get wood chips to replicate the pieces of wood that I see. What great texture—an element of design waiting to be in a great painting!

What is so good about this exercise is that you don't keep repeating yourself. Some artists have a tendency to copy their best ideas, especially if they sell a piece or win a prize. Dare to be different. Trying different shapes and ideas really is more fun and gives you more satisfaction. I hate to be bored, and this way of working certainly keeps me interested.

In scouting for good designs, first find a page that has good values—lights, midtones and darks. Tear it out and search the whole page with your viewfinder for a good design. You will know it is a good design if it has good values and different edges, shapes and sizes. I get so excited when I discover a gem that helps me come up with a great painting design.

On the next page are some of the good design sections I found using this method, and following is a demonstration of an abstract painting that was inspired by a design section.

Get inspired by architecture

This is a great design pulled from a section of a building. The blue rectangle within the large gray shape is actually tape I had to place there for my camera to focus correctly for this picture. In a painting, I would put in the upper-right quadrant a blue shape curving downward and into the diagonal shape. I would put a smaller rectangle somewhere in the right side of the gray shape to repeat the rectangles on the left side of the image.

Appreciate good mechanics

This piece of machinery has great angles, shapes and values. Simple, strong shapes have impact. The eye always goes to a V shape, so think of a great color or texture to place there for a perfect center of interest. This will be in the form of a small shape and will not only bring variety, but better balance to the painting as a whole.

Look for inspiration in the ordinary

Never say that you don't know what to paint. Paint a doorknob, a shirt and a shadow. See the harmony, rhythm and contrasts in this picture portion. Your eye moves up, down and around. What more could you ask for?

[TIP] To get great texture material free, go to the local lumber-

yard. They throw out sawdust. Place sawdust in wet ink or paint

and rub it off when dry. A great texture results.

See a room from a different angle

This section of a bedroom could inspire a great painting. I love the repetition of angles and the contrast of hard edges and soft edges. And, of course, I love the values. The oblique line in the lower right is placed just right to lead you into or out of the painting, and it gives the design tension, which is very important. Incidentally, the heavy black diagonal was placed so that my camera lens would focus. It works there, though. Diagonals can make for a strong design.

let a realistic picture inspire an abstract painting

Forget whether something is a pillow, a chair or a neck: Just think shape! Great paintings are in store for you when you practice this method. You can find spectacular shapes with a viewfinder, and your paintings will stay fresh and exciting if you seek out new ideas. In this demonstration we will find abstract inspiration in a realistic picture and use some of the texturing techniques you've learned.

My inspiration
This cropped picture contains wonderful abstract qualities. I love the contrasts—great values, shapes and lines. There is great variety and contrast in the repetition of the linework. It's all there: lines of various sizes in the sleeve, curved and straight lines in the collar, and the great juncture of lines where the neck meets the collar of the shirt. I especially like the line edge variation in the white diagonal line under the collar.

Great find
I have found a manufacturer to make a custom mouth atomizer that I love to use for most of my paintings. For more information about the Pat Dews Atomizer, contact Piper Plastics Corporation at (800) 966-9919 or send an e-mail to larry@larrysart.com.

1 Begin Creating Textures
In the upper-left area of the painting, use Indigo and Turquoise Tech inks and Black India ink. Fold and pleat the plastic wrap to try and replicate the wrinkles in the shirt before placing it into the ink wash. Use Antelope Tech Ink for the bubble wrap section in the upper right, and let Flame Orange acrylic ink peep out in the quiet (nontextured) Raw Sienna watercolor area for exciting contrast. Place plastic wrap in the wet Antelope ink to repeat the texture on the left.

Use watercolors Cerulean Blue, Alizarin Crimson and Burnt Sienna in the lower section with a rice paper grid. Dilute Indigo Tech ink and Black India ink with water and use them with care in areas with the paper grid. Keep lifting and checking to see if the texture has formed, and remove the rice paper before it can stick to the surface. Use Carbon Black in the middle right. Use plastic wrap and wax paper in areas for additional texturing.

materials

surface
140-lb. (300gsm) Arches cold-press watercolor paper, 22" × 30" (56cm × 76cm)

acrylics
Golden Airbrush Colors: *Raw Sienna Hue*
Golden Fluid: *Burnt Sienna, Carbon Black*
M. Graham & Co.: *Phthalo Blue*

watercolors
Winsor & Newton: *Alizarin Crimson, Burnt Sienna, Cerulean Blue, Indigo, Raw Sienna*

inks
Dr. Ph. Martin's Bombay India Ink: *Black*
Dr. Ph. Martin's Tech Ink: *Antelope, Indigo, Turquoise*
FW Acrylic Artists Ink: *Flame Orange, Turquoise*

other
Papers: *wax, construction, rice with grid pattern*
Brushes: *2-inch (51mm) Robert Simmons Skyflow, riggers of various sizes*
Liquitex white gesso
Fabric grid
Bubble wrap

Plastic wrap (preferably Saran wrap for better textures)
Mouth atomizer
Ruler (optional for linework)
Single-edge razor blade
Paper towels
Painter's tape
Natural sponge
Felt-tip marker
Craft knife or scissors
Brayer
Reference photos of rocks
Collage pieces

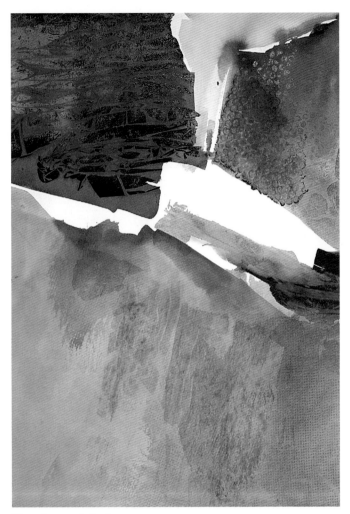

Step 1 completed

The painting has dried and all of the texture materials have been removed. Isn't it amazing? From a small image in a magazine has come a full-sheet painting start. I especially love the upper-left portion of the painting: the texture, the intensity of the inks, and the contrast of the inks with the more opaque and less intense colors.

2 Repeat Grid Shape

You have to start somewhere, so spray Flame Orange acrylic ink through a fabric grid with an atomizer. I use orange because it is the complement of blue. Paper towels are great for covering areas you want to save. Adding another grid of a different size to this painting helps to achieve repetition and variety. The grid also adds rhythm to your piece.

3 Make an Adjustment and Change Orientation

The middle grid looks a little too orange. This area needs some turquoise for cool/warm contrast and to lessen the overall area of orange. Reapply the fabric grid and paper-towel masking, and spray Turquoise acrylic ink.

After viewing my painting on an easel, with a mat and from every orientation, I decided that I wanted a horizontal format for this painting. This particular vertical format seemed too static to me—the two shapes at the upper left and upper right seemed too close in size, and the V shape that goes to the orange grid seemed to be right in the middle. It felt boring to me.

In a horizontal format, the strong white diagonal says it all. It gives movement and tension to the piece. The quiet space appears to be larger from this perspective, and the V shape is no longer so much of a V. The light edge area on the bottom right leads you down and out nicely. The orange grid just doesn't seem as centered.

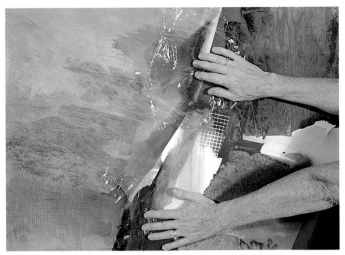

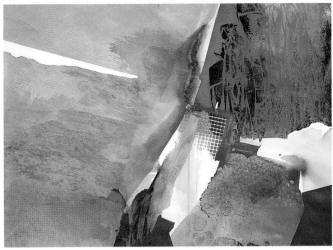

4 Modify the White Areas

I love the whites, but recommend against leaving them as is. I want depth and don't want my work to seem too slick. I looked at a slice of rock I have for inspiration and started to modify the white areas. Use Turquoise and Indigo Tech inks with Black India ink. Place plastic wrap on the wet ink, and allow it to remain until dry. To give shape and form to the lower-left quadrant of the painting, use your Skyflow brush with my favorite mixture: acrylics Phthalo Blue and Burnt Sienna with white gesso.

Use the same paint mixture to move the color across to the right of the grid, cutting a shape into and covering part of the grid, which may look too dominant. Using a rigger, paint a straight edge, continuing the shape and breaking into the light area to start giving form. A straight, hard edge will contrast with the curved white shape and visually continue the straight line from the grid line, giving rhythm to the painting.

5 Evaluate

At this point, I was starting to be sorry that I got rid of my sharp whites. Oh well, it was too late! Or was it? A diagonal white coming through the painting from the left will contrast nicely with the vertical whites in the center. Use a shape cut from watercolor paper to see if you like the idea, and plan as you go. The painting will start to come together.

[TIP] Using the same texture materials from beginning to end will give your painting unity.

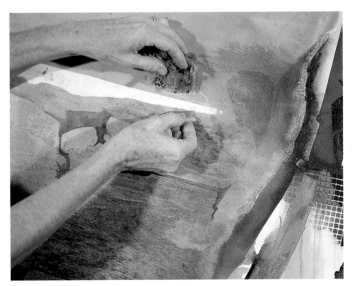

6 Add White Shape

I liked the white shape, so I went with it. Add the shape by making a transfer with white gesso. I usually remove the wax paper right away, but in this case I left the transfer on too long and it would not lift. I used a natural sponge to wet the wax paper and a single-edge razor blade to rub back and forth, scratching and lifting it off. The resulting cracks that formed were perfect for the rocklike feeling that I wanted.

Next, try to bring back some of the white taken out in the beginning by adding gesso to the center, along the left side of the blue curve next to the orange grid. Use Antelope and Indigo Tech inks to start giving form to the left side of the painting. Use photos of rock formations as a guide.

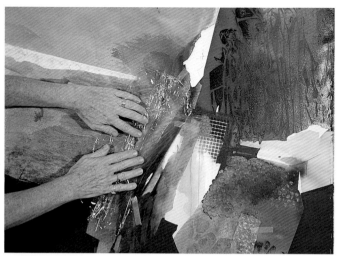

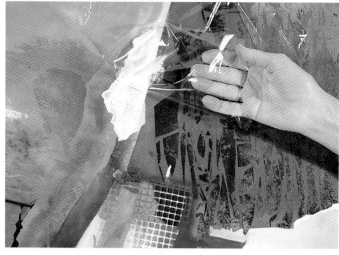

7 Use Papers to Test Additions of White and Black

The added white along the blue curve has got to go. It is too similar to the parallel white line and is too thin to add the weight needed for balance. Paint over it with Indigo ink and add plastic wrap for texture. Use Carbon Black acrylic to create a dark shape in the lower left. This moves the darks from the lower right across the page, creating unity and harmony. Use black construction paper to plan this area before painting it.

I missed having the larger, original white shape in the upper center of the painting (see step three) and felt that I took away too much. I tested a cutout white shape to see if I wanted it back.

8 Add a New White Shape

I decided to add the white shape I tested with construction paper, but I made it larger and more dominant. Paint a new shape using white gesso, press plastic wrap into the paint using a brayer, and lift it when the gesso is dry. I did it this way to allow some of the modeling of the undertexture to show through.

I often transfer the wet paint left on my plastic wrap somewhere else in the painting or onto a different painting in progress. I hate to waste anything!

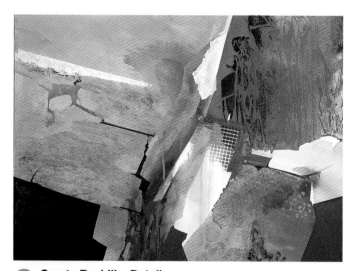

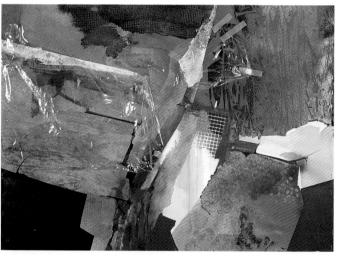

9 Create Rocklike Details

Add crevices in the rocks in the top upper left of the painting to break up the large space and give form. Add more of the Antelope color to this area to help balance the left and right sides of the painting. You don't want the rocks to look outlined—aim for gradation in size, color and value. Add linework to provide rhythm and repetition. Quiet areas should not be boring.

Paint more form and crevices in the center bottom. Add a directional black line to stop the long diagonal edge near the left side and lead the eye into the painting. More visual weight may still be needed on the left side of the painting to balance the two sides.

10 Repeat Colors and Textures

Use the same rice paper to add texture and more dark to the top left with watercolors Indigo and Burnt Sienna. Use Indigo to repeat the color from the right and Burnt Sienna to make it less intense. Add the same darks to the middle left; place plastic wrap over the wash. Use Turquoise and Indigo Tech inks to model the white shape at the top center, and place plastic wrap over the wash.

I decided to show my sister my progress, and she pointed out to me that, to her eye, the light beige shape in the lower right resembled a derriere! I decided that it had to go. The eye definitely went there because it was the brightest of the bright areas, and I didn't want the emphasis to be on that area.

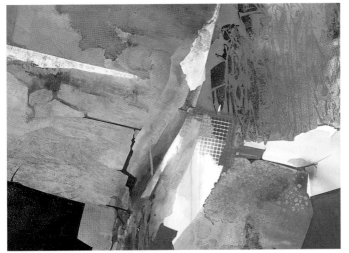
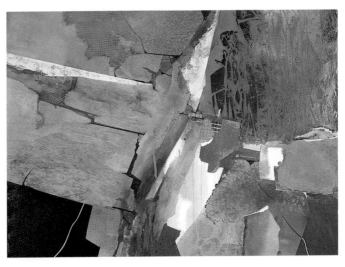

11 Consider Using Collage to Complete

The painting looks more complete. More form may be needed in the upper left, and a bright may be needed in the middle-left area near the white diagonal. I started looking through my collage box for pieces to cover the bright area in the lower right. I decided to use collage because this strong piece could carry it. Since my paintings are made using my palette, it was easy to find collage pieces that work.

Your painting will be more unified without the distracting bright area. I was able to find collage pieces with the same color and bubble wrap texture, so they definitely related to the whole. Add a piece of orange collage to cover too much orange grid in the center of the painting and to move collage to another area of the painting. Add two white lines to visually move the eye in and out of the painting and to anchor the painting. Note the color change of the line on the lower right. The line is blue in the orange area (the complement) and becomes white when it exits into the blue area, which is repeated throughout the painting. Repetition and variety are both important. Spray Raw Sienna Hue through the rice paper grid to add some bright sparks to the middle left of the painting and bring some of that color from the right side.

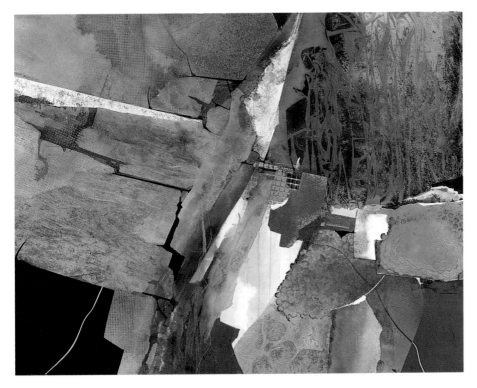

12 Finish

The painting is finished. The white curved line in the lower right of the painting connects the two added pieces of collage. The orange line that goes in and out of the painting on the top left brings orange to this side of the painting. It goes behind the rock shapes and comes out again and brings you down through the center. These and the white line to left of center are intentional.

Some of the fainter lines in my painting don't bother me, but they are actually the images left from trying to rub them out. The white curved line that connects the two pieces of collage is what is left of a circle I made, which seemed like a good idea at the time. In a final moment, I had a feeling of wanting to make the painting vertical, so I freely and with great glee added multiple lines. The horizontal format prevailed, and away they went.

UNFOLDING LANDSCAPE
Pat Dews • Watercolor, acrylic and ink • 22" × 30" (60cm × 80cm) • Collection of Thomas D'Emic

Different Artists, Different Approaches

One of the best ways to increase your knowledge of design is to look at what other artists are doing. Artists work in many styles and use many different methods to bring their visions to fruition. You develop a style over time through working. I have found that a style chooses the artist, rather than the artist choosing a style.

In this section we will see what some accomplished professional artists do, as described in their own words and pictures. Notice that each painter approaches design in a unique way. What all of these artists have in common is that they have spent many hours painting. There is no other way to become proficient in this craft.

WOODSIDE POND

Dorothy Masom • *Encaustic on Masonite* • 36" × 36" (91cm × 91cm)

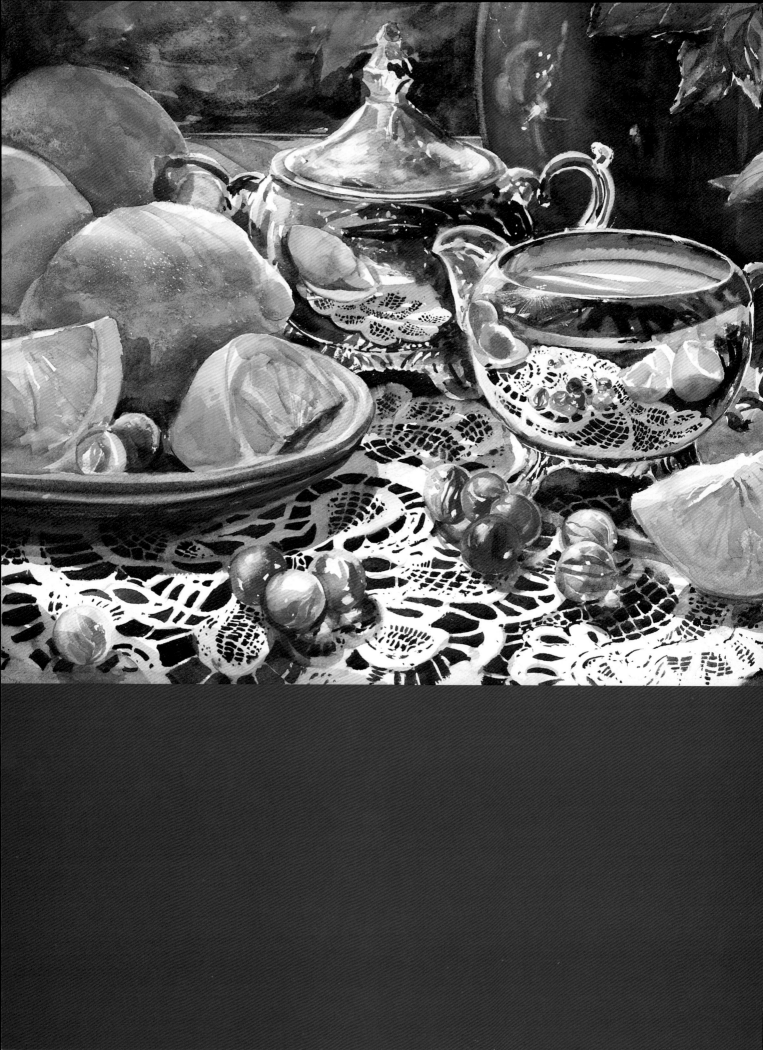

LETTING *Light* AND *Shadow* LEAD A *Composition*

Before beginning a painting, I ask myself why I want to paint it. Generally the reasons involve wanting to show the effects of light on form. One of the most important components for the piece to evolve into an artistic success is the design. Often artists jump into a painting because of its prettiness, sentimentality and conceptual thought without regard to its formal design.

My most successful paintings result when I've done various studies rather than settling on one hurried idea. Every successful painting is based on selection, proper balance, unity, rhythm, harmony and direction. A broad, simple organization of light, form, value and space will convey strength in the design.

My paintings are about light—not necessarily light as the subject, but the effects of light on the subject. I challenge myself in capturing its dramatic and/or subtle effects. I find it important at times to limit where the light hits to create a strong focal point. The spontaneous qualities of watercolor lend perfectly to my lively, loose style of realistic painting.

In planning a composition, think abstractly; observe light's quality and direction. Check the eye level and simplify. I strive for pleasing asymmetrical balance in my work using light, shadow shapes, color, temperature, repetition, escape routes and edges to move the viewer's eye throughout. Line, literal or implied, is also an important aspect in designing a composition. Directional lines (horizontal, vertical and diagonal) are fundamental in leading the observer's eye to the center of interest.

Shadows and light are great for direction, balance and movement. Think dimensionally when "seeing" light envelop form; observe positive and negative areas; check for possible tangents; be sensitive to value, temperature and edges. These factors all play important roles when addressing a painting. Squinting your eyes to eliminate useless details to see the basic forms in light will help you develop a strong composition.

Use a pattern of light to move a still life
Luminous light harmonizes the areas of this painting. The movement of light throughout the composition connects the lemons, silver and lace. Repetition of shapes helps to create unity. Complements are used to great advantage.

TIMELESS TREASURES
Betty Carr • Watercolor on 140-lb. (300gsm) cold-press paper • 16" × 22" (41cm × 56cm)

capture a dramatically lit scene

In getting ready to create my early-morning bouquet, I tossed cosmos haphazardly on a cutting board near my kitchen window. After a brief coffeebreak I went to gather up my flowers and was struck by the beauty before me. The abstract color shapes and network of connecting warm and cool shadows portrayed an exciting, spontaneous array ready to be painted. The contrasting dark, soft values in the background effectively showed off the design qualities of the random display of lines, textures, shapes and colors. This demonstration shows you my techniques as well as the thinking process behind the painting of this brilliant interplay of shape and value.

Reference photo
I love strong contrast between the light and dark shadow areas. Shadows make great abstract shapes. This shape is a crucial part of the design. The abstract, mosaic pattern of brilliant colors and subtle shadow is a light show waiting to be painted.

1 Plan the Values
More striking than the flowers themselves is the abstract network of connecting warm and cool shadows. Quickly sketch a value study to organize and simplify the lights, middle tones and darks. Create a dynamic composition of directional diagonals.

2 Make a Watercolor Sketch
Oftentimes because the early-morning sunlight changes so quickly, affecting the shadow shapes, a small, quick watercolor sketch is necessary. Studies like this can be paintings in themselves. Often it is the simplest statement that is the most satisfying.

materials

surface
140-lb. (300gsm) Arches cold-press watercolor paper, 12" × 20" (30cm × 51cm)
Painting board (for support)

watercolors
American Journey: *Burnt Sienna, Cadmium Orange, Cadmium Yellow Light, Cobalt Violet, Manganese Blue, Permanent Rose, Raw Sienna, Sap Green, Ultramarine Blue, Viridian*
Daniel Smith: *Quinacridone Burnt Orange*
Grumbacher: *Thio Violet*
Holbein: *Cobalt Blue, Indian Yellow*
Winsor & Newton: *Antwerp Blue, Chinese White, Winsor Red*

brushes
Sable rounds: *nos. 10 and 12 for large areas, nos. 2 and 6 for small areas*
Small rigger
Old brushes, for applying masking fluid

other
Sketchbook
6B pencil
Masking fluid
Rubber cement pickup
Small bar of soap
Various palette knives

3 Complete Drawing and Masking

Sketch the drawing on your watercolor paper. Using an old brush, first put soap on the hair and then dip it into the masking fluid. The soap will protect the hair; make sure to rinse the brush often, though. Mask small areas of light, especially where lights dance through heavy darks on the greens of the flowers. Mask the outer edges of a few flowers and some entire flowers, too. Use a palette knife to make small stems and lines. Protecting these lights early on will allow you to paint freely around them later.

4 Start With the Darks

Begin by painting the dark background with a variety of staining transparent pigments (Sap Green, Indian Yellow, Thio Violet, Ultramarine Blue, Quinacridone Burnt Orange and Cobalt Blue). Have your large rounds loaded and ready to spontaneously lay in the various colors wet-into-wet. Make your strokes quick, confident and interesting. This area will be glazed to a darker cool value later. Leave a few unpainted negative spaces, suggesting forms in the background that will spice up the area later when glazed.

[TIP] In painting creatively and with a loose realistic approach, you will have unattractive stages along the way. This is acceptable and important. It differentiates great paintings from mere pictures. It's fairly easy to pick up a brush and fill in the lines, but to paint and feel the process along the way is more effective. Even the most abstract initial shapes in your painting should be painted with strong design fundamentals in mind. This is the foundation on which you will build a successful realistic painting.

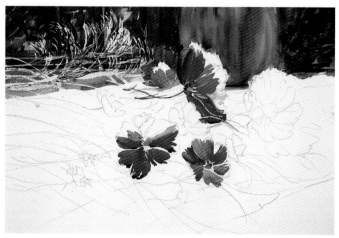

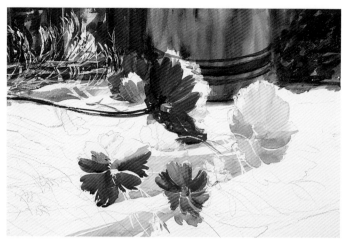

5 Block In the Flowers

Now that we have established a variety of colors and values to contrast effectively with our flowers in light, we will paint the dark flowers next, saving all the lights for the very last stage of the painting. Pick up Winsor Red, Permanent Rose and Cobalt Blue first for the medium-value cosmos and Thio Violet with Ultramarine Blue for the darker flowers. As you establish interesting asymmetrical shapes of flowers, leave little whites so that the flower color does not all blend into one shape. Start the flower centers with a mixture of Cobalt Violet and Indian Yellow. At this point I added a stem to one of the flowers, but most of the greenery will be added in step seven and later after the masking has been removed.

6 Begin the Shadows and Give Form to Background Pot

To suggest a vase in the center of the background, use Sap Green and Cobalt Blue to create horizontal detail lines. These details will subtly be seen through the final glazes. Add a light-pink flower with Permanent Rose and Indian Yellow for the center. For more contrast, deepen the value of the magenta flower.

With a mixture of Permanent Rose, Raw Sienna and Manganese Blue, introduce movement into the painting with diagonal shadows. Use more blue (Manganese Blue) for these initial cool shadow shapes. Think of the shadow shapes as an abstract. As long as the connecting shadow shapes follow a consistent light source, it works. Keep the shadows asymmetrical, carefully painting around the unmasked flowers and leaving some whites between diagonals.

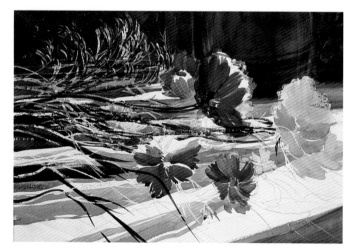

7 Glaze Background, Continue Shadows and Begin Greenery

With Cobalt Blue, Thio Violet and Quinacridone Burnt Orange, glaze the background, making sure it is very dry first. This simplifies the area, creating depth and placing more interest on our flowers and the light to come.

Continue to lay in the network of shadows. In the lower-left corner, keep the mixture on the cool side, while in areas of the direct light, warm up the mixture with more Permanent Rose and Raw Sienna. Don't go over and over the strokes; paint them directly to avoid making mud.

The complementary color to the reds we've been using is green. By bringing in the abstract shapes and lines of green, you will begin to turn on the painting. Using a variety of blues and yellow, create mixtures of greens from light to dark. Move confidently, using large rounds as well as a small brush or a rigger for small linework. You want your brushwork to look fresh and feel effortless to the viewer. Scratch in stems and leaves with a palette knife. Make sure the overall green shape has pleasing design qualities.

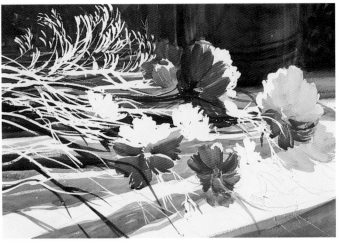

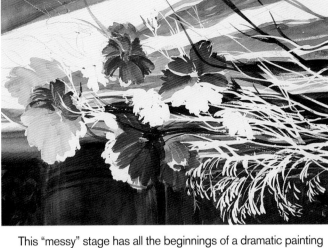

8 Remove the Masking and Take a Look

To give the light pink flower more dimension and play in light, paint a shadow shape over the lower petals using Permanent Rose and a touch of Viridian.

Now, remove the masking. Make sure the painting is completely dry, and, using a rubber cement pickup, go over the entire surface to make sure you remove all the masking. Be sure you don't miss smaller areas where you applied masking fluid with a palette knife.

This "messy" stage has all the beginnings of a dramatic painting of light. Up to this point you've been concentrating on building the darks; now it's time to work with the precious whites and lights. Turn the painting upside down to check its balance. One common mistake most beginners make is that they make their objects the star while they're painting. This literal thinking, rather than realizing the goal of weaving lights and darks for overall balance, makes all the difference when putting together a solid design.

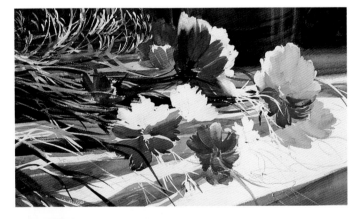

9 Glaze the Light Areas

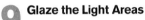

Let's bring "sunshine" into your lights by glazing the white areas with Cadmium Yellow Light, Cadmium Orange and Raw Sienna, while spotting a few opaques here and there.

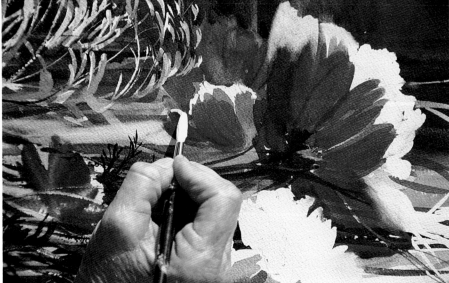

10 Add Light Details

Use Chinese White to add a few of the highlights on some of the petals, leaves and stems in light, making them sparkle.

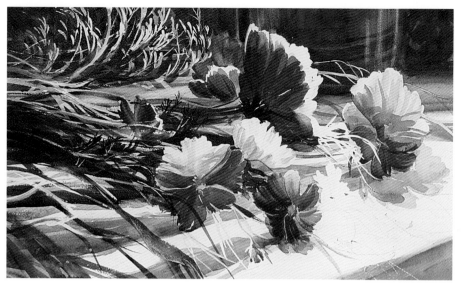

11 Add More Color Detail and Start the White Flowers

After the paint has dried, lightly glaze out most of the whites on the colored flowers. Then load your palette knife with a heavy, dark mixture of Antwerp Blue and Burnt Sienna to make more stems and greenery accents. You can also use a small brush or rigger to finish details such as this. Make sure to keep the detailing to a minimum; leave a little thought to the imagination of the viewer.

Use Cadmium Yellow Light, Permanent Rose and Manganese Blue to create various warm and cool grays for the white cosmos. Your final details will also include shadow shapes on the petals of the flowers, begun in this step. Tone down overly bright areas by glazing them with complements. For example, if one of the cosmos stands out too much because of its brilliance, tone it down with its opposite.

12 Finish

It's time to apply the final touches. In most cases, a painting begins with a large brush and ends with a small one. Use a small round and/or a rigger to touch up areas, creating contrast and calligraphy for interest. Loosely add a very diluted glaze of Cadmium Yellow Light and/or Cadmium Orange to warm the remaining white areas of the surface on which the cosmos rest.

Compare the reference photo, value sketch and watercolor study with the completed painting. Squint and look for odd shapes and for proper balance, unity and rhythm, and adjust any problem areas.

COSMOS IN LIGHT
Betty Carr • Watercolor • 12" × 20" (30cm × 51cm) • Collection of Pat and Joe Dews

[TIP] When mixed together, complements make great grays. When placed next to each other, they add excitement to your painting.

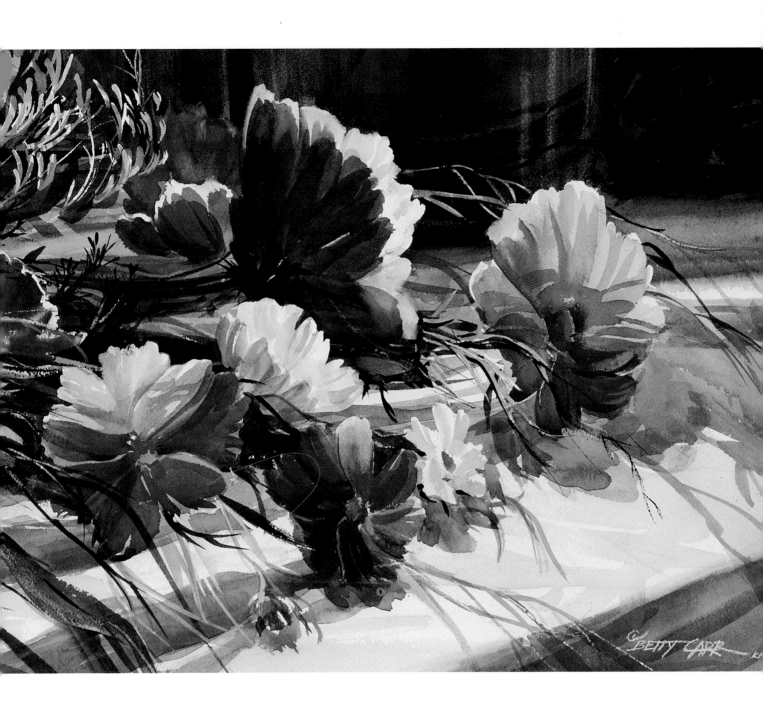

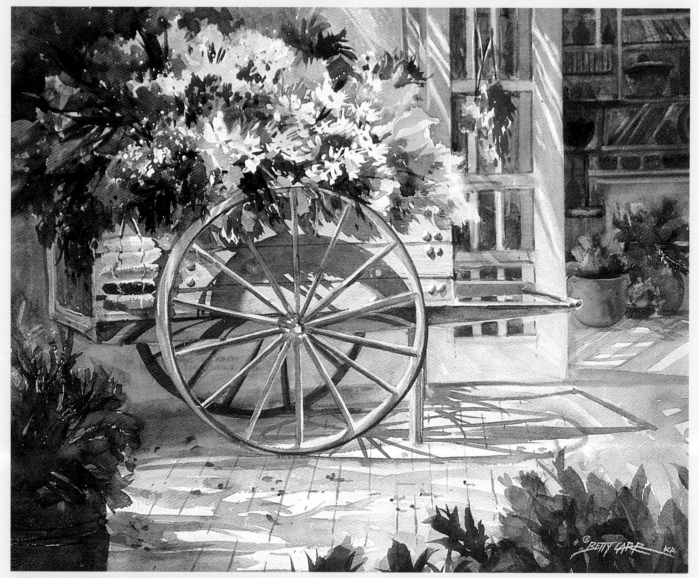

Play up the abstract qualities of a realistic setting

During a plein air painting journey I rounded a quaint street corner in Santa Fe, New Mexico, and spotted a colorful array of dancing shadows surrounding a parade of colors. The cozy setting was enjoyable as a subject and a challenge to paint.

It was important to determine the eye level of the viewer and the light's quality and direction in order to tackle this colorful display of basic forms (a circle, rectangle and square) in light. My goal was to capture the interior's depth along with the abstract qualities of the setting's light using creative shadow shapes, textural characteristics and colorful groupings. Shadows unite the shapes and create a wonderful balanced and rhythmic pattern along with a subtle background.

WAGON'S BOUNTY
Betty Carr • Watercolor on 140-lb. (300gsm) cold-press paper • 16" × 20" (41cm × 51cm)

[TIP] When natural sunlight is moving rapidly over your subject, instead of creating a large, full painting in a sitting, use the opportunity for fact gathering. Things you could do:

- Pencil a quick line sketch and value study.
- Shoot photographs, capturing a variety of angles and eye levels.
- Paint a speedy watercolor sketch.

Typically, I use all of these resources for a larger painting of light value and shape along with the abstract design qualities I discover as I paint.

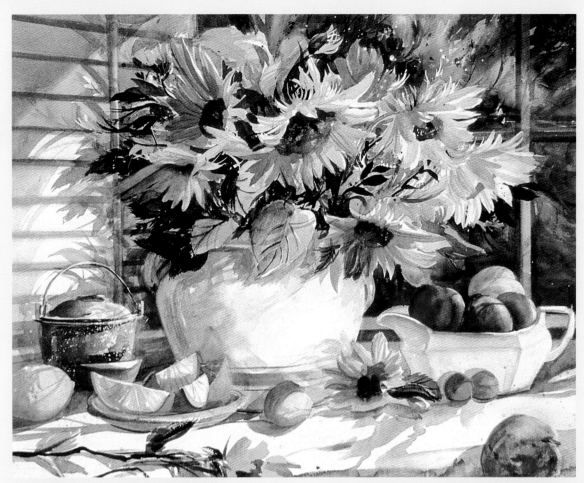

Guide the eye with color and shadow

The radial design of flowers and warm harmonious colors give life to this cozy setting. The repetition of color bounces into a nearby window while shadow shapes dance across the background blinds, filling the composition with painterly action.

SUMMER'S SUNFLOWERS
Betty Carr • Watercolor on 140-lb. (300gsm) cold-press paper • 17" × 22" (43cm × 56cm)

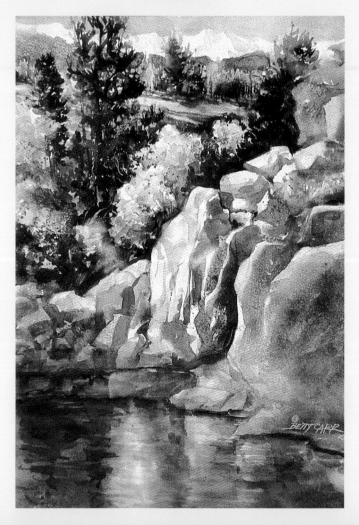

Put all the pieces together for a successful painting

The S design of this painting creates diagonal movement that guides the eye. Escape routes placed throughout the asymmetrical design, whether subtle or more open, help move the eye through forms and passages such as the trees and mountain opening. Warm/cool contrasts and good use of complements add to this pleasing composition.

GRANITE REFLECTIONS
Betty Carr • Watercolor on 140-lb. (300gsm) cold-press paper • 28" × 14" (71cm × 36cm)

Tell a Story With the *Elements* of *Design*

What story do you want to tell? This is the most important question you can ask yourself as an artist. The answer will determine both the content of your work and the specific mediums and techniques you use. For example, if an interesting texture catches my eye (leaves, ripples in water, a brick wall, etc.), then that becomes my story. I use the subject to help me tell the story of texture. I use the elements of design as tools to give the viewer my story. I emphasize whichever elements will reinforce my story.

I also love the drama of light and shadow. I can show that story using many different subjects, and I have—building facades, fire escapes, landscapes, animals and so on. I use the element of value to show my story of light and shadow.

The workshops I teach are titled "Design Your World With Shape, Value, Line and Color." You can use these elements of design and more to paint powerful, dramatic visual statements—and tell beautiful, memorable stories.

Let lines direct the eye
Use line to direct the viewer's eye through your work. The viewpoint in this painting creates strong diagonals that emphasize the grand architecture of the venerable buildings.

OLD BUILDINGS, NEW LIGHT
Mark E. Mehaffey • Sprayed transparent watercolor on 140-lb. (300gsm) hot-press watercolor paper • 29" × 21" (74cm × 53cm) • Collection of the artist

try a spray painting

Spraying transparent watercolor with a mouth atomizer is just one method of painting that I like to call upon. When opened, put in a jar of pigment and blown through, a mouth atomizer sprays a path about twelve inches (30cm) wide from two feet (61cm) away. I have had good luck with Daniel Smith watercolors for spraying. They are finely ground and go into solution quickly.

Because all of the shapes for my spray paintings are cut from Frisket film with a craft knife—and the spray path of an atomizer is rather wide compared to that of an airbrush—I tend to select subjects that have straight edges. Architectural themes are frequently the subjects of my spray paintings. It is easier to cut out shapes with straight edges than those that contain curves.

I do spray complicated, organic shapes sometimes, but it takes more time and energy. For this demonstration we will try to capture the natural curves of a heron on the rocks.

Placing your focal point

As you arrange (design) your subject, pick one of the four quadrants for your focal area or center of interest. The most exciting part of your composition should fall within this area. Think of your center of interest as a question: "Where do I want the viewer to look first?" If you place important shapes near the edge of your paper, they will take the viewer's eye off the edge, something you do not want to do. Avoid the very center of your rectangle because that visually divides the space into equal parts, which is boring compared to a more asymmetrical division.

1 Make a Preliminary Contour Drawing

Contour in a variety of sizes (some small, some medium and a few large) all the shapes necessary for your composition. You can begin to focus the viewer's eye on your center of interest by surrounding smaller shapes with larger shapes. Contrast of size will focus the viewer's attention just where you want it. I started with a contour drawing of the rock shapes minus the heron. This allowed me to design with these shapes as a separate composition before adding the shapes of the bird.

After your contour drawing is refined—all shapes added, arranged, rearranged—you are ready to move on to the value sketch.

materials

surface

140-lb. (300gsm) Arches hot-press watercolor paper or #115 hot-press Crescent brand watercolor board

watercolors

Daniel Smith: *Cadmium Red, Cadmium Yellow Deep, Cadmium Yellow Light, Cobalt Blue (or Indigo), Quinacridone Rose, Ultramarine Blue*

other

Gator board (used to stretch paper on before painting)
5B or 6B graphite pencil

Tracing paper
Frisket brand film (clear plastic film with a sticky backing, available in sheet form or by the roll)
Large spoon
Masking tape
Craft knife, plus extra blades for cutting the Frisket film
Baby food jars, or something similar for mixing and storing liquid watercolor
Mouth atomizer

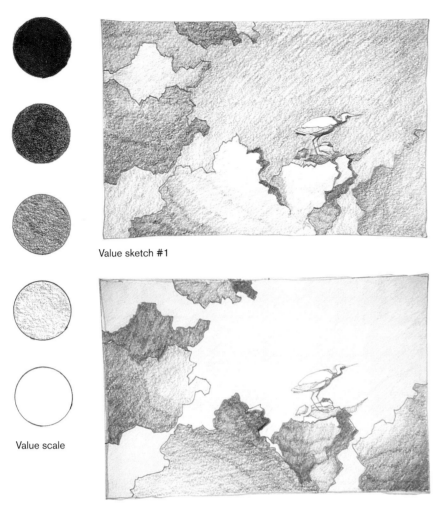

Value scale

Value sketch #1

Value sketch #2

[TIP] As we paint we sometimes add more, but it is a good idea to simplify as much as possible. A good place to simplify is with your value scale. Simplify from the start.

2 Work Out a Value Plan

Use a graphite pencil to make a value scale of quarter-sized circles. I rarely add the lights and darks as they occur in nature. I rearrange them for a more dramatic composition. A range of five values is enough to describe all shapes. I use a white, a light, a medium, a medium dark and a black.

Now assign these values to your shapes. Start with the focal area and add a dark and a light. It usually works best to have the darkest dark and lightest light (high contrast) at the center of interest. Make those shapes that are visually farthest from the center of interest closer in value (a medium next to a medium dark, for example). As the shapes get smaller and you get closer to the center of interest, the amount of value contrast becomes greater.

Further explore the composition with a second sketch. Make the rock shapes much darker and the largest shape—the water—much lighter. By making the largest shapes lighter we have increased the value contrast between the dark shapes on the bird with the largest light shape behind the bird, making a more dramatic design. I chose the second version to paint.

3 Make Final Drawing on Tracing Paper

Use a graphite pencil to redraw your sketch on a piece of tracing paper that is slightly larger than your painting surface. Use a heavy hand as you are depositing graphite, which will later be picked up by the sticky side of the Frisket film. As the artist, you can edit this larger drawing at any time. I chose to make the bird, a heron, larger in proportion to the rock shapes, giving this area more emphasis.

Securely tape the working drawing to a flat surface around all edges; when you apply the Frisket film, the sticky side will want to pull up your drawing as you remove the film. See "How to Transfer a Drawing for a Spray Painting" on page 68 for instructions on preparing your drawing specifically for this painting technique.

4 Select and Prepare Paint

Mix a warm and a cool for each of the primary colors. I use cool Cadmium Yellow Light, Quinacridone Rose and Indigo or Cobalt Blue and warm Cadmium Yellow Deep, Cadmium Red and Ultramarine Blue. Squirt a quarter-sized glob of tube watercolor into the bottom of a baby food jar. Fill with water, place the lid on straight and securely, then shake vigorously until all the pigment is dissolved. I shake until both arms get tired from shaking. Because of the many layers of sprayed paint that make up most medium to dark values, the color will become neutralized. I tilt the dominance of color temperature one way or the other (warm or cool) as my painting nears completion.

5 Begin Cutting the Stencil and Spraying Paint

Carefully cut around all dark-value shapes in your composition and remove the pieces of Frisket film. Change your blade as soon as it begins to drag or not cut all the way through the film. For a full-sheet painting, I may go through five to ten blades. Remember to wrap each blade with masking tape before you discard it to protect others who may come into contact with them.

Open the mouth atomizer until it is in the L position, insert the longest end well into your jar of pigment, point the atomizer toward the holes you have cut through your film and blow through the end of the atomizer. It will give a spray path about ten to twelve inches (25cm to 30cm) wide depending on how close to your surface you stand. The closer you stand, the smaller the spray path. To give some variety of color temperature within shapes, change colors for your next couple of spray layers. Continue to spray until all your darkest shapes have been brought up to about a mid value.

How to transfer a drawing for a spray painting

Follow these steps to transfer a drawing for a spray painting:

1 *Cut a piece of Frisket film about one inch (3cm) larger than your image and remove the paper backing.* Be sure the sticky side does not touch anything until you are ready to put it down on your drawing. It may be helpful to enlist a friend during this process.

2 *Place the whole piece of film, sticky side down, onto your working drawing.* Smooth the film from the middle outward until there are no bubbles. Burnish the film with a large spoon, going over all the pencil lines that show through the film. Burnishing picks up much of the graphite and deposits it onto the sticky side of the film.

3 *Move the film to the painting surface.* Have a friend help you slowly lift the film from your drawing, then carefully place it on your watercolor paper, sticky side down. Smooth from the middle outward until all bubbles are gone. The drawing should now show through the clear film. The graphite will not transfer to your painting surface since it is attached to the sticky side of the film, and the drawing can now be cut and used as a guide for spraying individual sections at a time. Paintings done with this technique should have no visible pencil lines.

First layers of paint completed
The darkest parts of the composition have been sprayed. These initial shapes will continue to darken as the remaining layers of paint are sprayed.

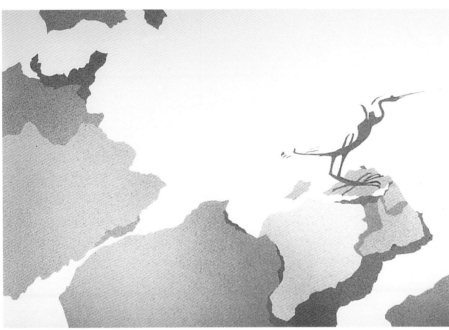

6 Spray the Next Darkest Values
Carefully cut out the shapes that are the next darkest in value (those shapes which are medium to medium dark), and spray them with a combination of all three primary colors. If you'd like an area to be mostly green, spray with quite a few layers (usually between four and eight) of yellow and blue. You must let each layer dry between sprays or the little drops of color will run together and give a mottled effect instead of the characteristic glow of watercolor that results from allowing each individual droplet to show. As you spray the mid-value shapes, the unprotected darkest shapes get even darker. This is why we do not have to initially spray the darkest shapes all the way to their final dark value.

7 Lighter Values Next
Continue cutting and removing pieces of film, then spraying. You can manipulate the color of individual shapes by aiming the atomizer only at those areas. There will always be some overspray unless you save a piece of film to re-cover an individual shape. This can be done and is a way to keep a shape lighter in value while you continue to spray other areas.

8 Complete Rock Shapes and Continue Spraying Water Shape

All the rock shapes have been sprayed at about their final value. The largest shape, the water, has been sprayed to its mid value. As you near completion, most of the shapes will be either very light in value or actually white, your lightest value. The only shapes left to spray are the smaller shapes within the heron itself.

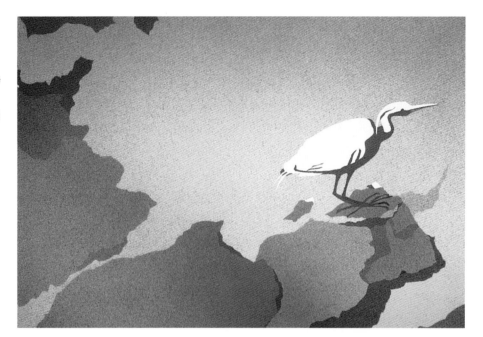

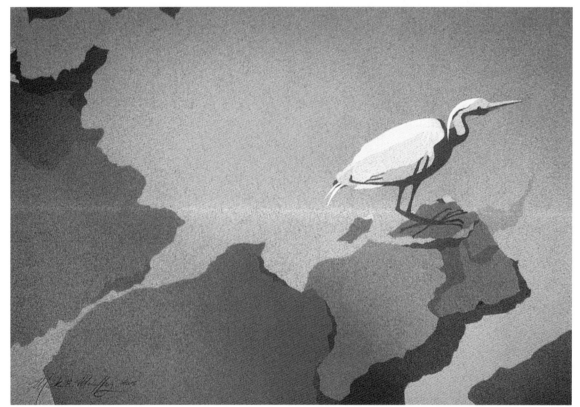

9 Finish

Cut out the two tiny shapes near the heron's feet. Before spraying the lightest shapes of the heron, spray a diluted mixture of Cadmium Yellow Deep over most of the painting, concentrating on the middle and the lower right. The warm yellow acts to unify the whole and to accentuate the white or lightest shapes that will be created or revealed at the end. Carefully cut and remove the film over the next-to-lightest shapes on the heron and spray from a greater distance of two to three feet away (51cm to 91cm). This allows the spray to build up very gradually so that you may control the final sprayed value more accurately. Cut and remove the final pieces of film on the heron, leaving the lightest value of white. When the modeling of the heron is completed, the painting is finished.

HERON ON THE ROCKS
Mark E. Mehaffey • Sprayed transparent watercolor • 21" × 29" (53cm × 74cm) • Collection of Matt and P.J. Hoover

use all the complements in one painting

This way of handling color evolved during a long recovery from surgery. I did not have the energy to draw with pencil and then paint in layered washes in a traditional way. I took a rigger brush dipped into Cobalt Blue (that's the color I had the most of) and drew with the brush directly on my watercolor paper. I then filled in with what I thought at the time were rather garish, riotous colors. I used all three complementary color groups together, within one painting. It was wild and fun.

I have since refined this method of working. Most of the time now, I draw in my sketchbook the basic shapes and their corresponding values. I intuitively use all three complementary color groups (red/green, yellow/violet and blue/orange)—the primaries and their opposite secondaries—within one painting. I try to tilt the color dominance to one color family toward the end of the painting.

__Note:__ Use tube watercolors for this demonstration. Pan watercolor will not give the thick consistency necessary for highly saturated color.

1 Make Preliminary Sketches

I often have my workshop participants do more than one value drawing before selecting the best one to paint. Both of these preliminary drawings have a similar arrangement of shapes (the landscape) but different value patterns. I chose to paint the one on the right because I like the greater contrast in value between the smaller shapes representing the buildings and the larger background shapes.

2 Define Shapes With Line in Final Drawing

Using your rigger dipped in a thick mixture of Cobalt Blue (or any color you choose), begin drawing freely with your brush. Try to vary the quality of the line as you draw—from thick to thin and back again. This kind of line is much more visually interesting than a line of all one width. If you are doing a landscape, you may even make the lines that are closer to you in space thicker and those that recede in space thinner.

materials

surface
300-lb. (640gsm) Arches rough or cold-press watercolor paper, 15" × 22" (38cm × 56cm)

watercolors
American Journey: *Cobalt Blue, Skip's Green, Wild Fuchsia*
Daniel Smith: *Cadmium Yellow, Hooker's Green, Phthalo Blue, Quinacridone Rose*

other
Brushes: *no. 6 rigger, rounds of various sizes (no. 10 for large shapes, no. 6 or 8 for smaller shapes, no. 4 for smallest shapes)*
5B graphite pencil
Sketchbook

3 Begin Painting at the Center of Interest
Squirt a large amount of all colors you think you will need onto your palette. Use fresh paint, straight from the tube. It is much easier to make a highly saturated color mixture with fresh tube color than to try and put dried pigment into solution. To set the tone for the entire painting, begin in or around your center of interest and build out from there. Try to be bold with your choice of hue. Add a very strong blue next to a very strong orange or a strong red next to a strong green. See where both of these complementary groups have been added, creating excitement from the start.

4 Use Gradation for Interest
Continue painting, working out from your focal area. For added visual interest, consider using gradation from lighter to darker or from one color to another within a shape. Try not to overdo the use of gradation; some shapes should be painted flat, with one overall tone. Those shapes that contain gradation will contrast nicely with areas of flat tone.

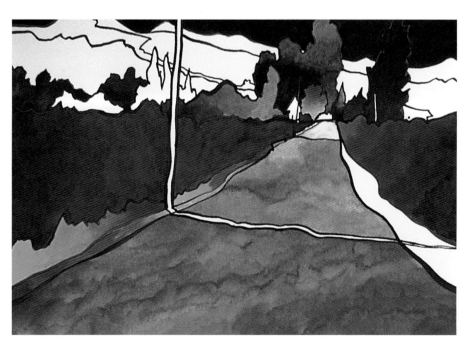

5 Add a Neutral to Balance Intensity
Highly saturated, intense colors will look entirely more so if they are balanced with some neutral grays. Mix your neutral colors by combining three primary colors, such as Cadmium Yellow, Quinacridone Rose and Cobalt Blue. These three pigments will yield a great variety of neutrals. If you'd like a warm gray, simply add a touch more Quinacridone Rose to your neutral mixture; conversely, for a cooler gray, add a bit more Cobalt Blue. For this painting, the large shapes that make up the road are all painted with warm and cool neutrals, with a cool violet-gray neutral dominating the mixture.

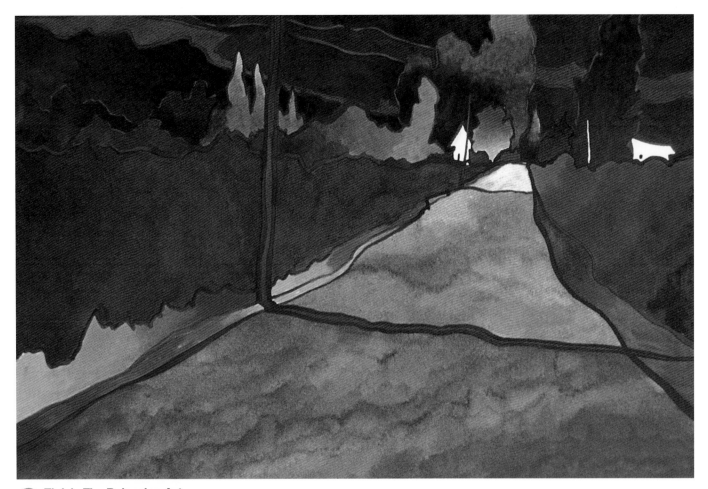

6 Finish: The Balancing Act

As you get closer to completion, the decisions regarding color become more critical. Slow your painting rhythm down so that you think more and paint less. The last shapes to be painted are usually where you will determine the overall color or temperature dominance. Dominance of color or a color family will unify the whole painting. As you paint those last few shapes, tilt the color dominance one way or the other. As I filled in the remaining shapes, not only did I increase the value contrast between the lightest shapes (the buildings) and the dark background shapes (the hills), but I also tilted the temperature toward cool. I further tilted the color dominance toward the analogous colors of blue-green, blue and blue-violet, giving the whole work a more unified appearance.

COUNTRY ROAD #2
Mark E. Mehaffey • Watercolor • 15" × 22" (38cm × 56cm) • Collection of the artist

[T I P] Often if your work has a disjointed look or it appears that the colors just don't go together, it is because there is a fifty-fifty split between color families (reds and greens, for instance) or between warm and cool colors. Strike an uneven balance.

Make the value contrast greatest at your focal point

This painting began with an intense, highly saturated underpainting that I let dry before working on top with heavy, dark watercolor pushed to the point of opacity. The one sliver of sunlight showing at dusk acts as the focal point, directing the viewer's eye. The large dry-brush stroke that defines the foreground water helps to lead the eye up and into the painting.

PICKERL LAKE SUNSET
Mark E. Mehaffey • Transparent watercolor on 140-lb. (300gsm) cold-press watercolor paper • 21" × 29" (53cm × 74cm)

Create movement with size and value contrast

The drama of using extreme value contrasts as a means of moving the viewer's eye through a painting is illustrated in this work. Larger shapes that surround smaller shapes will move a viewer's eye to the smaller shapes because of the contrast in size between shapes. When you add a high degree of value contrast, you further solidify your focal area. This painting also has a temperature dominance, leaning toward the cool colors (blue) with a nice contrast of warm color acting as reflected light.

COUNTRY CHURCH
Mark E. Mehaffey • Sprayed transparent watercolor on 140-lb. (300gsm) hot-press watercolor paper • 30" × 22" (76cm × 56cm) • Collection of Doctors Kyle and Dan Gulick

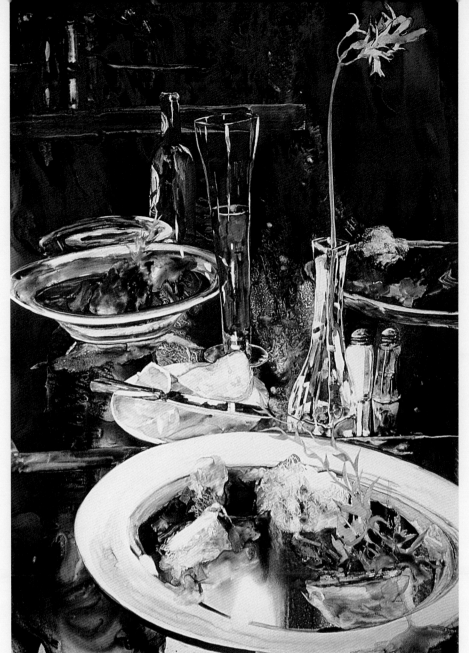

Try designing with texture

The most noticeable compositional element in this painting is texture. The viewer's eye is led into and through the painting by diminishing both the amount of texture and the degree of detail as the shapes recede in the distance.

Yupo, a completely synthetic, plastic surface, produces wonderful surface textures when watercolor is applied and manipulated. This painting uses the texture Yupo gave me after I covered the paper with paint, especially the foreground. The smooth washes in the background areas were the result of tilting the paper to smooth out the paint. Some of the food textures were the result of stamping with a damp paper towel. Most often I lifted shapes from the dark background with a damp, thirsty brush.

AFTER DINNER WITH FRIENDS
Mark E. Mehaffey • *Watercolor on Yupo paper* • *40" × 26" (102cm × 66cm)* • *Collection of Dr. Jeff and Mrs. Tiffany Sevener*

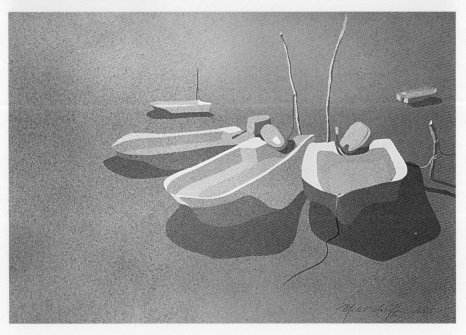

Reinforce a warm setting with a warm palette

This is a predominately warm painting in which the negative shapes, which make up the background, have as much importance as the positive shapes. These large negative shapes act as a foil of contrast for the much smaller shapes that make up the curved string of boats. The very warm colors act to reinforce the warm atmosphere of place. It was almost ninety degrees and very humid—too hot to paint, but not too hot to fish!

LATE AFTERNOON, YUCATAN
Mark E. Mehaffey • *Sprayed transparent watercolor on 140-lb. (300gsm) hot-press watercolor paper* • *22" × 30" (56cm × 76cm)* • *Collection of the artist*

Constructing a Composition WITH Color

Since my painting origins began with landscape, most painting sites found me. It is basically color that stokes my initial enthusiasm and produces an urge to duplicate that same sense of place.

Now, after a long career of painting landscapes, interiors, still lifes and portraits, I have to say that color is still my initial attraction. Next I check to see if the natural composition of the scene will withstand the transfer from real life to reproduction. If so, I then have both the challenge and the problem: how to allow the color to become an instrument of composition.

In this section you will see some of my paintings of interiors and landscapes. Interiors and landscapes are interchangeable in that they are both approached with the same design goals in mind. My aim is to provide a painterly reality, not a photolike reproduction, by (1) considering my subject matter in an abstract way, (2) constructing what I see in front of me with color, and (3) strengthening it with a sound composition. This philosophy can be applied to any subject matter, and it has become the backbone of my work.

Handle a mass of color with repetition
For me, painting is only meaningful when it poses a challenge. The challenge here was the overwhelming explosion of spring color. The problem was finding a way to transfer the sensation of glorious color to paper. Color repetitions, which guide the eye through space from the foreground to the background, solved the problem.

PHALANX ROAD
Jacqueline Chesley • Pastel • 30" × 38" (76cm × 97cm) • Private collection

simplify and bring balance to a busy setting

This was a complex view of a small but wonderfully crowded personal space that comprised two different living areas and had a huge vase of flowers at its precise center. It was this vase and the flowers that I decided to confront head-on.

The greatest challenge was that of balance: how to pay tribute to the flowers while still giving time and space to their surroundings. Monet was the master of this; with him as an example, I decided to attempt this compositional puzzle.

Reference photo
Wonderful living spaces are just that, and it is a joy to come upon a space that inspires the impulse to paint. This house had many places worth painting. After poring over my slides, I selected this particular view, primarily for its complexity and sense of space.

[TIP] I have found that creativity flows best in an organized environment. Because of this, it helps to have a user-friendly work space. Place two tables close to your easel. The first table should be large enough that you can spread out your collection of pastels and see at a glance what you have to work with. On a smaller table, have your bristle brush, chamois cloth and a small tray to hold the pastels you are currently working with. Adding a layer of rice to this tray will help keep these pastels clean. Next to these pastels lay down some white scrap paper for color testing, since what you see may not be what you get.

1 Make a Drawing, If Necessary
Sometimes I work from a drawing, and sometimes I don't. This scene is a bit complex, so I decide the best way to begin is to establish some guidelines. With the aid of a slide projector and a light tan pastel, I make the briefest of outlines to help me navigate.

materials

surface
White 100 percent rag paper, 22" × 30" (56cm × 76cm)

soft pastels
A cool and warm value of each primary and secondary hue, along with their tints and shades (*Note*: I do not use pure black or white to create shades and tints.)
Additional pastels: dark brown, light tan, warm and cool beiges

other
Homosote board coated with white gesso (for mounting)
Sturdy easel
Chamois cloth
Bristle brush

2 Block In Colors

This paper has a definite texture, so once the drawing is established, I begin to block in the colors using soft pastels and a chamois cloth. I use the chamois to spread the color thinly and grind the color into the paper. The first color I choose is one that is a match for something in the original picture. I then jump to the adjoining space with a color that works with my original choice.

Since the vase and its flowers are my center of interest, I decide to simplify the background and not be a slave to the original photo. I add only things that would fill but not overwhelm the background.

Everything is now established and ready to be clarified. At this stage, I spend a lot of time just looking and deciding exactly how to proceed.

3 Begin Defining

I begin to define the painting an area at a time, developing the form of the objects by adding and building with color. I also start to make corrections as needed. For example, the far right leaf appears to extend out much too far, so I decide to simply eliminate it. This I do with a bristle brush, which works as an eraser, taking out as much color as possible. Again I take up the bristle brush in order to simplify the reflection in the mirror, erasing the unwanted shapes and consolidating the color.

Now the painting has reached another stage of completion. Once again I must analyze what I have done and exactly what I must do to encourage the painting to grow to maturity.

Cool down the mirror by adding a slightly cooler beige. This helps to add distance to the space reflected by the mirror.

With a combination of true red and bluish reds, separate and define each flower.

Add warmer blues and cool down the contrasting light tone to suggest roundness in the vase.

Make the center leaves cooler with a dark brown and some very dark red.

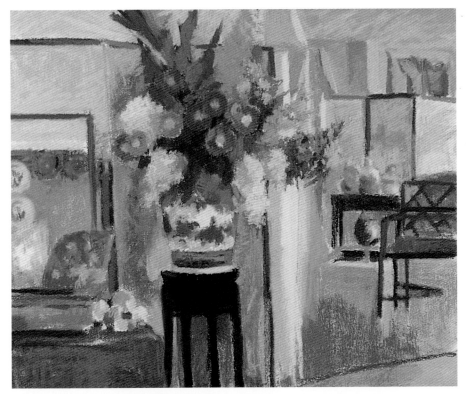

4 Finishing Touches

I go directly to things that need the most fixing. First is the left background, between the mirror and the wall. I cool the color and smooth the area with the help of a chamois. Next I tend to the tea service, which is still a white blob. I add a cooler color and a medium tone to give the appearance of light and shade, which is visually interpreted as volume. I examine the vase and work the color between a warm and a cool blue to add more dimension. Then I apply additional reds in a wider spectrum to the flowers to give greater accent. I examine the greens in the leaves and soften them as necessary.

In the final stages, I imagine the painting as a shadow box, and I check to see that everything is in its place. I also hope I have established that all-important sense of space inside the picture. Since the vase of flowers is the center of interest, I work over this until I can no longer see any glaring inconsistencies.

Now comes the crucial question: Is it finished? Every artist would give a different answer. I was drawn to this interior because of the complexity and sense of space. Since I can't take the painting any further without radically changing the composition, I have to decide if I want to leave it as is or crop it.

5 The Last Hurrah

I decide to crop some of the top, bottom and right side of the painting to bring the composition together. You choose a subject, you paint and then you change the piece to make it work. My challenge in this painting was to build a picture around the flowers—my main focus—which are almost in the middle of the painting. I think this additional cropping balances the entire painting and makes it work as a whole.

INTERIOR WITH FLOWERS
*Jacqueline Chesley • Pastel on paper • 19" × 26"
(48cm × 66cm) • Collection of the artist*

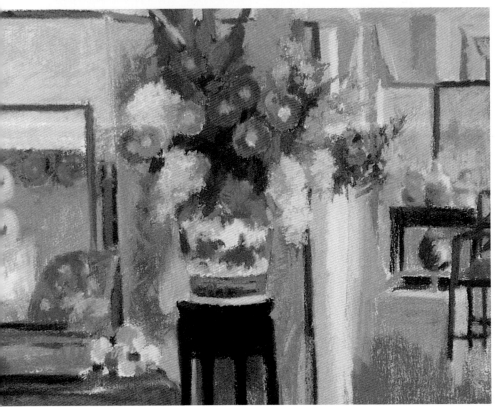

design lessons

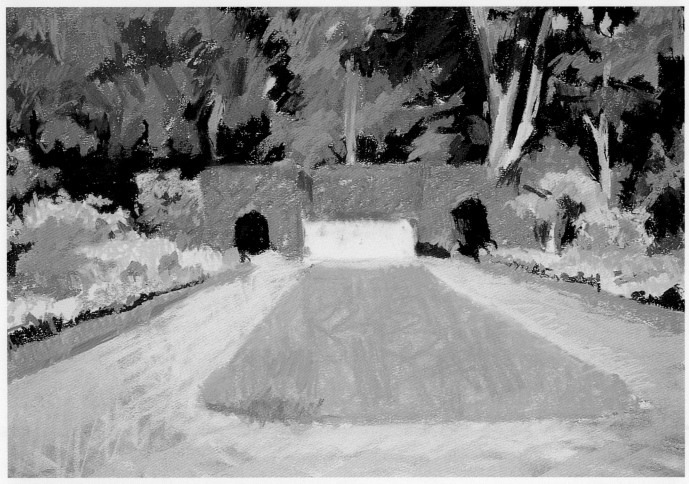

Establish space through careful placement of warms and cools

So often the landscape painter has to deal with panoramic space, great or small. This scene is all about distance and how to handle color so it will create that sense of space on a relatively small piece of paper. It is intervals of warm and cool tones that establish this imaginary vista.

OCTOBER AFTERNOON

Jaqueline Chesley • Pastel • 18" × 26" (46cm × 66cm) • Collection of the artist

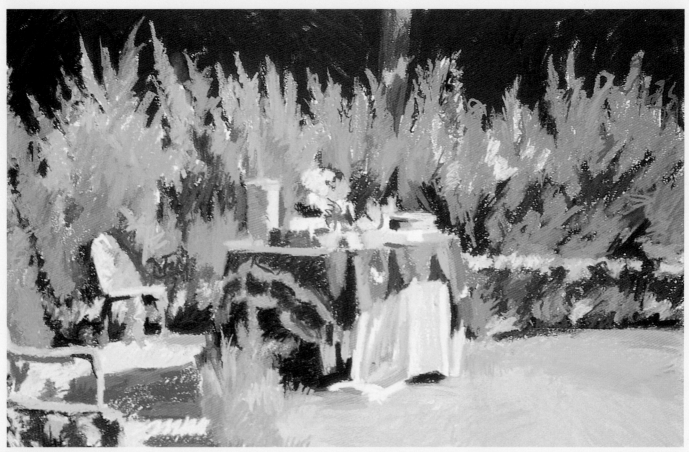

Your memory can be your greatest ally

This was an actual breakfast served on a glorious summer morning. The memory of marvelous food and good company was the inspiration that guided me through the entire painting. This portrait of a happy time has great contrast. The summer light plays against the shadows, moving your eye from dark to light. The chairs on the left are balanced by the expanse of lawn on the right. The simple shapes, great color and great light in this scene made this painting seem to paint itself!

THE BREAKFAST CLUB
Jaqueline Chesley • Pastel • 25" × 33" (64cm × 84cm) • Private collection

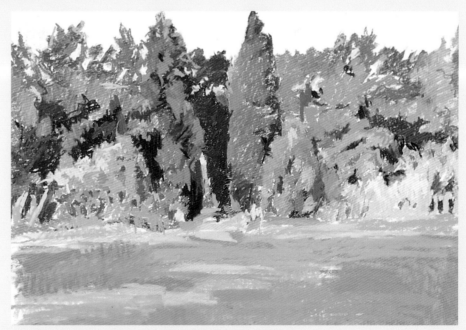

Surround a cool center of interest with warm tones

I loved these tall pines standing guard. Integrating these similar, central images so they would not appear as an obvious midpoint was the kind of challenge I like. Treating the colors that surround the two trees with a warmer palette and bringing these same tones into the foreground made this painting work.

SENTINELS
Jaqueline Chesley • Pastel • 29" × 37" (74cm × 94cm) • Private collection

Look for ways to simplify a complex scene

The challenge in this painting was making a picture that coordinated a very strong background with a rather complicated foreground. My aim was to create a harmony between the two without being overwhelmed by blueness. The yellow of the bananas on the table draws the eye to the foreground and then serves to complement the blue of the background. Concentrating on the shape and color of the fruit allows the foreground to dominate the painting in detail as well as color. Next, I worked to mute the patterning of the background to make it less prominent.

I always remember that I am working with abstract shapes that, when integrated with color, will give an impression of reality.

THE DINING ROOM
Jaqueline Chesley • Pastel • 30" × 36" (76cm × 91cm) • Private collection

Contrast color intensity and temperature for a dramatic impact

This painting is about very strong color, appearing not only as background, but also as foreground. Contrast in color intensity and temperature makes this painting work. I used a true red for the drapes and a cooler red for the carpet. The table and the books on it maintain a cool, low-key presence.

THE STUDY
Jaqueline Chesley • Pastel • 38" × 31" (97cm × 79cm) • Private collection

Eydi Lampasona

ALLOWING A
Composition TO
Evolve AS *You Paint*

Often I work in a nonobjective, simple, meditative manner. This straightforward creative process often begins with the exploration of inner avenues, which end up relating to outer expressions. I prefer originality and truthful art, whether it is realistic, abstract or nonobjective. I start with large, asymmetrical areas of muted colors using acrylic and/or collage papers. This leads me toward a design concept. I do not use a preconceived notion, preferring the composition to evolve.

Texture, strong composition and balance are all crucial in my unfolding creations. By balancing expansive color fields with sketchy lines and radical paint applications to the underlying surfaces, I transform multilayered and simple materials into artistic elements. I scratch, indent and decollage applications, inciting the viewer to react in a contemplative manner. My final intent is having the viewer of a finished piece be a participant, not a spectator. Exploring deconstruction with sanding and/or alcohol washes, I often find myself rebuilding and layering, which allows my work to evolve to its completion. I prefer using ambiguous forms that work at a cognitive level, creating works that echo and reveal a journey.

Successful design embraces many principles and elements of design, such as movement, value, line and harmony. Color needs to be addressed as well in design; however, I opt to limit my palette. Saturation of color can be quite seductive and cause immediate attraction, but I prefer to have the viewer look deeper into the creation with a limited color choice.

Let surface imperfections contribute to a composition
Weathered Wings has an asymmetrical cruciform (or crosslike) design, with the point of interest at the center left, where the cruciform intersects. Equally important are the calm and expansive areas in the painting, giving the viewer a place for the eyes to rest. On occasion, I use plywood and Luan (door skin) as a support board. Often, I leave imperfections such as tree knots and wooden textural designs showing because they can be used as a compositional tool.

WEATHERED WINGS
Eydi Lampasona • Mixed-media collage on Luan • 4' × 3' (122cm × 91cm) • Private collection

use a cruciform design to easily create a balanced composition

*In this demonstration, I will show you how an unlabored and free-flowing cruciform design is created. This particular painting will be a symmetrical piece, centered, but it could work equally well in an asymmetrical manner. In either case, balance is the key to this design. For the most part, design is not creative; what you **do** with design is the creative part. The inspiration for this piece was the actual weather conditions of the day: rainy, gray and somewhat contemplative.*

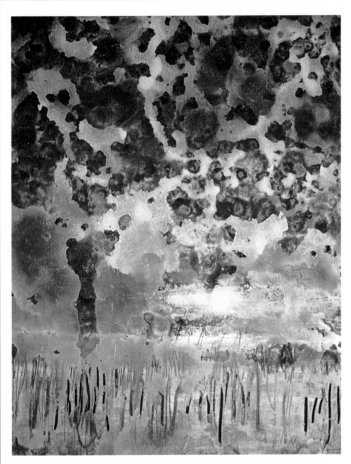

1 Create a Dramatic Beginning

On dry paper, apply a generous amount of black gesso to the entire support surface. This will give you a dark background, which will enhance the dramatic content of the painting. To avoid brush streaks, put the paper on a flat surface and use a foam brush.

After this is dry, apply a thin coat of heavy-body Titanium White over the entire surface using a housepainter's brush. While the surface is still wet, spritz with rubbing alcohol. Do not spray evenly; use a heavier hand in some areas so you will not have a totally uniform look. You will see a strong contrast of value emerge from the separating of the white layer of paint. This separation increases color depth and adds a dramatic impact to the look of the painting. While the surface is still wet, use the handle of your brush to scrape vertical lines in the lower quadrant of the painting. This gives stability to your piece by creating an "anchor" so the piece does not float.

materials

surface
140-lb. (300gsm) Winsor & Newton cold-press paper, 30" × 22" (76cm × 56cm)

acrylics
Golden Fluid: *Nickel Azo Yellow, Payne's Gray, Raw Sienna, Titanium White*
Golden Heavy Body: *Phthalo Blue (green shade)*
Grumbacher: *Titanium White*

brushes
2-inch (51mm) foam brush
2-inch (51mm) hake brush
2-inch (51mm) square nylon bristle house-painter's brush
no. 2 Robert Simmons watercolor brush
no. 6 Van Gogh Filament watercolor brush

water-soluble crayons
Caran d'Ache Neo-color II: *Blue Gray, Gray, Orange, Raw Sienna*
Staedtler: *Green Olive Fonce, Red*

other
Gesso (black and white)
Two spray bottles (one with 70 percent isopropyl rubbing alcohol, one with water)
Golden matte medium
Eberhard Faber Design ebony pencil
Sandpaper, #150 grit

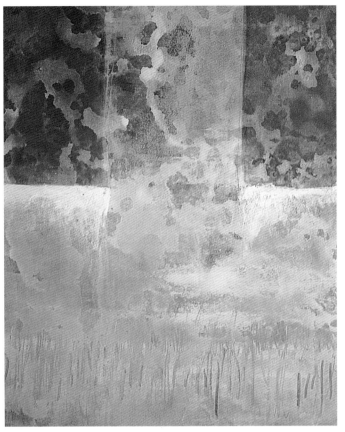

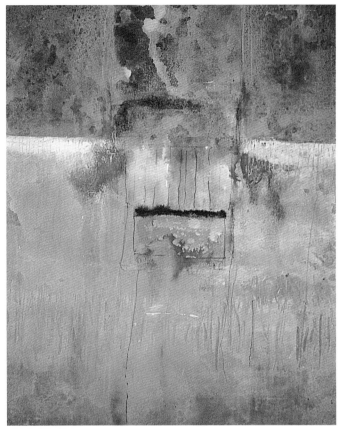

2 Soften the Contrast and Add a Cruciform

Mix some white gesso with a very small amount of black gesso and add it to a generous amount of matte medium. Use this to make a very transparent wash of pale gray. Starting a third of the way down, paint the wash on loosely over the entire lower area with a housepainter's brush. This wash serves as a transition between areas of the painting and creates a more exciting picture plane.

Using a wet no. 2 Robert Simmons brush, put on some extra Titanium White where the wash meets the upper quadrant. This will give greater contrast to the painting and make it more energetic.

This layering technique creates depth and richness while emphasizing the uniqueness of the entire surface. While the painting is still wet, paint a strong vertical stripe down the center of the painting using a paler wash, creating a cruciform. A cruciform design is practically foolproof because of its symmetry and ability to hold the elements of the painting together, giving harmony to your piece. Let the painting dry completely.

3 Add Color and Define Boundaries

Begin by using your ebony pencil to add loose vertical lines and define the boundaries of the cruciform. Use a dampened ebony pencil to bring more interest to the intersecting lines. Lightly water down the surface of the paper evenly with a spray bottle. Add a small amount of Raw Sienna to a generous amount of matte medium and, using a hake brush, glaze the entire bottom two-thirds of the painting. This unifies the surface and the composition by creating a harmony between the visual elements. Then soften the value of the entire structure by lightly spritzing rubbing alcohol all over the piece. Let the painting dry.

[TIPS]

- Label your spray bottles properly so you don't use the wrong bottle.

- Alcohol fumes can be strong, but they are basically nontoxic. Make sure you have enough ventilation where you work, and try not to inhale the fumes.

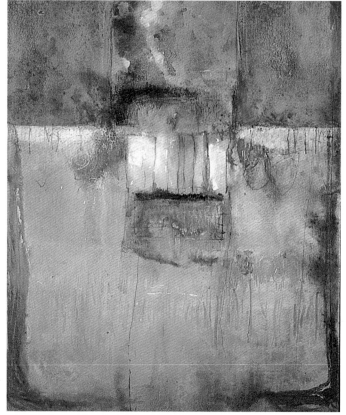

4 Add Water-Soluble Crayons

Water down the dried surface again to make a free-flowing surface. Now you should have a slippery surface that will accept water-soluble crayons easily and allow the crayons to "melt" on the surface. Use warm shades (Raw Sienna) and cool shades (Blue Gray) to enhance and give balance to the overall composition.

The contrast in value will give a texture and pattern to the surface, creating interest and a visual impact in your painting. You will notice that the upper third of the painting is darker in hue and the bottom is lighter. Draw on the surface with a Green Olive Fonce crayon, moving the color around with your fingers. This will give your painting an organic appeal. Use a no. 6 filament brush to paint surface areas with Nickel Azo Yellow and Payne's Gray.

5 Enhance the Overall Composition

Again, lightly spritz the entire surface with water to make a free-flowing surface. Using your Gray water-soluble crayon, outline the lower two-thirds of the painting to add containment and intimacy to the overall visual. Because the value structure has become somewhat muted, enhance the value structure by adding more Grumbacher Titanium White with a no. 2 Robert Simmons brush to the vertical cruciform line and to the central box in the middle of the painting.

[TIP] If you find that you are becoming too rigid or stiff with your brushstrokes, try using your brush or pencil in your less dominant hand. This will give your strokes an unlabored, fresh approach.

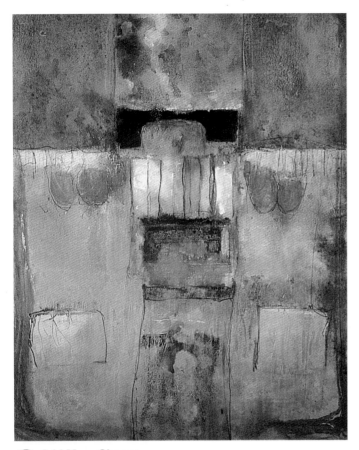
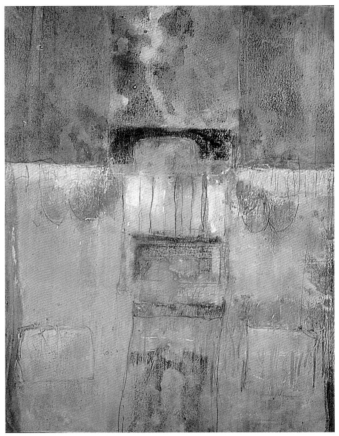

6 Add More Shapes

This step adds more squared images to the lower right and left. Using your ebony pencil, outline the area where the squares will go. Make up a glaze of Titanium White and matte medium and use a no. 6 brush fill them in. This will give your eye a place to travel and lead it around the painting, giving stability and balance.

With the ebony pencil, make four organically shaped circles under the horizontal line. With the no. 6 brush, wet the insides of the circles with water and fill them in loosely with a Gray water-soluble crayon, rubbing the paint with your fingers to smooth it. Add some Gray water-soluble crayon to the horizontal line of the cruciform for added balance. Enhance the upper part of the cruciform by painting a dark blue rectangle (building a bridge) with Phthalo Blue.

Use Red water-soluble crayon, ebony pencil and Payne's Gray to accentuate the edges of the square boxes you put on the bottom left and right areas of the painting . On the upper third in the right and left quadrants, mix a little Raw Sienna with matte medium and paint it on with the hake brush. Now step back and look at the painting.

7 Finalize the Painting

A couple of areas did not work well after step six. The dark blue color added to the bridge was a bit too strong and hard and needs softening. The red lines around the square shapes are distracting and do not belong. I have been using complementary colors and have established a color scheme. The introduction of the red hue disrupted the color scheme.

Once we correct these two issues, your painting should be finished. To correct the areas that do not work well, lightly sand the painting with sandpaper. That's right, sand it! This will take away the harshness of the blue bridge, mute out the red and give it a weathered look.

Now you have successfully completed a painting based on cruciform design. This image evokes strong memories of windows and doorways in weathered barns and buildings. This is realism pared down to its essence. The veil of mist adds a certain mystery. See the very watery texture created, hence the title of the painting.

RAINY DAY
Eydi Lampasona • *Mixed media* • *30" × 22" (76cm × 56cm)*

Learn the rules, then learn when to break them

By using the rule of thirds and a strong value base, this simple yet dramatic piece is structured by weight. The lower-right horizontal dark base balances and anchors the large dark area on the right side. The operative word here is *simplicity*.

Elusive View is a perfect example of breaking the "rules" of design, which one may do after learning the rules. This painting is practically split down the middle, which divides it evenly. However, by having quite a value contrast between the dark and light expansive color fields, visual weight has been struck by dominance, which the dark, somber color does. By working from macro to micro (large to small), I was able to lead your eye into the small "mark of the artist" areas, which create interest and show movement.

ELUSIVE VIEW

Eydi Lampasona • Mixed media/collage • 30" × 24" (76cm × 61cm) • Private collection

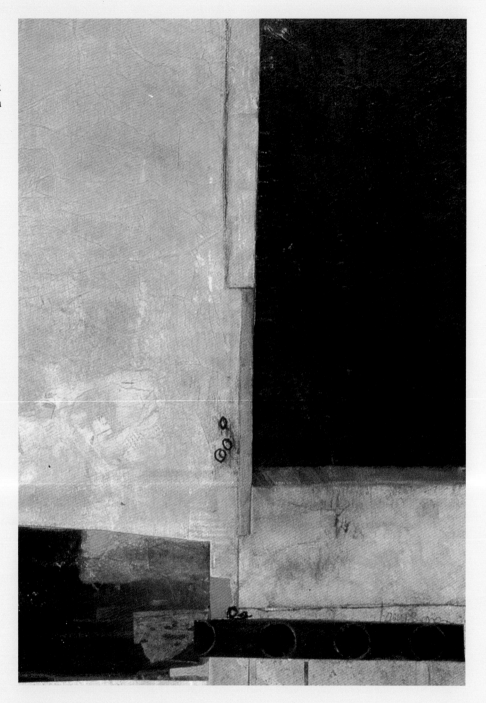

[TIP] How do you know when you've completed a successful design? Several factors come into play, such as listening to your inner voice. Rarely, if ever, will it steer you wrong. Haven't we all at one time or another gone a step too far with a painting and wished we would have left it alone? I would suggest intuitive judgment. Put away your work for awhile, and view it later with fresh eyes. What has often worked for me is to view my work turned upside down and sideways or in a mirror. This either confirms a finished piece or pops out problematic areas to be worked on.

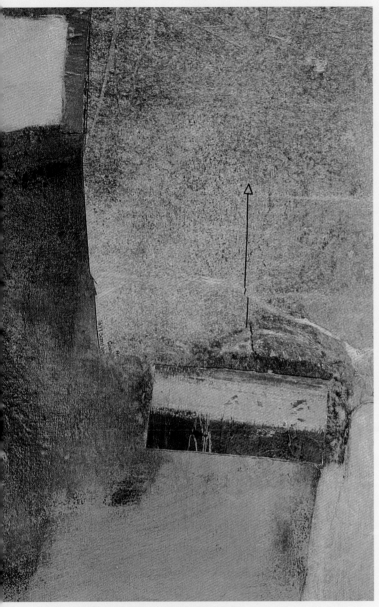

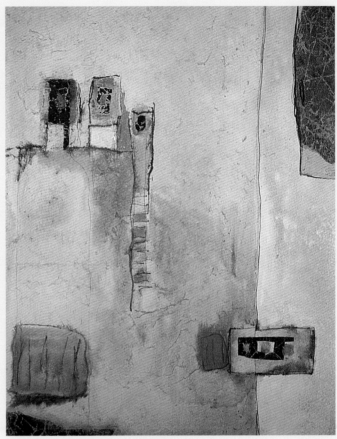

Provide a road and a rest stop
One principle of good design is to enable the viewer's eye to travel around the painting while giving a focal point or resting place. The three small squares in the lower-right area of the painting are an intriguing point of interest. Additional repetition of the square shape in different colors and outlines creates a visual pattern for the viewer's eye to follow.

While this painting stands as a nonobjective piece, its beginnings can be seen in torn posters that are passed daily.

POWER OF THREE
Eydi Lampasona • Mixed media/collage on 140-lb. (300gsm) cold-press watercolor paper • 30" × 22" (76cm × 56cm)

Unify with complements and texture
This piece has an asymmetrical design, with the rectangular shape in the lower quadrant being the dominant element. The continuation of the same yellow-orange color balances the composition. Complementary colors and texture work to the benefit of the piece, unifying the elements.

HEADLINE HIDE
Eydi Lampasona • Mixed media/collage on watercolor paper • 30" × 24" (76cm × 61cm) • Collection of the artist

Artists have practiced encaustic painting for over two thousand years. It is the oldest painting technique still in use today. Encaustic literally means "burning in." It is an ancient Egyptian method of painting with hot wax, where

MOVING FROM *Literal* *Interpretation* TO *Impressionism*

heat is applied with a torch to seal the layers of wax pigment to a surface. Today, molten bleached beeswax and damar resin are combined with dry pigment and painted onto a rigid surface. When finished, the surface is fused with a heat gun to burn in the layers of colored wax permanently. A final polish with a soft cloth is all that is needed to make a rich, enamel-like surface, making the painting durable. Some ancient encaustic paintings have lasted for thousands of years.

Artists bring the same composition and design concerns to each painting regardless of medium or subject. I usually paint something I have seen in nature that made me stop in my tracks and observe, whether it is a scene, object or person. What I can't sketch at the time, I take photos of to use later in my studio.

In approaching the design of a painting, the first key is to determine what I want to say and how to show the viewers where I want them to concentrate. Choosing the focal point of a painting and planning ways to accentuate it are keys to good design. I try to encapsulate the excitement of the scene by placement on the surface using these basic elements: line, form, color and value. These elements form the visual language of the artist and hopefully will work together to produce a successful painting composition.

Encaustic painting affects colors mostly. Lines can be softened easily, and blending is done with the heat gun. Colors are enhanced by heating and will not get muddy, no matter how much gets changed or painted over. The least important part to me is worrying about making changes as I go along. Encaustic paintings can be reworked again and again to strengthen the values or the composition without looking overworked.

Create a "watery" design
I painted on dark mat board so the fish would look more glowing. I used gold paint and pearlized colors to make it shine more and look like the fish were underwater. These fish were painted from my imagination. I call them "Masom Fish."

ENCAUSTIC FISH NO. 2
Dorothy Masom • Encaustic on mat board • 16" × 20" (41cm × 51cm)

rework subtleties for a better composition

Artists who are new to encaustics are surprised at the rapid drying of the strokes and the ease of overpainting without getting muddy colors. The colors immersed in the wax come to the surface when the final fusing is done, making the colors change from dull to brilliant. After the final buffing, the colors seem to rise to the surface and glow.

The most important design elements in this demonstration seem to be the values of light and dark, placed at crucial points to capture the viewer's attention. My reference for this particular painting was a bouquet of fresh flowers. All of my other paintings are done from sketches or photos.

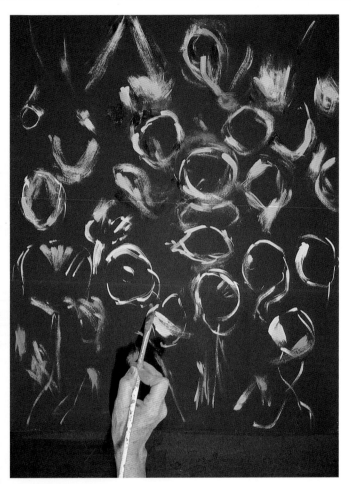

1 Sketch the Subject With Light Colors

Recoat the art panel surface with black gesso. I prefer working on a dark surface because this helps me understand my values better. Sketch in the subject, a close-up view of a field of flowers, with a bristle brush and light-colored encaustic colors.

[TIPS]

Here are a few helpful hints for working in the unique medium of encaustics:

- Encaustic colors can be made by mixing permanent, dry, colored pigment with wax and damar resin, but it is easier to buy ready-made colors. The names of the colors used are the same as oil paints.

- Heat the colors in muffin tins on an electric heating tray. Start painting when the colors in the muffin tin are molten and glide easily.

- Color mixing should be done on the electric tray at about 200°F (93°C). Over 300°F (149°C) will cause the wax to smoke.

- Use brushes made of bristol or ox hair. Good brushes such as sables should not be used, as they will burn.

- Keep brushes on the heated tray when not actually painting. A cool-edged tray is best so the handles of the brushes stay cool to the touch.

- Use adequate ventilation when working with encaustics.

materials

surface

24" × 20" (61cm × 51cm) Windberg art panel
(Clayboard, gesso coated)

R&F encaustic paints

Alizarin Crimson
Cadmium Orange
Cadmium Red Light
Cadmium Yellow
Cadmium Yellow Light
Cerulean Blue
Chromium Oxide Green
Deep Purple
Ivory Black
Manganese Blue
Manganese Violet
Naples Yellow
Titanium White
Viridian Green

other

Brushes: *bristle brushes, brights and filberts of various sizes (nos. 1, 3, 5, 7, 9 and 12)*
Black gesso
Electric heating tray
Muffin tin
Heat gun
Lint-free cloth
Palette knives

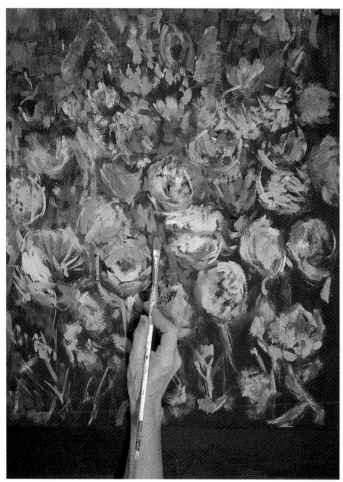

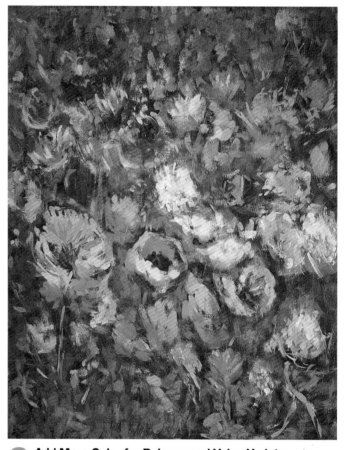

2 Start Filling In With Color

Add more color to the entire surface to keep the painting working as a whole. Add Deep Purple and Alizarin Crimson for more darks. Try for nice color variety in your greens. Colors can be reworked over and over again, as the wax dries instantly.

3 Add More Color for Balance and Value Variety

Add more details to the flowers, constantly painting over the entire surface to keep it fresh looking. Add colors that balance the composition. I brightened the orange flower on the top right and added more orange flowers to the top left to balance the orange on the right. In addition to several shades of Cadmium Orange, I added Titanium White, Manganese Violet, Cadmium Yellow, Cerulean Blue and Chromium Oxide Green. The colors should be arranged to juxtapose opposite colors on the color wheel for contrast and excitement and also to bring balance to the composition to attract the viewer's eye to the center of interest.

Try to keep the strongest contrasts away from any edges of the painting; you want to confine viewers to the area near the center. Add more darks to surround the flowers. Add Ivory Black to the centers of the flowers and to define the shapes of the flowers. It is not necessary for all the flowers to have a center; this adds variety.

4 Fuse the Painting and Keep Working

Fuse the painting with a heat gun, holding the gun over small sections for a few seconds until the wax turns wet and blends the colors. Control the heat by simply raising or lowering the gun on the surface. You can blend the colors only slightly or you can let the colors melt to a greater extent if you want to create more abstract effects.

After the entire surface is fused, let it cool, then work over the entire painting again. I reworked the white flowers in an effort to keep the highest value contrasts near the center of interest. In an overall pattern, you keep adjusting colors and values until they look right. The bottom flower to the left of center seems to attract too much attention and is adjusted so that the viewer's eye is drawn to the entire poppy field, not just to that one flower.

The colors are softened and integrated in the whole painting and the bright, strong colors are slightly muted to simplify them. Emphasize the flowers in the center by adding more dark greens and playing down the flowers near the edges by painting darker colors to make them recede. You want the viewer's eye to stay in the center, not there.

I decided that the upper-left portion of the painting was too busy and the color too intense, so I eliminated some of the flowers to quiet the area and give the viewer's eye a rest. By muting the color of the flowers, the area recedes, giving depth to the painting.

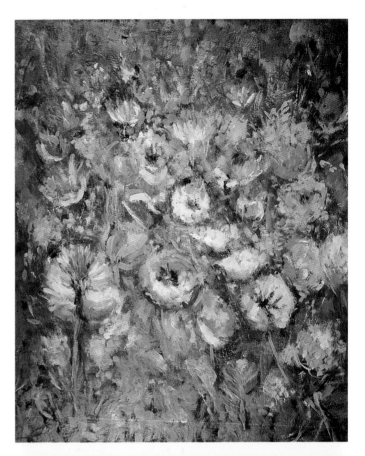

5 Refine Value Changes and Other Details

Fuse the painting again to blend the colors and integrate the surface. The wispy leaves behind the flower in the upper right are eliminated. The flower below and to the left gets a more pronounced center, and the shape is slightly modified. Cadmium Yellow Light is added to the orange flower in the upper right next to the edge to lighten the value. The blue is lightened on the flower in the left quadrant of the painting for value change as well. The flower above and to the right gets an added white line and the start of a darker center. Further modeling is made on the top white flower in the center. The small petal that is changed to jut out on the bottom left of the flower will remain in the final step and finish. This becomes a directional line to move your eye to the dominant poppy below. I am finding my way to the finish.

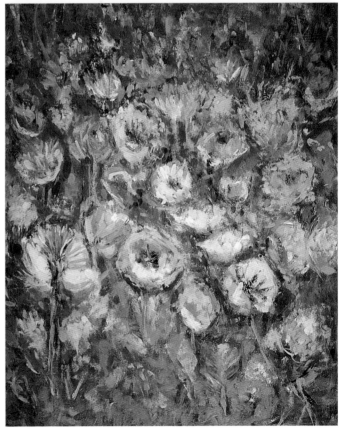

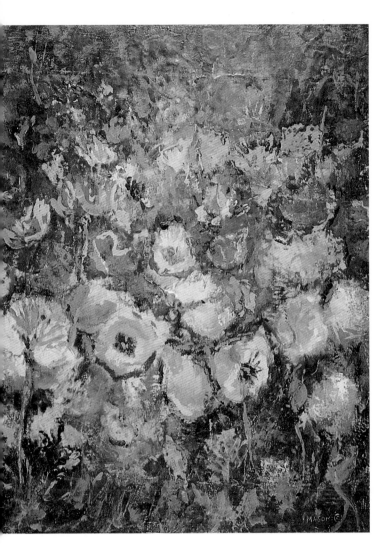

6 Finish

Many changes take place in the final step. In the first steps, I establish a literal interpretation of my subject. In the final stage, I actively break up and fracture the imagery to show a more impressionistic, personal style.

I punch up the color for value and color contrast. Cadmium Yellow Light and Naples Yellow are added to lighten and brighten the yellows for contrast of intensity and to add more yellow in general. Manganese Blue is added to play the complements of blue and orange against each other, adding excitement and more darks to the piece. Greens are made darker using Viridian Green, and more form is established in the bottom leaf area. Whites are added for further brightening. Look at the white added to the dominant poppy edge: The center is now more defined and the contrast of dark against light draws you into the painting.

Additional changes that made a significant difference were changing the direction of the spiky pink flower at the top to the right and moving it slightly. The diagonal slant creates a more rhythmic flow. The flowers to the left of the pink flower were unified by color to make a bigger shape, creating variety in shapes in the overall painting. Flowers were eliminated to create more negative space. The negative spaces are as important as the positive spaces. The line at the bottom edge of the dominant poppy is made stronger and more solid with an additional application of Alizarin Crimson. The center of the poppy in the lower right is made more pronounced.

As I change the literal interpretation, I create a more patterned application of color, keeping in mind that fusing further alters the colors as well as the appearance. Fuse the painting again to blend the colors and integrate the surface. This will be the final fusing with the heat gun. Fusing allows the hues in the underpainting to rise through the wax surface, and it gives a more vibrant look to the color. After the painting cools for about four minutes, polish the surface with a lint-free cloth until the whole surface glows. The painting now has the same appearance as enamel.

The painting is finished. I feel the painting has harmony and unity, and there are no other changes I would like to make.

Poppy Fields
Dorothy Masom • Encaustic • 24" × 20" (61cm × 51cm)

Pull the viewer into your painting with one-point perspective

This painting was inspired by a place in Butchart's Garden in Canada. One-point perspective was used to lead the viewer into the solarium. Everything else in the painting was intentionally placed to keep the viewer inside the painting and to hold interest near the center.

SOLARIUM
Dorothy Masom • Encaustic on Masonite •
36" × 36" (91cm × 91cm)

Experiment with a monoprint

I began by painting the Nefertiti image on one half of the primed (white gesso) Masonite using Viridian Green, Ultramarine Blue, Alizarin Crimson and touches of gold. Then a piece of flat, smooth watercolor paper was placed over the painted face, and a hot, dry iron was pressed over the image. The wax melts from the heat of the iron and can be easily lifted. I check to see if the image is lifting off and always work from top to bottom.

The dual image design came from using a "happy accident." I pulled the print and placed it aside while answering a phone call, and came back to discover a better composition of a face looking at another face. The lifted-off print was then glued onto the opposite side of the primed Masonite support, creating a mirror image. I touched up some colors here and there to make the dual portrait seem closer in value, touched up the center line, and gave the painting a final fusing and polish.

NEFERTITI IMAGE
Dorothy Masom • Encaustic and monoprint on Masonite and paper •
17" × 24" (43cm × 61cm)

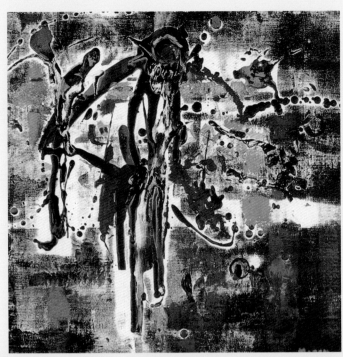

Attempt a literal interpretation

During a Lenten season I read in the Bible Psalm 22:14: "I am poured out like water, and all my bones are out of joint. My heart has turned to wax; it has melted away within me." The words *wax* and *melted* seemed to leap out at me. I had been working with melted wax (encaustic) paintings for years, trying to find a way to express my feelings about Jesus through this ancient way of painting. It was an inspiration for me to try a wax painting based on the very words used as part of the Crucifixion scene.

The melted wax literally poured on the surface of the painting, and gold wax was melted in the scene, depicting Jesus' aura along with the cross. Dark red painting was added to show how Jesus bled in this darkest day, his suffering in a timeless tragedy. The cross was placed in the center for emphasis and strength. Thus a series was born.

STATION 12—THE CRUCIFIXION
Dorothy Masom • Encaustic on Masonite • 18" × 18" (46cm × 46cm)

USING YOUR *Computer* AS A *Tool* FOR *Creative Design*

Computers are becoming increasingly prominent in the world of art. There are many advantages to knowing this complex and versatile tool. I had the opportunity to learn about the computer when I worked as an editorial designer. Before computers, putting together a magazine required an entire staff of people. As the computer became more popular, many people were no longer needed to take a concept from beginning to end. One designer could do the work of four to six people and have more creative control.

As I used my computer daily, I slowly started to depend on it. I used all the design elements that were easy to execute and omitted those that were difficult or time consuming. I noticed all my work started to look the same. Although it was done well, my work became lifeless. I saw that the older designers who had not started using the computer exclusively still had exciting work. I realized I had fallen into a trap.

I was no longer a designer: I had turned into a computer technician. As hard as it was, I pushed away from the computer and turned again to my drafting table. Only after I had done the creative part of my designs did I turn to the computer to execute the ideas. Almost immediately, my work started improving. I learned a valuable lesson: A computer is not a substitute for creativity. It is merely a tool. Now, instead of using my computer to create ideas, I use it to execute them.

Working now as a fine artist, I still use the computer. I scan my drawings and change the size and/or proportion without losing the spontaneity of the originals. I manipulate images to find the best combinations and design possibilities before starting a painting. When searching for a color choice, I photograph the painting, scan it into the computer and try multiple options before actually applying paint to paper. It is a wonderful tool.

Blend two compositions into one painting
In this painting, I maneuvered the figures in my computer until I was able to make them into one shape that spanned the width of the painting. This type of composition I call a "wedge" because the three figures split the page in half. Behind the figures is a simple cruciform composition. By using additional color and pattern, I was able to blend the two compositions into one painting.

DAWN³
Lynn Weisbach • Mixed media on illustration board • 36" × 36" (91cm × 91cm)

firm up your composition with a computer

Nothing is more heartbreaking than finishing a painting only to see a bad design error as you put on the last brush-stroke. To try and avoid this I have learned to use my computer as a sketchbook. I can enlarge, reduce, move or change proportions of parts in a matter of seconds. Not only is the computer faster, I have found it to be more accurate in proportioning subject matter such as figures. By the day's end, I not only have many good possibilities, I have eliminated many bad ones. This demonstration is an example of how I have incorporated the computer into my painting process.

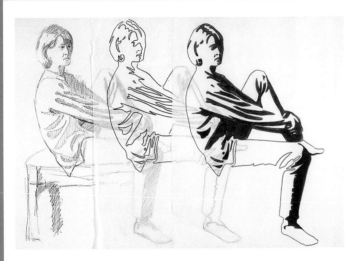

1 Start With a Drawing
I start all my figure paintings the same way. I begin with a drawing or sketch and refine the shapes until I am pleased with the play of light against dark.

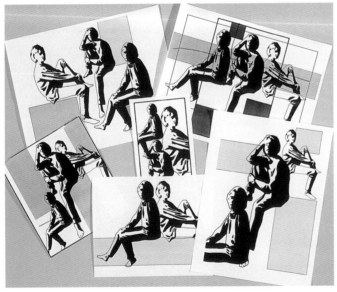

2 Refine the Composition on Your Computer
Each drawing is scanned into the computer independently. This way I have complete control over the size and placement of the individual figures. I manipulate the figures to create a basic composition. I try not to take the computer design process any further than this. I don't want to inhibit the spontaneity of the painting process.

materials

surface
Crescent No. 110 Illustration board, 36" × 36" (91cm × 91cm)

mediums
Acrylic paints, various colors
Dr. Ph. Martin's Tech Ink: *Antelope, Olive Green, Rose, Turquoise*
Watercolor crayons and pencils, various colors
Watercolor paints, various colors

other
Onion sack
Plastic needlepoint canvas
Fabric lace
Papers: *tissue, collage, tracing*
Bubble wrap
Dried and green leaves
Cheesecloth
Grout tool
Rubber rug liner
Drywall spackling tape (used to repair drywall)

Plastic wrap (preferably Saran wrap)
Hole-punched polyester film (Mylar)
Various stamps
4B or 6B pencil
Craft knife
Paper towels
Brown paper tape
White gesso
Computer with Adobe Photoshop software (or another similar program)
Scanner

3 Test a Variety of Different Backgrounds

As a separate process I begin my backgrounds. I like to work on several backgrounds at the same time. This way I have a variety of colors and textures to test with my figures. Also, by working on the backgrounds independently, my tendency to "control" the colors and textures is eliminated. I find that the more I try to control the process, the worse the backgrounds look.

I start by taping the edges of my illustration board for protection and covering the painting surface with white gesso. While it is still wet, I press different objects into the gesso to create multiple textures, and I set it aside to dry. Nothing in my home is safe from this step. I use lace, shoe soles, sea sponges, plastic needlepoint canvases, grout tools, bubble wrap, cheesecloth, leaves and anything else I believe will make a good pattern. (Incidentally, light blue was rubbed over the gesso in the top picture so you can better see the textures created.)

When the gesso is thoroughly dry, I apply watercolor paint (a color from my basic palette) directly from the tube to the surface of the prepared board. I add water to the fresh paint, one color at a time, starting with the lightest value and moving progressively to the darkest. As the paint moves and blends on the surface, I place a variety of materials into the wet paint. I cover the entire painting with plastic wrap and set it aside to dry.

The beginnings of a background are shown in the bottom right picture. This is not the one I ended up choosing for the finished painting, but it shows many of the textures I commonly use.

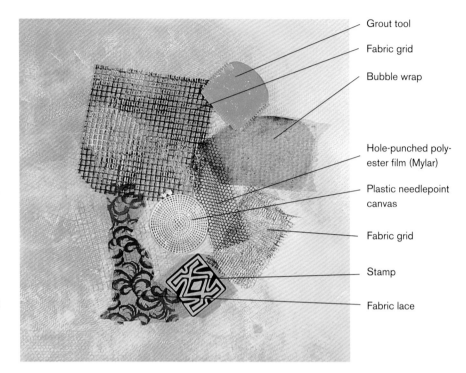

Grout tool

Fabric grid

Bubble wrap

Hole-punched polyester film (Mylar)

Plastic needlepoint canvas

Fabric grid

Stamp

Fabric lace

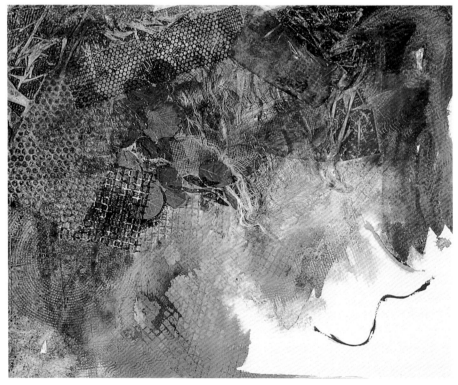

4 Choose a Final Background

After I remove all the dried materials, I place the final figures on a variety of different backgrounds. I consider three things: (1) What textures fall into what shapes? (2) Do the textures add or distract from the figures? (3) Once I have lifted the shapes that make up the figures, will there be interesting textures that remain?

Once I have settled on a final match of figure and background, I begin the next step. The other backgrounds I save for another figure painting. Eventually there is a figure for every background I make, so I don't worry about wasting my materials.

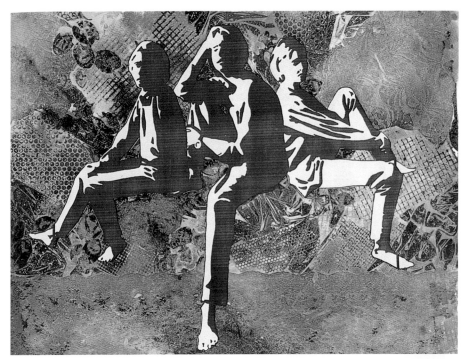

5 Make Figure Drawings on Tracing Paper and Cut Out Highlight Shapes

I trace each figure separately onto tracing paper. This allows me to make the final adjustments of figure to background. (Also, tracing paper is much easier to cut than computer paper.) When I am satisfied with my figure placement, I carefully cut out each highlight shape with a craft knife. Since there are so many shapes involved with the figure, I always keep the computer printout handy so I can refer to my original drawing if needed.

I tape the tracing on the background. Using tracing paper gives me a preview of how the figure and background will interact once the light shapes are removed.

6 Trace the Highlight Shapes Onto the Background

As I cut each shape out of tracing paper, I draw the shape directly onto the background using a 4B or 6B pencil.

7 Lift Paint from Highlight Shapes

I flood each highlight shape with clean water. The gesso is a very slick surface for watercolor, and the paint releases easily in just a few seconds. Only the highlight shape is removed. The background color will remain, forming the rest of the figure.

After the paint has loosened from the background, I carefully lift the water and paint with a clean paper towel. I am careful to dab—not rub—to avoid smearing the paint around the edges. I will repeat flooding with water and lifting until all the paint has been removed from the highlight shapes.

Lifting partially completed

As each shape is lifted, the figure emerges from the background. Because of the gesso base, the watercolor lifts easily with just clean water and a paper towel. I continue lifting until the shape is free of paint and the edges are well defined. Sometimes I have to do this several times until I am satisfied with the way the shape looks.

[TIP] Subdue parts of a painting to make other areas more important. This can really help to integrate the subject and the background.

8 Finish

When the figure has been lifted completely, I use watercolor pencils, watercolor crayons, acrylic paints, hand-painted collage papers and sometimes lace itself to complete the painting. Acrylic paints are used only after the figures have been established on the backgrounds to add emphasis to a particular area of the painting.

This is one finish I arrived at using the techniques in the previous steps. Notice how much better the overall design is by cropping the figures. You now come in for a closer look. The legs were too important and the background and figures competed. It is OK to crop for a better composition. Do whatever the painting needs.

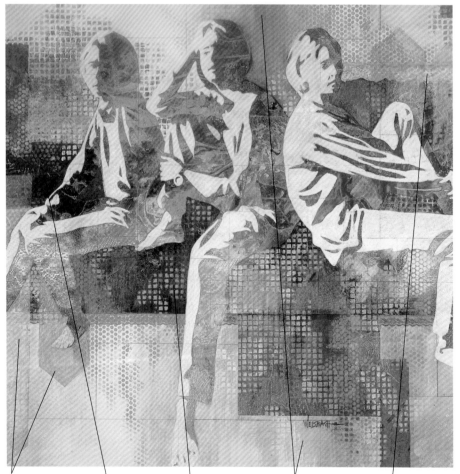

Painted tissue paper applied and rubbed with watercolor crayon

Transparent acrylic paint layered on surface

Handcut grid stencil used with gouache

Damp cloth lightly wiped across the surface to subdue the textures

Lace painted and collaged onto the surface

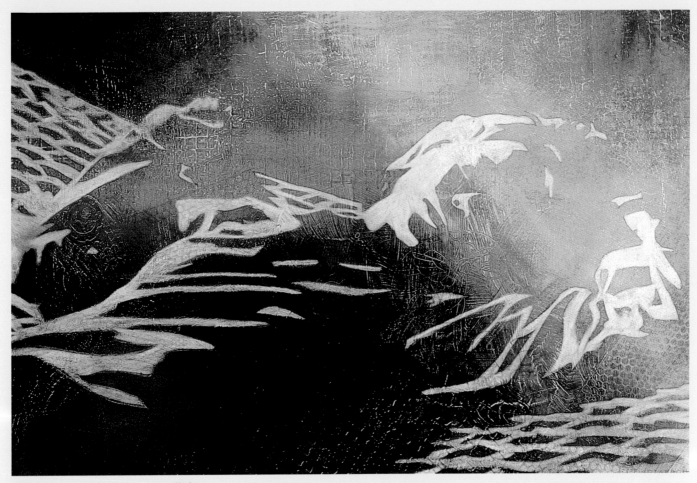

View figure subjects in a new light

This painting is a little different from my other pieces. Instead of placing objects, such as leaves, directly into the applied paint, I put the paint on a damp cloth and rubbed it directly onto the surface with no further modifications. I used values with darks and lights as the dominant consideration and cools and warms as secondary. This worked well because of the complexity of the hammock shapes.

This is a good integration of the background and foreground. The figure was designed as a wedge shape, starting from the left and finishing out the right side of the rectangle. Using the values, I placed the face of the figure in the lightest area to create the feeling of the sun streaming through the trees and across the face. This unusual positioning of the figure, and its integration with the shapes of the background, make you look closer. The band of light makes you want to get in a hammock and feel the warmth.

SUNDAY AFTERNOON
Lynn Weisbach • *Watercolor* • *29" × 38" (74cm × 97cm)* • *Collection of the artist*

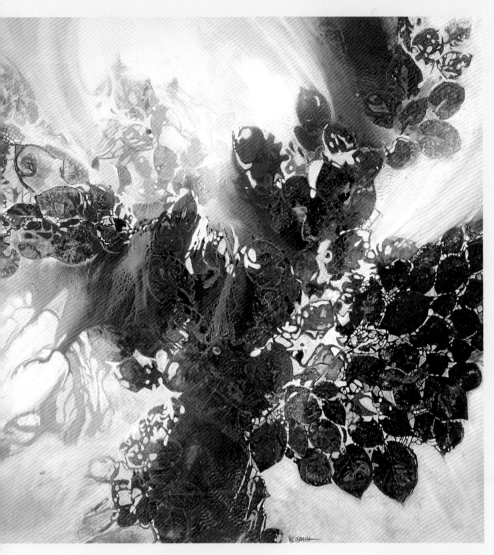

Tantalize the eye with color and texture

My purpose in creating this painting was to see how many warm colors I could use. Value contrast—darks and lights—was used to move the viewer's eye in and out of the cruciform design. Large, simple shapes were created as a contrast to all the strong and busy textural areas and to give the eye somewhere to rest. While I kept to the warm palette, I did use Davey's Gray, a cool color, only to influence the warms and allow for more color variety. Real leaves, placed in wet ink and paint, made for great texture in this painting.

CELEBRATION IN RED
Lynn Weisbach • Mixed media • 28" × 28" (71cm × 71cm) • Collection of Bob and Mary Wolfson

See accidents as opportunities

This piece started as a traditional watercolor painting. The figure and the umbrella reminded me of the beach, so I painted in mainly warm colors, using cools only as needed for shadows and background. I split the square format vertically with the figure and horizontally with the umbrella. The umbrella makes a great integration between foreground and background.

I was just about finished when my dogs barked and I dropped my brush onto my painting. It rolled down the entire image, depositing Indigo paint as it went. I thought the painting was ruined; then I considered this an opportunity to try something new. I cleaned the surface as best I could and covered it entirely with torn pieces of washi paper. I then repainted areas that I wanted to emphasize. I repeated the process four times before I was pleased with the result. I feel the painting is actually better now than I had planned. The rice paper adds textural interest and softens the look of the piece, drawing the viewer in for a closer look.

SUMMER BREEZE
Lynn Weisbach • Watercolor, Japanese washi paper and matte medium • 20" × 20" (51cm × 51cm)

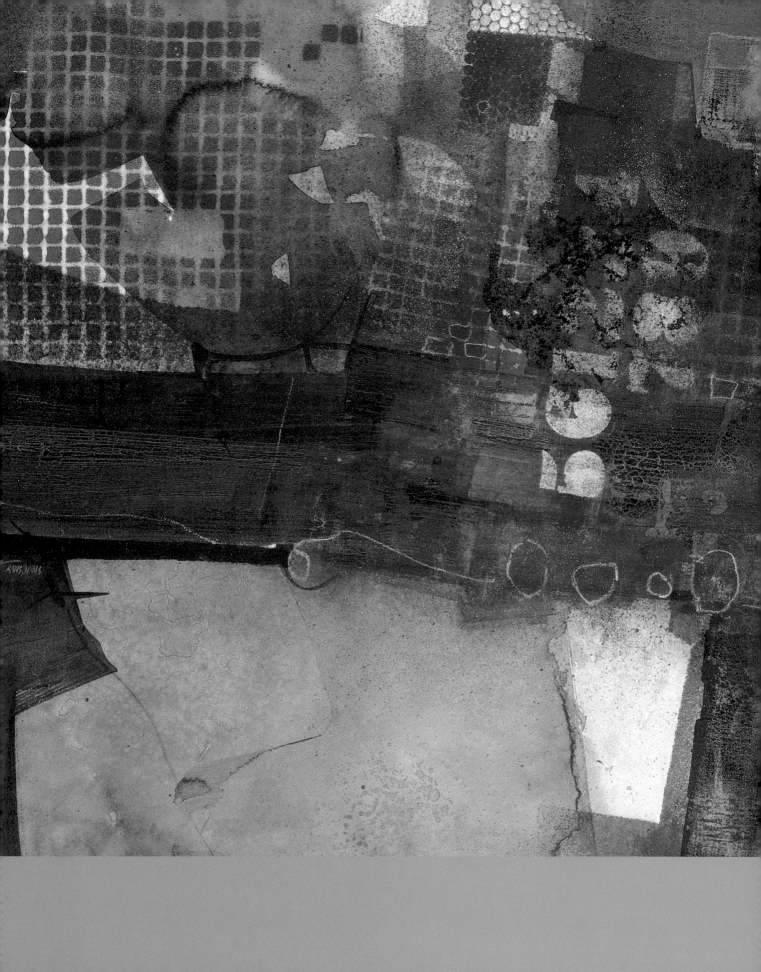

How to Bring a Good Start to a Great Finish

Many beginning artists know how to start a painting, but don't know where to go with their starts. In this section you will find a list of questions to consider when you are ready to finish your start, and I will tell you just what I am thinking as I finish a few of my own starts. I'll also critique several student paintings and offer design suggestions for bringing them to successful completion.

HOPSCOTCH, CITY SERIES 1
Pat Dews • Ink, acrylic, watercolor crayon, and crackle paint texture medium on 140-lb. (300gsm) cold-press Rives BFK printmaking paper • 20" × 32" (51cm × 81cm) • Collection of the artist

what to check when it's time to finish a painting

It can be easy to make interesting painting starts. What to do with these starts can be a problem. Knowing when and how to finish a painting is a challenge for many artists, especially those who create abstract artwork.

Before moving forward with a painting, do an evaluation. First, prop up your painting start in an upright position on an easel, and have a mat handy. I see the negative spaces that surround the positive shapes much more easily with a mat, so this practice is a must for me. Stand about five feet (one and a half meters) from the painting so you get a good overall view. Now, consider the following as you examine your work:

1. Is a change of orientation needed?
A really good abstract design start can often work in every orientation, but usually one orientation works best. My hope is that one orientation becomes the obvious good path to follow. For instance, while landscapes can be vertical or horizontal, a horizontal format does make you think "landscape" more readily.

2. Has color dominance been established? One color theme should dominate. If there isn't a dominant color, decide whether you want the painting to be predominantly cool or warm. Cool colors such as blues and greens are befitting of water or snow scenes, for instance. Warm colors (red, orange or yellow) may better describe a hotter scene. Of course, each color has warms and cools as well.

If you have a more abstract aim, you can play with your colors. Realistic imagery will look more abstract if you use nontraditional colors. Ultimately, you want a good balance between cool colors and warm colors whether your painting is realistic or abstract, but make sure one or the other is dominant. For instance, if your painting is predominately cool, a small amount of a warm color contrast will add variety and interest. Within

subjects it is a good idea to go from warm to cool as well. For instance, a barn side that has variation in color from a warm Burnt Sienna to a cool blue or blue-gray will have more appeal than a barn side that is a solid color.

Decide if you want a high-key painting with bright colors or a low-key one with dark colors. If you have intense, bright colors, make sure you have a neutral or dark color in the painting for contrast and interest. If you have mostly dark colors, a spark of pure, intense color will add great impact.

3. Does your painting have good values?
If you have a problem in your painting, it is often related to the values. You want to have lights, mediums and darks. Often the artist doesn't go far enough and needs more darks.

A dark is only dark in comparison to the values around it. Darks can appear to be midtones. It works to have the lightest light next to the darkest dark at the center of interest.

You can easily adjust values by using transfers to add paint, lifting paint while it is still wet, applying a gesso wash (gesso thinned with water to lighten), repainting with opaque color or adding collage.

4. Does the linework support the painting? The lines should be varied—straight and curved, long and short, fat and thin, etc. Horizontal lines can be restful; vertical lines can add a feeling of strength; and diagonal lines can create tension, conflict and movement. Color changes within lines are exciting.

A city-themed finish from a workshop start
The painting on pages 108-109, *Hopscotch, City Series 1*, started as a workshop demo (see my start above). I liked the contrasts of warm vs. cool, light vs. dark, soft edge vs. hard edge. I was working on a series using letters at the time and wanted to try numbers as well. The numbers and grid squares that developed reminded me of a city scene. The numbers, sprayed on with a stencil, reminded me of playing hopscotch. The diagonals that were added for sidewalk information give tension and excitement to the painting. I used repetition by spraying through a grid—also indicating high-rise windows—to emphasize the city motif. Linework was added for movement and rhythm. The great texture was made by using crackle glaze. I thought, If it works on furniture, why not here?

Linework can lead you into, through and out of a painting, and it can direct the eye where you want it to go (the center of interest). Linework essentially is the icing on the cake. Remember, however, that all the lines in the world will not correct a poorly designed understructure.

5. Does the painting have content? See if the textures or the shapes of the underpainting bring a theme or idea to mind. Is it one that you wish to explore? If it is, look for reference material. In order to add realism, I find it is always best to have a literal source for reference.

6. How do the shapes look? Is there variety in size (large, medium and small) and in color (warm and cool, dark and light) within these shapes? Be sure that your shapes are connected so there is unity in the composition. Also check for repetition of shapes. If you use a circular shape in one area, repeat the same shape (or an oval, semi-circle, donut or another similar shape) either larger or smaller elsewhere in the composition. A student of mine had a great idea to use a new pencil eraser for stamping opaque circles.

Be on the lookout for unique ways to repeat similar shapes.

If there is a problem with size variation in shapes, simply adjust some shapes to be larger and others smaller. You might need to scrub out, lift or paint over existing shapes. A lot will depend on what medium you are using. If you use transparent watercolor, you can simply lift out nonstaining colors. If you are using acrylics on a surface that has been treated with gloss medium, you can simply lift and change, as long as the paint is still wet. It is possible to lift dried acrylic paint by saturating it with alcohol and using a credit card or scraping tool to scrape and lift. You also can just paint right over the existing shapes with opaque paints.

7. Does your painting have texture and contrast? Texture adds interest to a painting. Texture should be varied: Some areas should have heavy texture, some should be moderately textured, and other areas should be quiet with minimal texturing. Have variety within textured areas as well. For example, if large bubble wrap is used to make a texture, use bubble wrap with smaller circles elsewhere. If you use a fabric grid similar to ones

used for hooking rugs, use drywall spackling tape that has a smaller grid design for repetition and variety.

Contrast in paint quality also adds interest. Transparent areas are more special when placed next to opaque areas. I start with transparent watercolor and inks and finish using acrylic mixed with gesso for opaque areas. Try scumbling, drybrushing and wet-into-wet painting to vary the paint quality. Also vary the edge quality (soft edges, hard edges).

Above all, the most important thing is to paint what you want and what you feel. You learn by doing. More than your successes, your mistakes and struggles are what will make you a better painter. As you are finishing a painting, don't worry about which show you might enter or whose home or gallery it might end up in. Paint each piece for itself. Decide what areas of the painting seem to work and which ones don't, then fix the ones that don't. If your painting is good, the rest will follow.

Test changes with colored paper

Using pieces of colored construction paper can give you a good idea of whether you are headed in the right direction. By moving different-colored pieces of paper on top of your painting, it is possible to test color changes and placement before you actually change anything. You can also make your composition stronger by adding shapes or taking out shapes.

The colors of the paper are often limited, so take this into account when coming up with a construction paper plan. Sometimes you may want to use saved collage pieces instead of construction paper. These pieces can represent paint application to come or they can be incorporated into your painting as actual collage. (I would never use the construction paper as actual collage, however.)

When working in a more experimental manner, the direction to take can often be found within the painting itself.

These construction paper studies help you make a plan after you have made a painting start in experimental work. Although many realistic painters prefer to plan with sketches and value studies before they start to paint, construction paper can help you find and correct design flaws in your composition.

Seeing an image made of paper is different from seeing it painted, but I have not found a better way to plan my finish when I'm stuck. Each start can take many different directions. All could be good, but you have to pick one. If it works, great! If it doesn't work, change it. The process is really as simple as that. Many times it is a matter of going with your gut feeling until the painting looks right. Each change affects another change, but you have to start someplace. Work until there are no more changes that you want to make.

finish #1: divide and conquer with extreme cropping

The following demo is actually a painting I signed and thought was finished. The intense colors against the white background of the paper and the contrast of the neutral and intense colors were great, and I loved the painting. When I was a beginning artist I reserved a lot of white areas when painting, but over time I started adding opaque areas of paint—covering the entire paper—and putting whites back in later.

Upon closer inspection, I saw that I had lost the initial excitement and that the orange I once loved was now discordant. Follow along as I solve the problem with cropping.

A good start

What I had loved the most about this start was the intense orange in the top left. It looked great when there was a lot of white in the rest of the painting. None of the dark blue opaque areas were there, only the white of the paper. With the orange next to the blue and white, the painting sang. Now it stands out too much and seems discordant. I need to make it relate more to the rest of the painting, establishing unity.

1 Reintroduce Whites

I add whites in the form of water, using the technique shown on pages 35-36.

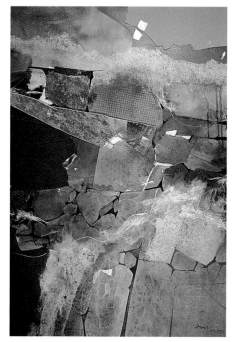

Crop #1

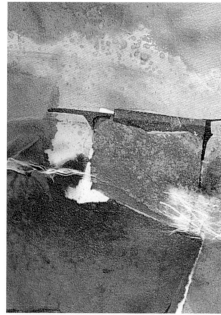

Crop #2

2 Use Colored Paper to Test Color Placement

I can either add more of the orange or eliminate it altogether; either would bring unity to the piece. I tape collage and construction paper pieces to the painting to see if that helps. I vary the size and shape of the orange and pink pieces for variety. The black collage piece is a big shape that I think will work better, as there are too many same-size shapes. I also feel that a dark is needed for value contrast.

Color now moves the eye through the painting, creating rhythm. However, I still miss the original white and decide I have lost the emphasis I wanted when I started the painting.

[TIP] Two-thirds of a painting may be great, but the whole painting has to be great! A favorite section has to go if it doesn't work with the rest of the image. Remember that section for your next painting.

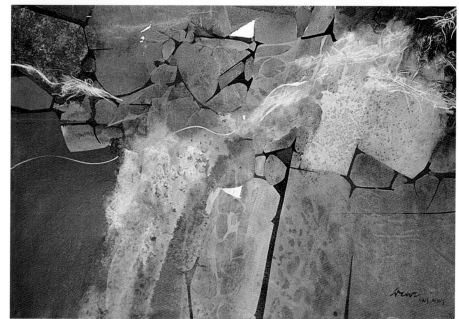
Crop #3

3 Crop for Three Paintings

I think this painting will need radical color changes to relate the orange area to the rest of the painting. Before undertaking such a major change, I take different sized mats that I have on hand for this purpose and see what happens when I isolate different sections of the painting. I think in this case that I can get three really good-looking paintings from this full sheet and decide to crop.

Crop #1 has dominance of color (cool) with warm accents. The shapes are varied in size, and the warm water/sky area is connected to the warm color in the bottom lower right. The values are good, with lights, mediums and darks. I like the horizontal/vertical contrast in crop #2 and think this small piece can end up being a gem!

Crop #3, without the orange distraction, has unity, and the sizes and shapes seem to work. I would like to see some more darks, a punch of intense color and a bit more excitement in this piece.

4 Play With Juxtaposing Collage Pieces

Crop #3 is the image I will finish. I tape collage pieces to see how they will help complete the cropped version. I want lights and darks, warms and cools. The orange and blue collage piece that I find in my collage box is just the right piece for this painting. It will bring emphasis to this piece and "make" the painting by providing my center of interest. Remember, complements placed next to each other add excitement.

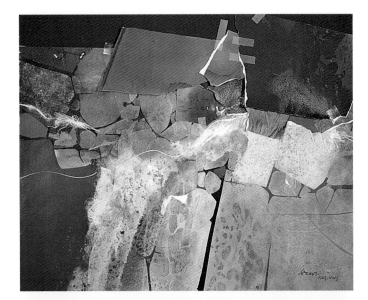

5 Look at the Painting Through a Mat

I look at my painting upright and through a mat from a distance. When I look through the mat, I see the great contrast of the orange next to the blue complement; good contrast in value; and good directional lines from the white, torn collage edges moving the eye down and through the painting. These white edges repeat the filament lines in the rice paper (Natsume 4002) already glued to the paper with gloss medium, as well as the lines painted with white gesso and my rigger brush. Repetition adds rhythm to a painting.

The small gray collage shape under the dark blue on the top left brings the gray color across to the left side of the painting, offering unity through repetition.

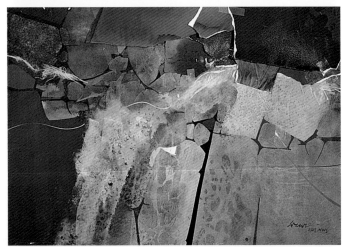

6 Finish and Evaluate

I trace a pattern of the taped collage pieces onto wax paper to use as a guide for gluing them on properly. Sometimes the taped pieces look good but seem different once flatly attached to the painting.

Despite careful planning, I realize I inadvertently added a small blue shape of a darker value than the planned gray shape (located under the dark blue shape on the top right). The small, rust-colored collage piece added near the center of interest to brighten it looks a bit contrived. The center of interest seems crowded, and the blue too dark. By not adding the small, gray collage piece, the painting looks very different.

Having both the top right and bottom left corners so close in color and value doesn't seem like such a good idea anymore. The top-right dark looks like a hole. The painting feels static.

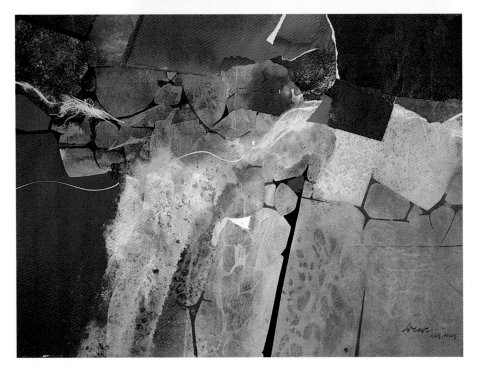

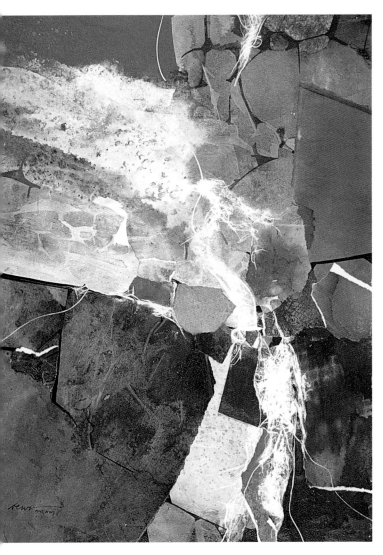

7 Take the Painting in a New Direction

Here's what I do: I change the painting orientation to vertical. I add collage pieces from the right, in the bottom quadrant, going across the page. I alternate warm and cool colors to create rhythm. The added collage pieces are darker in value; I want a strong solid foundation, and the dark adds weight to this area. I also want a strong contrast of light and dark to highlight the water as the dominant feature. Note the grid pattern in the collage piece on the lower right; it adds more variety than the solid blue shape it covers. The white edge at the bottom of this piece moves your eye in and out of the painting.

Small and medium-size collage pieces with warm and cool contrast bring your eye to the center of interest (the bottom right, below center). The contrast of light and dark is greatest here. Blue collage shapes break up the light value channel of water that dissects the painting vertically and forms a bridge, connecting the right side of the painting to the left side.

Natsume 4002 rice paper is added for more whites; now I have the whites back that I had longed for in the beginning, in the form of water that flows nicely through the piece. Carbon Black gives form and white rigger lines add directional flow. The final, very important adjustment was cropping two inches (5cm) from the top, coming in closer to the water; the proportions are better. The painting has all the principles of design working here: proportion/scale, unity/variety, rhythm/repetition, emphasis and contrast. I really like this painting.

FALLING WATER 20
Pat Dews • Mixed media/collage/rice paper on heavyweight Rives BFK printmaking paper • 20" × 15⅝" (51cm × 40cm) • Collection of Mr. and Mrs. Kenneth Kennedy

[TIP] Starts are always great fun. You can just play. Then it's time to think! Many of my paintings begin simply by making a plastic wrap transfer. Just as with writers, there is comfort in not having a whole sheet of white paper staring you in the face!

finish #2: repeat shapes and textures

While teaching a workshop at a center that had equipment for making pottery, I glanced over and saw a cover for a potter's wheel. I was ecstatic! I thought this would make a great print when left in wet paint and decided I had to try it and see for myself. I often get another idea while working and immediately go with it and start another painting, which is why I have so many starts.

I don't often use many circular shapes in my work and thought I would also like to explore this avenue. I always tell my students that circles are a bull's-eye—your eye goes right there. Does it ever! It took a long time to integrate this painting to make it work to my satisfaction.

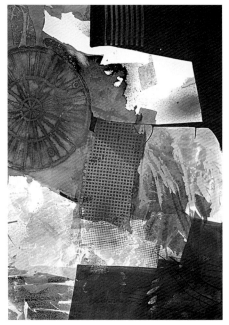

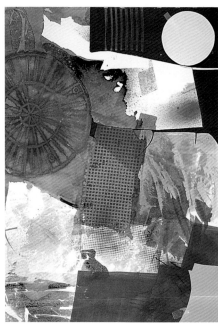

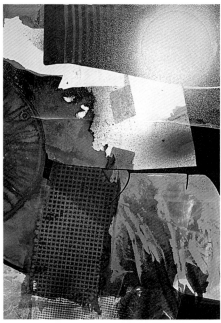

A good start

The great circular shape that looks like a man-hole cover is the pottery wheel cover, or batt. I saw it, loved it and used it to show my students how you can make a print. I used this paper to then show other techniques. The pink and brown shape in the right center is a plastic wrap transfer. The lines in the bottom right were a demo on how to hold your rigger when painting linework. (Incidentally, it's from the end of the brush, standing, with full wrist motion.) The stripes in the top center of the painting were made by scraping a tile grout tool through opaque acrylic paint.

1 Use Paper Pieces to Start Planning

I cut a piece of computer paper in a circle and use turquoise construction paper to start planning my composition. This is a good way to test your ideas. You tape and look. If you like it, do it; if not, keep searching for a plan. I know I need to repeat the circular shape because I need repetition in the painting. It is good that the half batt is not a full circle. I thought of that from the very beginning, because I knew I needed variety. Color has to move throughout the painting for repetition and unity, and the bottom right seems like a good place to start.

2 Repeat Circular Shape With a Stencil

Clear contact paper is used to make a stencil for spraying on a circle with white FW Acrylic Artists ink and a mouth atomizer. I am hoping that since the paper sticks to the surface, the paint will not run under the edges and I will get a perfect circle. I also can preview how the circle looks in its surroundings since I can see through the contact paper; I can wash off the paint immediately if I don't like it.

I found that the paint did run under the mask, but I am glad it did because the edge has more interest now. Incidentally, I sprayed rather than painted because I could add white by degrees. I could see if I liked just a bit of white with the underpainting still showing or whether I wanted a more solid white.

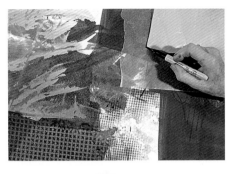
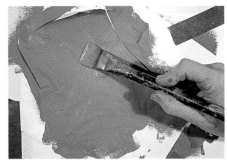
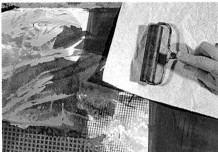
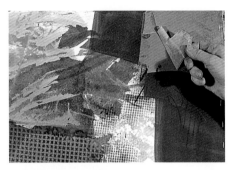

3 Make a Transfer

I decide that I need turquoise in the bottom right. I can paint it on with a brush, spray it, or transfer it with wax paper. I use transfers to change color or value and to create an interesting surface by adding texture rather than just a solid color. I also use them when I want part of an underlying color to show through.

To make a transfer, follow these steps:

1 **Place the wax paper where you want to transfer color** and make a tracing of the desired shape. Use a felt-tip marker to trace the shape and then mark the front side with a check so you know which side of the wax paper to apply paint on.

2 **After cutting the pattern piece using a craft knife or scissors**, place the pattern face side down and apply the paint mixture to the wax paper. Gesso is mixed with the acrylic colors to give the paint mixture body. If the mixture is too thin, it will pill because of the wax in the paper. It must be thick enough to completely cover the wax paper.

3 **Place the wax paper paint side down** onto the painting. Place paper towel over it to pick up any excess paint. Roll a brayer over it several times to transfer the paint from the wax paper to the painting's surface.

4 **Lift the wax paper.** The transfer repeats color in the painting, and there is now a contrast in paint quality (opaque vs. transparent).

[TIP] A transfer is also useful for lifting paint when you have applied too much. Place plastic wrap in the puddle and then transfer the excess to another piece of paper.

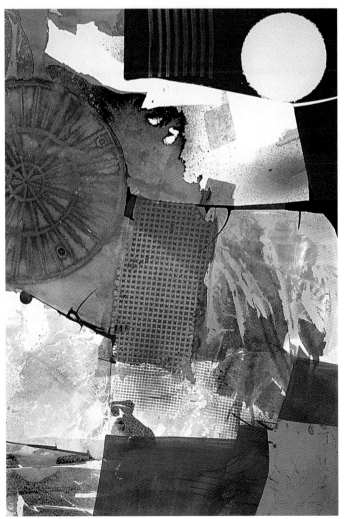

Steps 2 and 3 completed

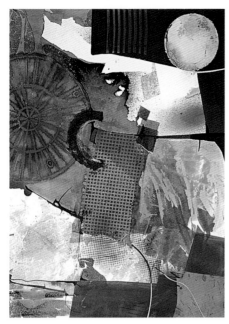 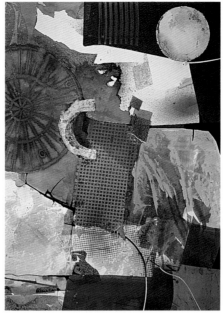 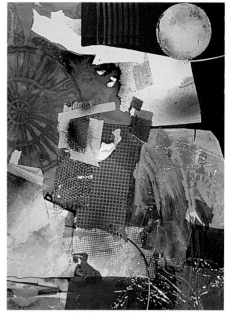

4 Develop Round Shapes and Linework

Using stencils, I spray on more geometric shapes of different sizes in the white space in the top right under the circle, providing repetition and variety. I also want to add more warms, and I make them more intense to develop a center of interest. Warm colors come forward, and I am using color to create depth. The overlapping also creates depth. The beauty of spraying is that you can apply multiple colors without disturbing the layers of paint.

The circle is modeled to give it form. Linework is added to give form and movement. A black half-circle shape is tried out near the middle of the painting. I need more than two circular shapes for repetition and variety.

[TIP] I do not preplan my paintings; I plan as the painting develops. If I had preplanned this painting, I never would have thought to use the batt cover to make a print. Always be on the lookout for ideas and grab them when you see them. Be a discoverer.

5 Adjust Problem Shape

The black half circle does not look right to me, so I make a wax paper transfer using white gesso. Transfers allow part of the underpainting to show through (the black in this case). This looks better to me, but I don't think I like the shape; it looks like a big C.

6 Add More Texture and Color

White paper with a different edge is taped to test a shape change for the C. Black and turquoise are sprayed through hole-punched Mylar onto the half circle for contrast and variation. Black India ink is sprayed through a small rice paper grid for repetition (color) and variety (grid size). A gesso wash and plastic wrap are applied in the warm shape at the bottom to make a bridge connecting the two white shapes and to move color through the piece.

Steps 4 through 6 completed

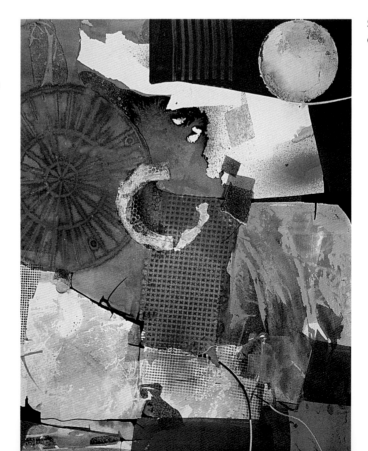

[TIP] When examining different areas of a painting, try testing your ideas on tracing paper. Once I changed this painting's orientation to horizontal, I made a tracing of the upper-left corner and played with placing three circles of different sizes and shapes in this area. Hold your tracing over the painting to see if your idea will improve the area.

7 Switch the Orientation

After studying the painting, I decide it is stronger with a horizontal orientation. The circle on the top right looks balanced and fine as a vertical, but I don't like the feel of the broken circle shape overlapping the batt; it seems awkward, as though it's falling down. When I look at it in a horizontal format, it seems more dramatic and draws the viewer towards it. The batt looked scrunched in the vertical format but looks fine in the horizontal one.

The gesso wash from step six did not have enough pigment, so I adjust it with more paint and plastic wrap. I like this organic shape as a contrast to the more geometric shapes, and the white now moves nicely through the painting. In the horizontal format, the top left of the painting seems to be begging for some black to balance it with and connect it to the other side. The black seems stark and I still need another circle to repeat for unity and rhythm, so I add a circle by tracing around a small dish with red and white watercolor crayons. I consider a line exiting in this area, but I like the starkness.

I test a white paper shape to connect the white circle on the bottom right to the edge of the painting so the eye can move in and out of the image with a sense of flow.

8 Consider a Few Design Options

The white solid circle in the bottom right was at first meant to be a play at balance, sort of like the seesaw imagery you often see in art books, with balls of differing sizes on each end. In the vertical format it worked and was resting in place. After the change to a horizontal format the design looks more striking and unusual to me, and I like that aspect. Even though the circle isn't connected to the edge, I am intrigued enough to consider leaving it floating in space (not anchored as I had tested in step seven).

The broken circle shape feels like a magnet tugging at the solid circle in the lower-right corner. I would like the viewer to imagine the solid circle being pulled by the magnet and then continuing its journey, exiting out the top left of the painting. I like the stark simplicity, and would like to go with this imagery, but upon reflection decide there are problems that have to be addressed. A viewer's eye is always drawn to a circle, especially one that is not anchored. (I had hoped that the solid circle would be anchored because it is tangent to the line, but feel it falls short.) The brightest light is the white shape in the upper right, and the viewer's eye goes right there (lightest light next to darkest dark). I want your eye to go to the center of interest: the magnet shape and the geometric shapes under it, not the edge of the painting.

9 Solve the Problems and Finish

I start by cropping the bottom edge so that the circle goes out of the picture plane, and I darken the right edge so that it is close in value to the background. I model the white shape in the upper-right corner to cut the whiteness and bring a warm color into the area, connecting it to like colors elsewhere for unity. A grayed turquoise flap breaks into the white shape, connecting it to the blue background. The shape now curves back down and into the painting. The turquoise is modified and made less intense in the "magnet," and a warm, curved edge is added, again moving color and repeating the circular shape.

The edge of the "magnet" is made less prominent, and a single circle is drawn using a watercolor crayon. This circle repeats the two white shapes that peek out from the blue background just to the right and also the small circles that are in the batt print. The line with color change in the lower-right quadrant curves, replicating the circular shape and adding contrast to the straighter lines behind it.

As I study the painting through a mat, I decide that additional changes are needed. I realize the stark black is confined to both edges and does not continue in the middle of the painting. I also think the large white shape on the left is too similar in weight to the white shape on the right side. I add a bit more warm color and darks to the white shape, breaking it up into more interesting segments. Form is given, and shapes are made smaller in relationship to the larger shapes already in the painting.

I spray through the hole-punched Mylar for repetition. I add black and brown diagonal lines that move the viewer into the painting, breaking the straight lines of the grid section and adding tension to the piece. Finally I add the last line of white to the stark black area, realizing that it is needed for unity and rhythm.

RELICS 2
Pat Dews • *Watercolor, ink and acrylic on heavyweight Rives BFK printmaking paper* •
20¼" × 30" (51cm × 76cm) • *Collection of the artist*

[TIP] Say you have 35mm slides of one of your paintings but want to have a larger transparency made by a professional photographer. If you are pleased with the color accuracy in your slides, it is best to use a photo lab that shoots with the same film you use, or the colors may look quite different on your new transparency. For example, I have found that Kodak film is warmer than Fuji film.

the value of working with others

Throughout your painting career it is good to spend time painting with other artists and sharing ideas. Workshops can be a great place to learn new ideas, sharpen skills or simply get motivated.

Request to see a class plan before deciding on a workshop. Instruction varies. Some instructors paint while the students watch; some lecture and critique your work, but do not paint; others lecture, critique your work and give daily demonstrations. All are valid.

Beginning, intermediate and advanced painters may have different needs at different times, and a workshop can often fulfill those needs. Know your level of ability and decide which workshops work best for you. What you learn at a workshop should stay with you for months or years as you continue working. Keep in mind that paintings you complete in a workshop cannot be entered into a juried show if they have been critiqued by the instructor. Most show applications state this.

Consider joining a critique group. It is often easier to see what someone else's painting needs than what your own needs. Someone else can give you just the right idea to help you finish. Many times the answer is so simple, you will wonder why you didn't think of it yourself! For example, while working with a painter friend, I told her that I was having trouble making my body of work look like it was created by the same artist. My florals tend to look more realistic. She suggested that I include an important element from my abstract work in my more realistic paintings. I tried spraying through the same grid that I use in my abstract work. It worked!

Just as in sports, it is better to practice painting with and be critiqued by someone better than you. Bear this in mind as you choose a group to join. Be open to learning how to improve your skills and become a better painter. In the end, it is your painting and you must decide, but it can be helpful to get direction.

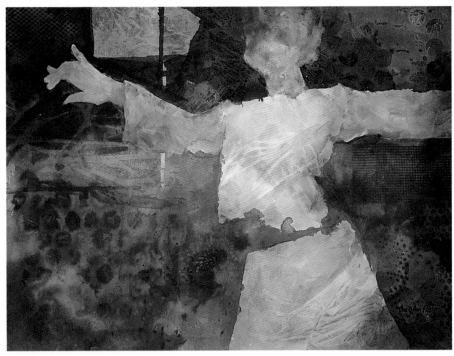

A workshop success
This student had a lot of experience painting figures, and she was able to readily see how her reserved white shapes could read as a figure. This was a very different type of figure painting for her. She left my workshop feeling as though she would "see" in a whole new way. She has successfully begun combining realism with abstraction in her paintings.

FINDING MY WAY
Mary Ann Putzier • Mixed media on watercolor paper • 22" × 30" (56cm × 76cm) • Collection of the artist

[T I P] Try viewing your paintings through a slide projector. This is especially helpful when you have a group critique. Most times, when your paintings are juried, the judges will view your painting in slide form. Seeing your paintings in relationship to other paintings can be very eye opening. It's easy to spot the good ones and the bad ones.

how to approach (and accept) critiques

As a starting painter, I was very defensive about my work and did not like to be told what was wrong with my painting. Now I take all the help I can get. This comes with confidence from working. I now know that others can have more knowledge and better ideas in some areas and with some paintings. This is when it is good to have a painting group to share ideas.

Critiques should never be mean spirited. Painting styles are a matter of taste. Criticism should be based on the elements and principles of design—the language of design—not personal likes and dislikes. However, since painting is very subjective, it is hard to be totally objective when evaluating someone's work. Some paintings break the rules and work. Some paintings show honest effort and are more satisfying than those with more technical skill.

Early in my art career, I submitted five paintings to be juried for membership in a local art association. I wanted very much to be an exhibiting member. I got the call; I was made an associate member instead. I still remember hanging up and crying for an hour. I went to the critique session to find out why my work wasn't good enough. The artist/teacher giving the critiques said what was good about each piece, and I said, "If this is good and that is good, how come I didn't get full membership?" She replied, "They are not *that* good!"

The artist later became a close friend of mine, and she was so right: they were not that good. It is OK to like your work and defend it (you'd better!), but there is a lot of rejection in this field. You have to be tough, and you must have tenacity. In time, you will learn to be more honest about your own work.

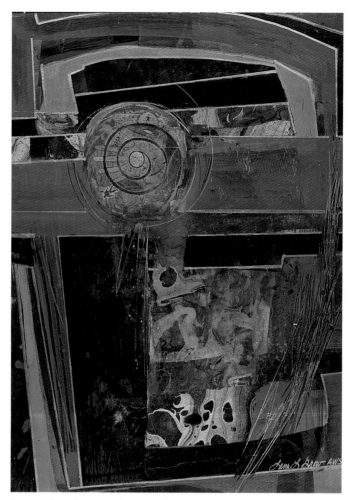

BEYOND YOUR CIRCLE OF IMAGINED LIMIT
Lana Grow, AWS • Mixed media/collage on watercolor paper • 30" × 22" (76cm × 56cm) • Collection of the artist

A successful finish
This complex piece by one of my students uses a frame within a frame to great effect. Great linework moves you through the painting and adds variety. Straight lines and squares create tension and lead your eye away from the circle bull's-eye. Random, squiggly lines also move you away from the circle. The circle is the center of interest, but the rest of the painting is orchestrated to move you through and around the whole painting.

That being said, paintings that have won awards in one national show have been rejected from other shows. Are those paintings good or bad? They are good paintings. The judge may have felt they weren't in keeping with the show's theme, did not compare to the other paintings in the show, or personally found the style of painting or color displeasing. You enter shows; you win some, and you lose some. Paint and enjoy the journey. Be glad with your successes.

I have great students. I learn as much from them as they learn from me. Some of my students were invited to share their painting starts and finishes with you on the following pages, and I have offered my suggestions for improvement. You can learn along with them, at home, just as if you were in a workshop. In most cases, the paintings were started using one of the design methods we explored in preceding chapters.

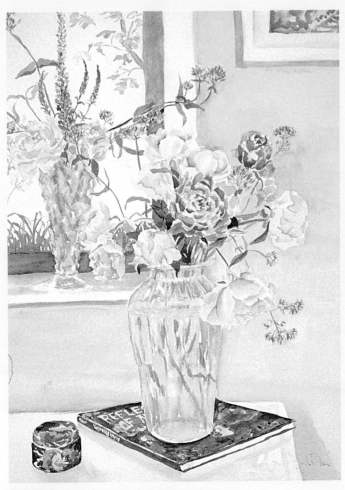

Original

Often artists spend so much time on individual objects in a still life that they forget about the whole picture. In this picture, the eye goes right to the book and box because they are strong in value and color contrast. The background could be more interesting, and there is not much variation in the flowers or containers.

Realistic painters often have trouble getting great backgrounds to complement their still lifes. Many of the textures we learned in preceding chapters could be used to great advantage here. The artist could add more darks and go back into the background, but it would take a lot of integration.

Note: In realistic work, avoid putting the waterline of a vase at a windowsill edge or the roof line of a building at the horizon line or mountain edge. (Art by Judith Ritner)

How to improve it

I think it makes sense to begin by cropping this painting. What this piece has is great watercolor painting in the flower areas. Don't fret or lose heart over the parts that don't work; be glad for the parts that do work. This small painting is a gem.

I would add a few dark blues for value contrast and color variation, but not necessarily the blue shown (this is painter's tape that I used in a pinch). The dark could be a great blue-green. I love to combine Phthalo Blue and Burnt Sienna for a good dark. Greens can show the difference between a beginner and an advanced painter. Vary the greens, having gray-greens and blue-greens, and don't use color straight from the tube. Try mixing your reds with your greens. I like using Raw Sienna or Burnt Sienna mixed with Sap Green.

Adding a touch of orange to the main flower repeats the color of the clump of smaller flowers located above and to the right of the main flower. It also gives color variation to the flower.

[TIP] It's a good idea to limit a project from the start. Learn to paint just a few objects well, then paint these objects again with an interesting background. You can add more as you progress. Master the pieces, then put the pieces together. Make it easy on yourself. You want to succeed, and nothing makes you a better painter than success.

student critique #2

Original

This painting is the first attempt by the artist who did the floral on page 123 to paint from nature in a more abstract manner. Using non-traditional colors can make a work seem more abstract. Water can be pink, and skies can be red. You are the painter; you get to decide. In this piece, using the complements blue and orange is a good choice.

The size variation in the rock shapes is also good. Contrast in color temperature, as well as size, is important. The left side of the painting has more intense color, and the right is crying for more of the same. The blue needs to have some variation. (Art by Judith Ritner)

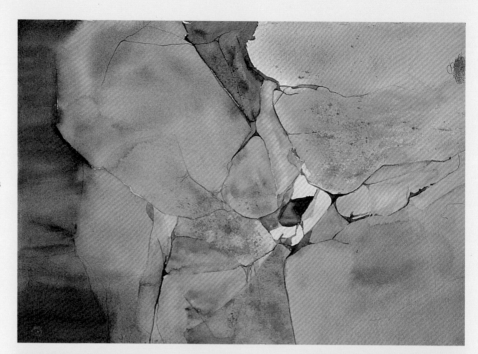

How to improve it

Contrast in color and contrast within a color family is what you want. Green, blue and purple are analogous colors and always work together. The added piece of green on the right picks up other spots of green in the painting. I also would carry blue and purple (the darker values) to the right side, connecting both sides of the painting with color. The purple on the lower right should appear on the left side as well for unity and to break up the predominantly blue left edge for variation.

Complements will add some excitement to the piece. The yellow linework in the added purple section not only adds excitement, but gives direction and movement within the painting. The orange line that exits/enters on the top left provides needed breakup of space in that quadrant. Note that the line was changed from yellow to orange, the complement of blue.

I added an intense orange rock to bring the orange from the left side to the right for color balance. It also serves to add variety to the size of the rocks in that quadrant. If the small, intense orange rock did not seem like enough to carry the weight of the large orange rock in the top left, I would then do a transfer and add more orange color to either the top or bottom rock or both. The small touch of red on the yellow line adds a little excitement at the center of interest. This painting is about color and shape.

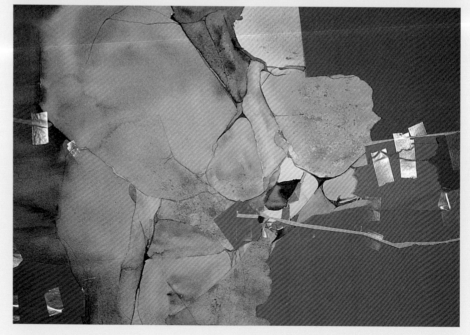

student critique #3

Original

This painting has good color, and the water looks and feels like water. It would read better if it had an orientation change. The space divisions need some adjustment as well. (Art by Joyce Anson)

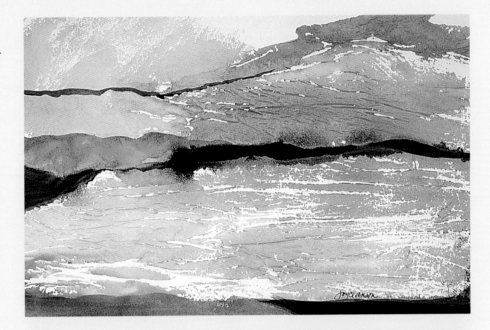

How to improve it

This painting could become a nice beach scene if turned upside down. Here's how:

1. A perfect wave shape can now be seen at the top right. Do you see it?

2. A very natural looking beach area exists along the bottom, with a wave breaking onto the shore. The lower right is a perfect spot for emphasis. This could be in the form of a shell, seagull, footprints, a color change or a texture change.

3. The dark in the middle is too dark, competing with the dark rock area in the background. This dark also divides the painting in half. This dark area is a perfect spot to use the water technique from pages 35-36. Gloss medium, white gesso and alcohol can be used to make the foam of a breaking wave to change the value of the dark area, creating interest and variation and giving content to the painting.

Since the dark edge at the top of the painting and the dark shape in the middle are almost the same size—as are the top and bottom divisions created by the middle dark—the new foam and added darks should hit at a different spot, perhaps a little lower, to change these same-size divisions. Some dark should remain, and the foam should not completely cover the black. This is when a photo is a must to guide you in designing the wave break and deciding how much foam there will be.

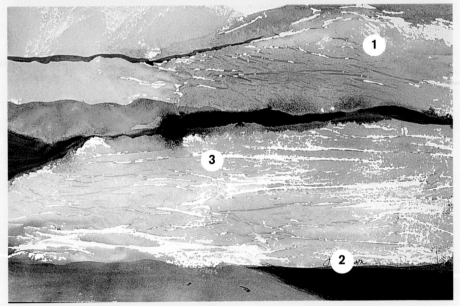

student critique #4

Original

It is hard to not go with the imagery found in the painting, which was the direct result of a texture sheet. When the texture materials were removed, the image of a boot appeared in the lower-left part of the painting. I can see the skirt, a lace petticoat, and flowers falling. Can you? This was a happy accident and a painting waiting to happen. We are about to have a hoedown! (Art by Clara DeMott)

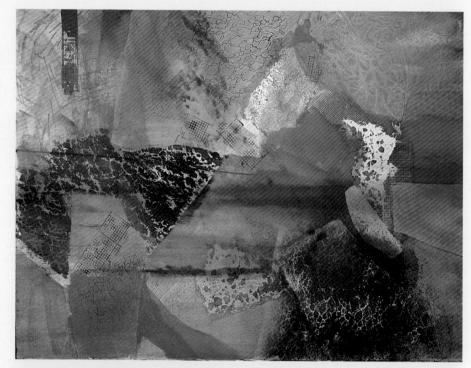

How to improve it

The skirt needs to have lace peeping out, so paper lace is taped on and studied. The white can be sprayed right through the holes in the doily to create the lace petticoat. The whites on the right are the falling flowers. Yellow centers will help them read as daisies. Small lines of color could explode from the upper right of the painting, indicating that the festivities are about to begin. Stamp your feet and start dancing! Orange and red are placed on the boot to move color through the painting and create more interest in that shape.

As the artist continues working, shapes in the background will become more integrated and defined (perhaps with some additional negatively painted flowers). The introduction of opaque areas will give good contrast to the transparent areas.

No matter how this artist decides to continue, with the boot motif or as a nonobjective or abstract piece, she should make sure that the red line currently in the middle of the painting does not stay there. It draws too much attention and divides the painting in half.

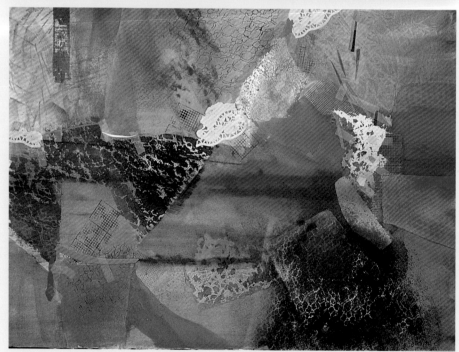

student critique #5

Original

This piece got its inspiration from a cropped magazine image of a room interior showing an outside view through a window. Geometric interior shapes were connected to the sky and trees outside. This combination makes for a great abstract landscape. Having the trees in front and behind these geometric shapes adds depth and gives push and pull to the piece.

Using this method of composing a painting based on part of a larger image allows you to find new ideas and use shapes you don't usually use. It keeps your work fresh by not repeating the same shapes and design plan. This particular design needs just a few adjustments to pull it together. (Art by Nancy Davis)

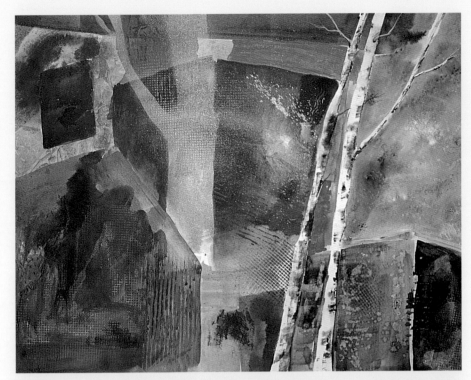

How to improve it

Wax paper is taped over the orange shape in the top middle of the painting to judge if it works better to make that color less intense. It does—the orange color is too intense to be so close to the edge, and the most intense color should be saved for the center of interest.

The large, brown house shape on the lower left needs more variety in hue. The cool blue and purple are good contrasts to the warm brown. Placing blue here also repeats and moves the blue sky color to that area.

Lines are tested to move the eye through the painting. Lines added to the trees better integrate them into the painting. The tree limbs added to the large single tree bring this shape into the right side of the painting. Intense orange is placed next to the blue (its complement) at the center of interest. This shape will act as a bridge to connect the left side of the painting to the right side. The white line will further connect the two sides. A touch of red above the orange adds visual excitement to this color arrangement.

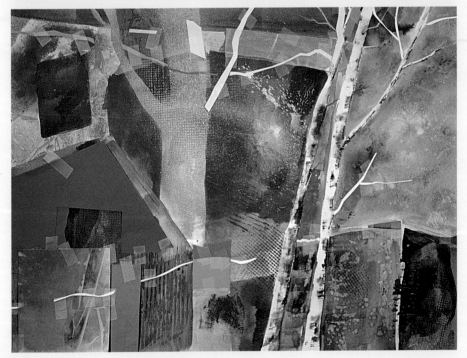

student critique #6

Original

The top and bottom parts of this painting seem disconnected. An attempt is made to begin integrating the top portion of the painting with the strong lower part of the piece. The lone bird in the upper-right corner seems to need company, so more birds are added. Orange is brought into the middle right to move some of the sky color down and through the painting. Of course, the actual orange wouldn't be as intense as the construction paper shown here; it is for color indication only, not intensity. Green is moved up to the middle right as well to integrate with the lower portion. (Art by Len Fischler)

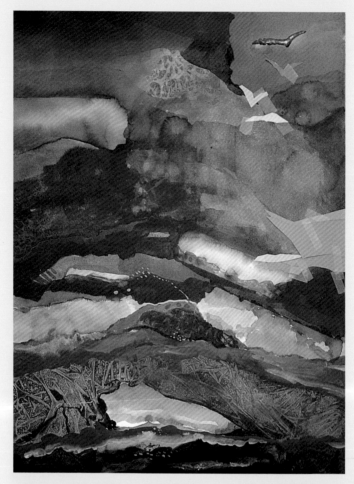

How to improve it

After studying the painting with a mat, cropping seems to be the best solution. The scale of the entire piece seems wrong. Also, the arrangement of the parts doesn't seem to make sense. It appears as though a cloud formation exists over the bridgelike rock formation in the lower half, but the top half seems to show a second sky area on top of valleys and hills.

The lower portion seems to be a complete painting in itself. As a cropped piece, this painting looks monumental, with a sure sense of place. The viewer moves right into the inviting sea beyond. The plastic wrap-textured rocks add much to the overall excitement of this piece.

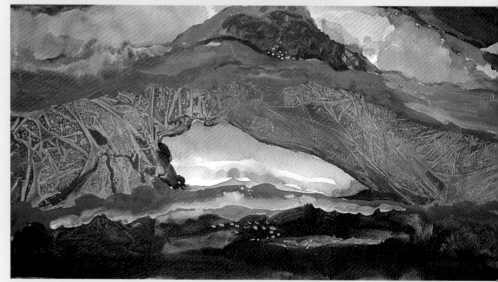

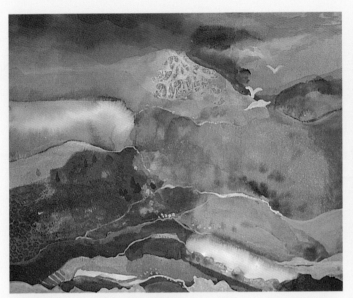

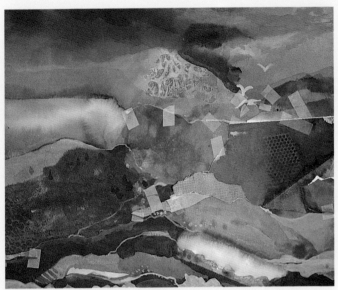

A second crop: student's finish

This cropped section of the top part is its own landscape as well. After changes, the artist sent back the art for further critique. The sheen in the middle-right portion of the painting is a result of using iridescent paint. Some of this paint was scrubbed off, leaving that area lacking a bit. More interest seems to be needed in this area. The strong blue on the bottom also needs to be moved up and integrated into this area.

How to improve it some more

Pieces that would work with this painting are found in my collage box. They seem to integrate the painting better. The large wine collage piece on the middle right is a good color for connecting that area of the painting to the very strong sky.

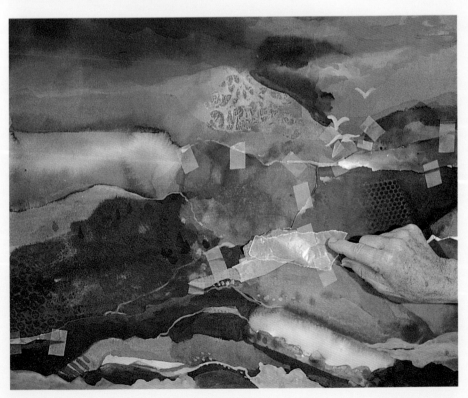

Try adjusting color intensity

Wax paper is used to see if perhaps the intensity of the blue in the middle will need adjustment. The blue is a bit intense, but I think the problem is more about having a shape of such a solid color. This could be changed by adding some warm color and keeping part of the intense blue.

I ended up sending the pieces of collage tested on this painting to the artist. He was thrilled and planned to glue them right on to finish this piece. Instead of one great painting, he got two!

[TIP] Don't be sad if you have a failed painting. Recycle good parts of unsuccessful paintings by using them as collage in your next piece. You might even start hoping for mistakes.

129

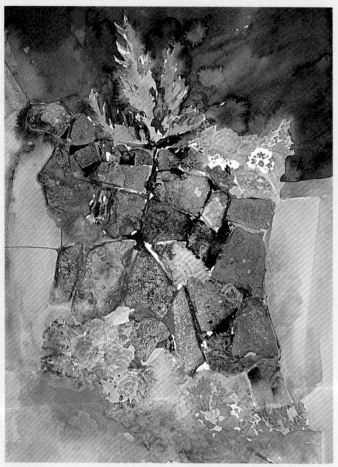

Original

A photograph of a rocky cliff was used to get this great start. This is the best texture for painting rocks that I have seen in a long time. Sedimentary rocks were placed in wet paint, and the texture was made by the rocks themselves. Because of the central placement and shape, the rocks look more like a container, however. The blue foliage that seems to come out of the central rock formation looks unnatural, making the rock formation look like a vase holding flowers. I love the color and paint quality of the leaves and background, but the scale is wrong in comparison with the rock shape. (Art by Robin Tilton)

How to improve it

To make this more naturally resemble a rock cliff found in the woods, it would be better to extend rock shapes of various sizes to the edges of the painting for a more realistic interpretation. More variation in value (darks and lights) will help lead the viewer through the painting. Placing foliage at the top and bottom gives depth by establishing a foreground, middle ground and background. Of course, the greens would be varied; the construction paper is only a color indicator. Added trees on the right could provide a great vertical in the horizontal rock formation, and they would also serve to give depth.

[TIP] Using collage can add new dimension to your work. Do a series and use collage as one option. Working on different supports and with different mediums will make you a better painter. One enhances the other.

Student's finish

What a dramatic change! The artist has opted for a rock segment and eliminated the foliage altogether. The intense blue at the top is a great contrast to the overall orange tone of the painting. The neutrals in the upper left add good contrast to the strong, intense rock colors. It feels like more could be happening in the neutral area, though.

The neutral area is now a plane behind an outcropping of rocks. With the intense blue and very strong orange on the right side of the painting, all the weight is on the right side. The neutral area needs some value and shape changes if it is to be a distant plane to better relate in weight to the right side. If indeed it is a rock cliff, it needs to be brought into the foreground more and in the same plane as the right side of the painting. Because the blue-gray area cascades down from the intense blue in the upper right—and it seems to be on the same plane as the foreground—we should make the left side have more variation and bring it forward in the picture plane.

How to improve it some more

Collage papers are used to try extending the rocks to the edge of the painting on the left side. Now the planes are clearly established. The left side of the painting comes forward and becomes part of the cliff section in the foreground. The neutral area recedes and is a more distant plane, with the intense blue area receding still further.

The blue at the top seems isolated; moving that color through the painting will lead the viewer's eye there. Adding blues among the orange rocks adds excitement. A blue piece of collage is added to the left of (not directly under) the intense blue notch in the neutral background, representing where the center of interest could be best placed. You wouldn't want the center of interest directly under the blue notch, as it would be too close to the right edge. Even though the intense blue grabs your attention, it is too high on the picture plane to be the focus.

The added gold and darks provide variation and contrast. The gold color of the added rocks also repeats the color above the center of interest in the upper right of the painting. Care needs to be taken to not make two centers of interest. Where the blue was added on the top left could compete with the center of interest under the intense blue sky area. If the center of interest is developed on the top right, the blue on the left should be less intense. If you want to make the area on the top left the center of interest, that would be OK too; in fact, it might be better to have your eye move from the intense sky area down and through the painting to there, making that area the center of interest instead.

A small dark was used to give form to the lower right, but it looks better without the indentation. The dark line on the lower right is important because it leads you in and out of the painting and visually helps support the rock structure while moving dark value through the piece.

student critique #8

Original

This painting started as a texture practice sheet and ended up as a birch. This is a great start, but it needs a few adjustments. The right side has more weight. The left seems unfinished, needing more shapes to balance the painting as a whole, to unify the whole. More warms could be added for contrast and variety and to move the eye through the painting, creating rhythm. A dark value could exit the painting on the left as well.

A smaller point, but one that should be addressed: Iridescent paint was used in the upper right of this painting, creating a glare that makes it difficult to take proper slides. Areas like this would have to be reworked if you ever planned to submit a slide of a painting with this type of paint for an art exhibition. A bad slide of a good painting won't make the grade. (Art by Carolyn Walter)

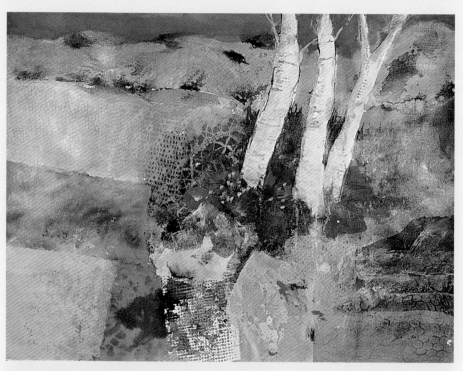

How to improve it

More blue shapes are tested to better connect the rock shapes. A dark shape placed at the bottom allows the eye to exit the painting and provides a value change. A warm color is needed on the right side of the painting so the eye moves from the red in the distant hill to the rest of the painting. A purplish tree trunk solves the problem.

The left side of the painting feels empty; a tree placed in the upper left provides needed balance and invites you over to that side. The torn white edge on the test collage piece in the middle left moves the eye to that side, too.

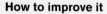

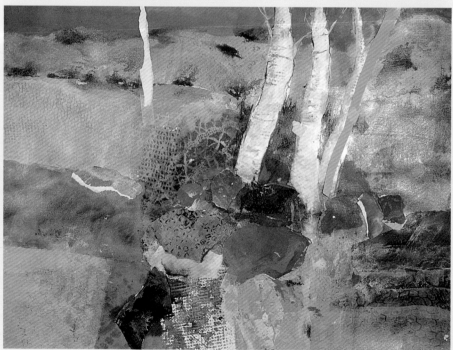

Student's finish

The artist reworked the painting, and it is almost finished. The rock shapes are varied in size, and the gray-green is an effective color choice. It would help to tone down and vary the green in the lower right by glazing with a wine red, its complement. It is a little too green and needs to be grayed. A little glazing or spraying of the complement in the upper right would also enhance the painting. Spraying paint with an atomizer is a good way to change value and color without disturbing the under-painting too much. This will also visually bring the red tones in the hill area down and through the painting.

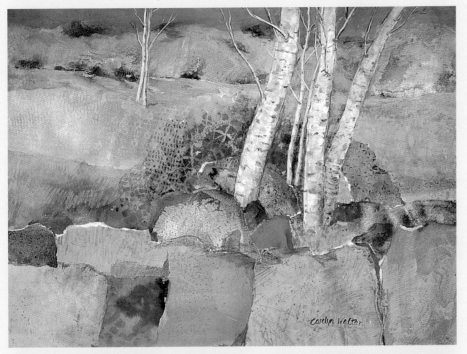

How to improve it some more

After studying the painting upright with a mat, we decide that the painting would work better cropped. There still isn't enough happening in the left side of the painting. Cropping brings the painting together, and we can now focus on the trees. The dark rock shape in the middle left that gets cropped has to be replaced since this exit/entrance dark is very important. It moves the darks through the painting and adds weight to the lower-left side of the piece. It also adds balance to the weight of the tree shapes.

Additional wine-colored papers are tested and will work to move the red into the rock area. The red also gives contrast to the pre-dominant green. A wine collage piece is placed in the middle-right rock area above the existing gray piece. This placement breaks the straight line and adds more rhythm to the darks and variety to the line.

The blue exit line in the lower right grounds the rock section. The scratched lines give tex-tural interest and enhance the paint surface. Once the green is toned down and made less intense in the lower right, the painting should be complete.

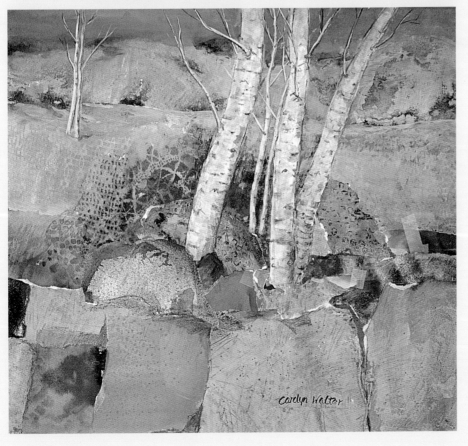

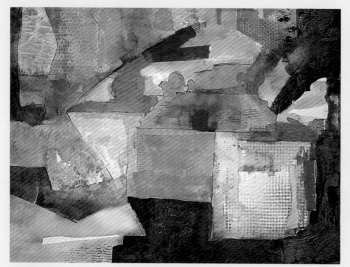

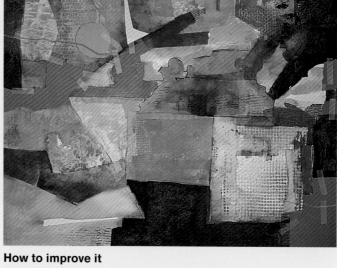

Original

This is a great texture sheet start. There is variation in size and good color. However, the arrowlike shape in the middle points the viewer out of the painting, perhaps to the painting on the left! I had an instructor who told us to not point at the painting next door; he said, "They'll get the prize!" If the painting were to be turned to a vertical format, the arrow would point up or down. This could lead you to think of directional road signs such as a stop sign, and you develop the painting in that direction. This is how ideas are generated through images in your painting starts; look for content that is more unique. (Art by Ceil Fischler)

How to improve it

To stop the arrow from pointing out, a curved red shape is introduced to bring the eye back into the painting and then move it through the painting. Adding an orange circle gives good contrast to the geometric shapes and fills the blue space. Yellow is added next to the blue shape with the circle to further counterbalance the arrow shape and move the color through the painting. The white geometric shape in the lower right appears to be floating and is anchored by a purple shape.

Shapes on the right side of the painting could be better connected to the edge and to the other colors with the addition of a mixture of Phthalo Blue, Burnt Sienna and white gesso for contrast and variation. Lines are introduced to add direction and rhythm.

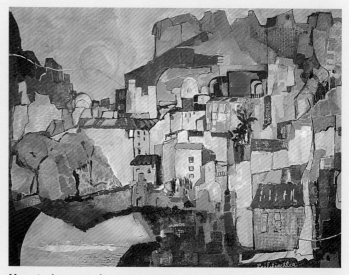

Student's finish

The artist kept the circle but changed the abstract shapes into buildings. What fun! The arrow is now a rooftop. What an imaginative use of shapes and space. This artist is not afraid of change; she enjoys the journey, as we all should.

How to improve it some more

The lower left needs a dark to anchor the bridgelike shape that seems to be hanging and not connected to the space. The dark curve directs the eye back into the painting. Depth is now pronounced, and the viewer wants to go under the bridge and out to sea.

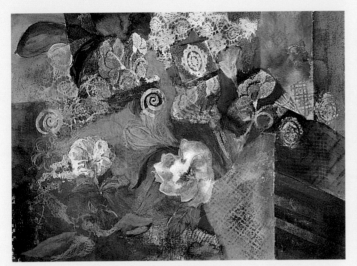

Original

This piece shows great integration of saved white areas. The vase was a white shape resulting from an abstract design understructure.

This painting could be enhanced with the addition of some more lights and brights to connect some of the elements in the painting, giving it unity. The stamped shape to the right of the vase could be developed into a flower, giving needed weight to the floral arrangement in relationship to the sizable vase. It also gives balance to the large flower coming out of the vase on the left. The diagonal lines exiting/entering the painting on the bottom right give tension, but combined with the slanted vase they seem a bit jarring. (Art by Sandra McCourry)

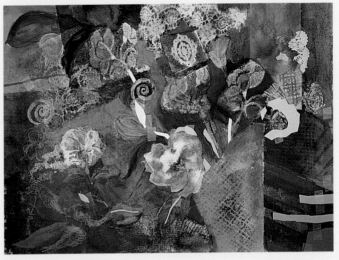

How to improve it

Curving the severe slanted shape and lines on the right side of the painting brings the eye back into the painting instead of out. Adding more whites to the far-right side of the painting repeats color and light in that area. Yellow is moved through the painting. It doesn't matter what the shape is–fish, fowl or flower–if you need a color to move, just make any shape or object that color.

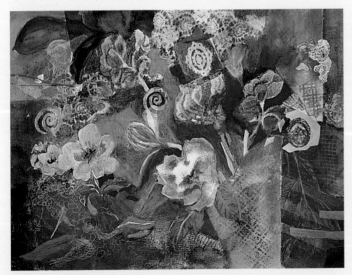

Student's finish

After the artist made adjustments, the painting was returned for further critique. The exit/entrance line in red in the upper left has been made more curved to go with the flow of the curving petal shapes. Turquoise and red construction paper lines are added around the leaf shape on the vase. These lines add needed excitement to this area. Colored lines can be the perfect final touch.

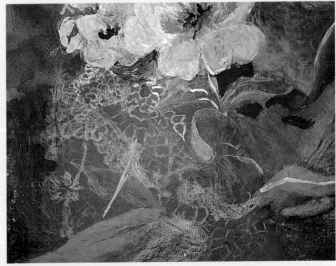

Detail

The artist has done a great job of integrating mechanically engineered texture with the real thing. Adding drawing to your work is a big plus. Colored pencils and watercolor crayons can do wonders for a painting. It is always refreshing to see the artist's hand in a painting.

RICHMOND LETTERS
Pat Dews • *Ink and acrylic on 300-lb. (640gsm) cold-press watercolor paper* • *22" × 30" (56cm × 76cm)* • *Collection of the artist*

CONCLUSION

As you paint, you reach plateaus in your work. It can be difficult enough just to learn the basics and how to use your materials. Then you have to figure out what you want to say and how you want to say it. You need patience and time.

Often I find that students want to become serious painters but dissipate their energies by going in too many directions. There is only so much time, and painting takes time. If you want to paint, do it; don't waste valuable time. Concentrate on those things that will help you achieve that goal.

Paint what you know and love. Often the painting is right in front of you. Ordinary subject matter can become important and special if you use nontraditional colors or a different vantage point. As you grow as an artist, you'll learn that it's not necessarily *what* you paint, but *how* you paint it. As you paint, try to really think about what you want to say.

Whether you are just starting your painting journey or looking for direction along the way, I hope my book inspires you, makes you paint and helps you grow as an artist. Make it easy on yourself. There are enough rules you need to learn that you shouldn't put a lot of additional restrictions on yourself. If you need to use opaque paint to correct an area, do it. Working in only a transparent manner can come later. If you need to crop a part of your painting, crop it. In time, you will learn to fix anything, and if you don't want to crop, you won't.

Work hard, paint often and have faith in yourself. And I can't repeat often enough: Have plenty of paper. If you have only one piece of paper, that painting had better be good!

Good luck with your endeavors.

Pat Dews

BIBLIOGRAPHY

Anderson, Donald M. *Elements of Design*. New York: Holt, Rinehart and Winston, 1961.

Bates, Kenneth F. *Basic Design: Principles and Practice*. New York and Cleveland: The World Publishing Company, 1970.

Batt, Miles G. *The Complete Guide to Creative Watercolor*. Fort Lauderdale, Fla.: Creative Art Publications, 1988.

Beam, Mary Todd. *Celebrate Your Creative Self*. Cincinnati, Ohio: North Light Books, 2001.

Beitler, Ethel Jane, and Bill Lockhart. *Design for You*. 2nd ed. New York: John Wiley & Sons, Inc., 1969.

Betts, Edward. *Master Class in Watercolor*. New York: Watson-Guptill Publications, 1975.

Brommer, Gerald F. *Collage Techniques: A Guide for Artists and Illustrators*. New York: Watson-Guptill Publications,1994. *Space*. Worcester, Mass.: Davis Publications, Inc., 1974.

Collier, Graham. *Form, Space, and Vision: An Introduction to Drawing and Design*. 4th ed. Englewood Cliffs, N.J.: Prentice-Hall, Inc., 1985.

Cortel, Tine and Theo Stevens. *Basic Principles & Language of Fine Art*. Newton Abbot: David & Charles; New York: Distributed by Sterling Publishing Co., 1989.

Elsen, Albert E. *Purposes of Art*. 4th ed. New York: CBS College Publishing, 1981.

Evans, Helen Marie, and Carla Davis Dumesnil. *An Invitation to Design*. New York: Macmillan Publishing Co., Inc., 1982.

Friend, David. *Composition: A Painter's Guide to Basic Problems and Solutions*. New York: Watson-Guptill Publications and London: Pitman Publishing, Ltd., 1975.

Goldstein, Nathan. *Painting, Visual and Technical Fundamentals*. Englewood Cliffs, N.J.: Prentice-Hall, Inc., 1979.

Handell, Albert, and Leslie Trainor Handell. *Intuitive Composition*. New York: Watson-Guptill Publications, 1989.

Leland, Nita. *Exploring Color*. Rev. ed. Cincinnati, Ohio: North Light Books, 1998.

McCarter, William, and Rita Gilbert. *Living With Art*. New York: Alfred A. Knopf, Inc., 1939.

Preble, Duane, and Sarah Preble. *Artforms*. 3rd ed. New York: Harper & Row Publishers, Inc., 1985.

Smagula, Howard J. *Creative Drawing*. London: Calman and King Ltd., 1993.

CONTRIBUTOR PERMISSIONS

Betty Carr
Pages 54-55, *Timeless Treasures*; pages 60-61, *Cosmos in Light*; page 62, *Wagon's Bounty*; page 63, *Summer's Sunflowers* and *Granite Reflections*; page 140, *Grand Entry* © Betty Carr

Jacqueline Chesley
Pages 76-77, *Phalanx Road*; page 80, *Interior With Flowers*; page 81, *October Afternoon*; page 82, *The Breakfast Club* and *Sentinels*; page 83, *The Study* and *The Dining Room*; page 140, *Antique Collection* © Jacqueline Chesley

Ruth Wood Davis
Page 28, *Tai Chi* © Ruth Wood Davis

Lana Grow
Page 122, *Beyond Your Circle of Imagined Limit* © Lana Grow

Eydi Lampasona
Page 84, *Weathered Wings*; page 89, *Rainy Day*; page 90, *Elusive View*; page 91, *Power of Three* and *Headline Hide*; page 140, *AM Dalbergergarten 7* © Eydi Lampasona

D. Martine
Page 16, *Tinta Y Tono Agosto* © D. Martine

Dorothy Masom
Pages 52-53, *Woodside Pond*; pages 92-93, *Encaustic Fish No. 2*; page 97, *Poppy Fields*; page 98, *Solarium*; page 99, *Nefertiti Image* and *Station 12— The Crucifixion*; page 141, *The Café* © Dorothy Masom

Mark E. Mehaffey
Page 64, *Old Buildings, New Light*; page 70, *Heron on the Rocks*; page 73, *Country Road #2*; page 74, *Pickerl Lake Sunset*

and *Country Church*; page 75, *After Dinner With Friends* and *Late Afternoon, Yucatan*; page 141, *Rigging Up* © Mark E. Mehaffey

Mary Ann Putzier
Page 121, *Finding My Way* © Mary Ann Putzier

Mickey Schemer
Pages 10-11, *Morning, Noon and Night* © Mickey Schemer

Kaili Sherman
Page 15, *Moonie With Hands* © Kaili Sherman

Selma Stern
Page 44, *The Ancient Mariner* © Selma Stern

Jo Toye
Page 139, *Spaces of Time* © Jo Toye

Lynn Weisbach
Pages 100-101 and 105, *Dawn*[3]; page 106, *Sunday Afternoon*; page 107, *Celebration in Red* and *Summer Breeze*; page 141, *Relaxation, Lost in Thought* © Lynn Weisbach

SPACES OF TIME
Jo Toye • Mixed media on watercolor paper • 22" × 28" (56cm × 71cm) • Collection of the artist

ABOUT THE ARTISTS

Betty Carr

Betty Carr received her M.F.A. from San Jose State University and has twenty-five years of teaching experience. Carr is a full-time painter who currently teaches art workshops throughout the United States, England and Europe. She is a signature life member of Knickerbocker Artists, and her work has been included in numerous books and magazines. She is the author of *Seeing the Light! An Artist's Guide* (North Light Books, 2003). Carr is represented by Mountain Trails Gallery in Sedona, Arizona; El Presidio Gallery in Tucson, Arizona; Lee Rommel Gallery in Santa Fe, New Mexico; Taos Gallery in Scottsdale, Arizona; Judith Hale Gallery in Los Olivos, California; Oscar Gallery in Ketchum, Idaho; and Gallery Amsterdam in Carmel, California. Carr lives in Arizona with her husband, painter Howard Carr. They spend half the year traveling and painting scenes around the country.

GRAND ENTRY
Betty Carr • Watercolor • 14" × 20" (36cm × 51cm)

Jacqueline Chesley

Sketch by Judy Martin

Jacqueline Chesley's work is represented in both public and private collections, and she is the recipient of many awards. She was an elected member of the Pastel Society of America and has been honored with the title of master pastelist. Her paintings have been featured in *American Artist*, *The Best of Pastel 2* and, most recently, *New Jersey: Art of the State.*

Chesley is represented by the Walker Kornbluth Gallery in Fairlawn, New Jersey. After studying mosaic design with one of Italy's foremost artists, she is currently creating mosaic furniture. Her Web address is www.asbury@home.com.

ANTIQUE COLLECTION
Jacqueline Chesley • Pastel • 36" × 30" (91cm × 76cm) • Private collection

Eydi Lampasona

Eydi Lampasona is a full-time exhibiting artist who received her B.F.A. in painting from Florida Atlantic University. She has received numerous national and international awards for her mixed-media works and is a signature member of the National Watercolor Society, National Collage Society, International Society of Experimental Artists, and the Society of Layerists in Multimedia.

Lampasona exhibits her work in museums and galleries throughout North America and Europe. She conducts workshops nationally and currently teaches classes at Boca Raton Museum of Art and Coral Springs Museum of Art in south Florida. She is represented by Zagami Fine Art Gallery in Fort Lauderdale, Florida.

AM DALBERGERGARTEN 7
Eydi Lampasona • Mixed media/collage on watercolor paper • 30" × 24" (76cm × 61cm) • Collection of the artist

Dorothy Masom

Dorothy Masom, known as the "Dean of American Encaustic Painters," holds a master's degree in art from Bloomsburg University in Pennsylvania. She was also a scholarship student at the Pennsylvania Academy of Art.

A distinguished lecturer and professor, Masom taught art for eighteen years at Susquehanna University in Pennsylvania. She won international recognition for the prestigious award she received from the Interfaith Forum on Religious Art and Architecture for her fifteen encaustic paintings of "The Stations of the Cross." These paintings have been exhibited around the country.

Masom is the author of *Encaustic Painting* (Bergess Publishing, Inc., 1989). She is the past owner and director of Woodside Art School and Gallery in Sussex, New Jersey. Masom continues to teach and lecture and lives in Florida with her husband, Richard. She is represented by the Patricia Cloutier Gallery in Tequesta, Florida.

THE CAFÉ
Dorothy Masom • Encaustic on Masonite • 36" × 36" (91cm × 91cm)

Mark E. Mehaffey

Nationally recognized artist Mark E. Mehaffey is a signature member of the National, American and Midwest watercolor societies, Watercolor West, and the Rocky Mountain Watermedia Society, among others. Mehaffey has won major awards in juried exhibitions across the country, including the Beverly Green Memorial Purchase Award from the National Watercolor Society, the M. Grumbacher Gold Medal from Allied Artists of America, and the Skyledge Award from the Midwest Watercolor Society.

Mehaffey's work has appeared in many publications, most recently in *Splash 5: Best of Watercolor*; *Places in Watercolor;* and *Creative Watercolor*. His paintings are included in corporate, public and private collections throughout the United States, and he is listed in *Who's Who in America* and *Who's Who Among America's Teachers*.

Mehaffey recently retired from a thirty-year career as a public school art instructor. He is a popular juror and continues to give workshops and lectures around the country.

RIGGING UP
Mark E. Mehaffey • Sprayed transparent watercolor on 140-lb. (300gsm) hot-press watercolor paper • 22" × 30" (56cm × 76cm) • Collection of Mike Bailey

Lynn Weisbach

Lynn Weisbach graduated with a BFA from the University of North Florida. She worked for twelve years as a graphic designer, art and creative director before returning to her first love of painting. She is a signature member of the Southern Watercolor Society and signature member and past President of the Georgia Watercolor Society.

Weisbach's work has been juried into local, state and regional shows, and it appears in corporate and private collections as well as the permanent collections of the Cultural Arts Center in Douglasville, Georgia, and the John Marlor Art Center in Milledgville, Georgia.

Weisbach teaches watercolor and mixed watermedia classes and workshops in and around the southeastern United States. Her works can be seen at Opus One Gallery in Atlanta, Georgia. Visit her website at www.LynnWeisbach.com.

RELAXATION, LOST IN THOUGHT
Lynn Weisbach • Watercolor • 17¾" x 12¾" • Collection of the artist

More of the Best From North Light Books!

This lively, liberating guide will have you shedding your tight painting approaches in favor of what is called "quick studies." Craig Nelson's proven method of painting focuses on the essence of the subject and the mastery of the medium rather than the minute details that seem to mire some artists and prevent them from improving.

ISBN 1-58180-196-3, hardcover, 144 pages, #31969-K

Ensure that your compositions work every time! Inside you'll find an insightful artistic philosophy that boils down the many technical principles of composition into a single master rule that's easy to remember and apply. Greg Albert provides eye-opening examples and easy-to-follow instructions that will make your paintings more interesting, dynamic and technically sound.

ISBN 1-58180-256-0, paperback, 128 pages, #32097-K

Mastering basic brushwork is easy with Mark Christopher Weber's step-by-step instructions and big, detailed artwork. See each brushstroke up close, just as it appears on the canvas! You'll learn how to mix and load paint, shape your brush and apply a variety of intriguing strokes in seven easy-to-follow demonstrations.

ISBN 1-58180-168-8, hardcover, 144 pages, #31918-K

Many adults who decide to "study" art become too serious and frustrated, thinking they will never learn what it takes to be really good. *Paint Happy* encourages readers to relax and enjoy their work by combining expressive painting techniques with their own unique style. Cristina Acosta emphasizes self-expression without leaving out basic tools of composition and color.

ISBN 1-58180-118-1, paperback, 112 pages, #31814-K

These books and other fine North Light titles are available from your local art & craft retailer, bookstore, online supplier or by calling 1-800-448-0915.